THE BITTER SEA

HARPER

An Imprint of HarperCollins*Publishers*
www.harpercollins.com

THE BITTER SEA

COMING OF AGE IN A
CHINA BEFORE MAO

CHARLES N. LI

HarperCollins books may be purchased for educational, business, or sales promotional use. For information, please write: Special Markets Department, HarperCollins Publishers, 10 East 53rd Street, New York, NY 10022.

FIRST EDITION

All insert photographs are from the personal collection of the author.

Designed by Emily Cavett Taff

Library of Congress Cataloging-in-Publication Data

Li, Charles N.
 The bitter sea : coming of age in a China before Mao / Charles N. Li.—1st ed.
 p. cm.
 ISBN: 978-0-06-134664-4
 1. Li, Charles N., 1940– 2. Linguists—United States—Biography. 3. China—History—1949–1976. I. Title. II. Title: Coming of age in a China before Mao.
 P85.L54 2008
 951. 05'5092—dc22
 [B] 2007025697

08 09 10 11 12 WBC/RRD 10 9 8 7 6 5 4 3 2 1

TO KATE,
GABRIEL,
AND RACHEL

CONTENTS

AUTHOR'S NOTE

"BITTER SEA" IS THE LITERAL TRANSLATION OF THE Chinese expression *ku hai*, which means "life and the human condition." The metaphor originated in India and entered the Chinese language through Buddhism, which preaches that insatiable human desires make life bitter like brine, and that the endlessness of human suffering resembles an open sea: grief and sorrow, like water, everywhere.

Growing up in China, perhaps influenced by the Buddhist metaphor and the marine environment of Hong Kong, I thought of life as a journey by sea, floating like flotsam, cresting with waves, dropping into troughs, lurching hither and thither, pounded and buried by the heaving sea, only to surface again and again.

This book is a narrative based on what I can remember of the first twenty-one years of my life, from 1940 to 1961. It was a tumultuous period of war, calamity, upheaval, and transformation in China, where killing, depredation, dehumanization, and the infliction of suffering occurred every day, everywhere.

Remembrance of the past is subjective, and memory of the same place or event can differ from person to person, as madeleines can vary in shape or taste from patisserie to patisserie. I am not speaking of the dramatic variation so vividly portrayed by Akira Kurosawa in his film *Rashomon*. Neither do I wish to invoke the art of forgetfulness so skillfully captured by Milan Kundera in his literary tomes. As long as I feel that a madeleine remains a madeleine and hasn't morphed into a macaroon, I have given it free rein to appear in this memoir.

—*Charles N. Li*

THE BITTER SEA

PROLOGUE

THE COLONY

Hong Kong, 1950

THE FIRST DAY IN MY NEW SCHOOL HAD NOT begun well.

To start with, everyone spoke Cantonese, a language I did not understand. As the teacher came gliding into the classroom, his traditional long garment fluttering behind him, I could only follow my classmates and copy what they did.

The class prefect barked unintelligible orders three times, and the entire class stood, bowed, and sat down again in unison, with me trailing slightly behind.

The teacher nodded slightly to acknowledge the respect paid to him. It was a ritual that began every class in every Chinese school-room in those days. I looked at him timidly, as did every other student.

Short and dark, my teacher had a velvety Cantonese face with soft eyes slightly protruding like the eyes of a seal. After surveying the class of seventh-graders briefly, as if he were making an assessment, he began to bark out names in a roll call. When my name

came up, he paused for a couple of seconds, staring at the paper in his hands, and called out, "Lay Lap," a Cantonese rendition of "Li Na." Then, he added, as if talking to himself, "'Lap' means 'dumb.'"

My classmates exploded in laughter.

The teacher gave the class a hard stare, which stopped the laughing instantly. Turning his attention to me and gesturing with his hand, he called me up to his desk.

That was when he found out that I didn't understand or speak Cantonese.

"Your given name, 'Na,' is written with the 'language' radical, correct?" he asked quietly in an approximation of Mandarin I could barely understand.

I nodded.

My classmates started giggling as the teacher sent me back to my seat.

Glaring at the class ferociously, he launched into a reprimand. Only now he switched to Mandarin, obviously for my benefit. Grateful as I was to understand what was going on, I had to refrain from laughing at his horrendous accent.

"You think a humble name is funny! Why? Because you all have flowery, laudatory names?"

Looking down at the name chart in front of him, he continued.

"Let's see what we have here. 'Pillar of the Nation,' 'Pride of the Clan,' 'Glory of the Family.' Do you think you are really and truly pillar of the nation, pride of the clan, glory of the family, or whatever grandiose personage, just because your parents gave you those names? *Do* you?" the teacher thundered.

There was absolute silence as he surveyed the room with blazing eyes. Then he softened his voice.

"I want you to remember two things right now. First, we Chinese are fortunate that we don't have a fixed set of meaningless names as the British devils do. We use meaningful words to name

our children. This practice is one of our important cultural heritages." He glared around to make sure he had our full attention.

"Second, while most people name their children with glorifying words, some prefer words of humility. A humble name extols and promotes modesty as a motto of life. It reminds a person bearing the humble name to strive for improvement. There is nothing funny about it. What you ought to know is that a person named 'dumb' is not necessarily dumb, just as a person named 'smart' is not necessarily smart. Remember this and behave yourself!"

The teacher's admonition was comforting, and the way he effectively controlled the class impressed me. I also appreciated his use of Mandarin. With such a head teacher, I would do fine, I thought, trying to calm my racing heart.

Then came recess. Trying to mind my own business, I wandered toward a shady corner of the schoolyard to get out of the hot sun. Being new to the school, I didn't know anyone.

A group of kids I recognized from my class approached me. One, a big, well-built boy of thirteen or fourteen, stepped forward and planted himself before me.

"Hey, Dumb Li!" he called in oddly accented Mandarin, smirking. His speech was marked by a particular machine-gun-like rhythm. "Are you mute also?"

He was big and intimidating.

Of course, from my perspective, everyone in my seventh-grade class appeared big and intimidating. At four feet in height and ten years of age, I was a midget. Cantonese boys typically began elementary education at the ripe age of seven or eight. I had followed the northern Chinese tradition of starting first grade at age six and then skipped sixth grade, at Father's command, when I arrived in Hong Kong, in 1950.

The one who had spoken to me was just average in size for a Cantonese seventh-grader.

I didn't respond to his rude question. What I wanted to do was

punch him in the stomach, which lined up with my neck, but I didn't dare. Not only was he intimidatingly huge, but approximately ten of his similarly sized friends surrounded me. I looked to see if a teacher might be nearby.

No luck.

"Look, we are not trying to insult you," Machine Gun said. "Your name is Dumb Li, isn't it? We are just calling you by your name."

His words were reasonable, but his tone said otherwise. Sure enough, as soon as the Machine Gun opened up again, everyone cracked up laughing.

A wise guy behind me said something in a similar rhythmic pattern, which I, of course, didn't understand.

"My friend behind you wanted to know who gave you your name," Machine Gun translated in stilted Mandarin. He gave me a toothy smile.

I tried not to look them in the eyes and prayed for the next class bell to ring as my heart pounded against my chest. Viewing my silence as submission, Machine Gun plowed on amid waves of laughter.

"Your father must be a dog turd to give you such a name!"

This was too much!

"Fuck your mother!" I shot back instinctively in Mandarin, glaring up at the tall Machine Gun. Even if I couldn't defend myself physically, filial loyalty dictated that I had to at least retaliate against an insult to my father. Filial loyalty meant more than just being loyal and obedient to parents—it meant that you were expected to worship your parents, defend them with your life if necessary, and provide for them after you grew up. These concepts were pounded into the head of every Chinese during childhood.

"Hey, this midget ain't mute! He can swear!"

Everyone roared.

A crowd began to gather.

I did try to get away. But Machine Gun shoved me back with both hands, and before I could stop stumbling backward, someone behind me shoved me forward. I pitched toward Machine Gun. Someone else on my left caught my elbow and shoved me sideways. My body started spinning around involuntarily. Then the pushing and shoving came from all directions. It became a game, all of them playing with gusto and laughter—only I was the bouncing ball.

When they stopped, I was sure they would try to figure out another way to torment me. I thought to myself, *That's it! I am not going to take it anymore!*

I steadied myself and, gathering all my strength, punched Machine Gun in the solar plexus, right above his stomach. As he was doubling over from shock and pain, he brought his two fists down on my shoulders like a timpanist bearing down on the kettledrum for the last note of the finale of Beethoven's Fifth Symphony.

The blow hammered my trapezius muscle and shook my brain. I crumpled to the ground as kicks landed on my body from every direction. I closed my eyes and covered my face with my arms.

All of a sudden, the blows stopped and footsteps started scattering away. Cautiously, I opened my arms and eyes to see the silhouette of an adult standing over me.

Ah, my teacher from the first class has saved me, I thought dazedly.

But as my vision cleared, I realized from the supine position that the man looming above me wasn't my head teacher. This man had a long and stern face and seemed older, taller, and much more officious than my teacher. He opened his mouth and barked. I didn't understand anything, but his intonation and facial expression told me that he was angry. Then he switched to Mandarin, in a formidable voice.

"What happened to you? Get up!"

"They beat me up."

"Who are 'they'?" the man demanded as I got to my feet.

"Everybody," I replied, brushing dust from my uniform. My arms and body ached where I had been kicked.

"*Everybody* beat you up and you are now standing on your feet? I have never heard of such a ridiculous claim in my entire career as the principal of this school," he snapped, raising his voice.

"Yes, everybody!" I stood my ground.

"This is disgraceful! A brawl on the first day of a new academic year! You can be sure I will be looking into this!"

With that pronouncement, the principal straightened his posture, folded his hands behind his back, and stomped away rigidly, just as the bell for the second period rang.

I sat in the second-period class, nursing my sore body and wounded spirit. This was a different teacher lecturing on a different subject, but it didn't matter—I couldn't understand a word of it. This teacher, too, spoke in Cantonese. They all did. I was no longer in Nanjing or Shanghai, where I had lived up until now. I had arrived in Hong Kong, where everyone spoke Cantonese, only four days ago.

Normally I had difficulty sitting still for a long time, but during the second period of this first day of school, I sat transfixed, lost in my own world. It was no problem for me to remain in my seat.

I was trying to figure out how to survive the next class break: Should I follow the teacher to his office, run to the bathroom, pretend I had fallen ill, or simply stand in a corner so that no one could attack me from behind? I tried my best to focus on assessing the pros and cons of each strategy. Even the sounds of the teacher's incomprehensible lecture barely registered in my head.

Twenty minutes into the period, my concentration was interrupted by the sudden appearance of a messenger at the door of the classroom. He spoke to the teacher in a hushed voice and left after handing him an envelope. The teacher motioned for me to step out

of the classroom with him and told me in broken Mandarin, "You should go home and hand this letter to your father."

I couldn't believe it. What luck! My problem disappeared. I was liberated from my anxiety about the bullies during the next class break. Picking up my belongings, I ran out of the school with relief.

———

On September 1, 1950, three days before the beginning of the new school year, my Aunt Helen had brought me south from where we lived in Shanghai to join my family in the British colony of Hong Kong. Mandarin was my first language; Shanghainese became my second. (Mandarin- and Shanghainese-speakers are mutually unintelligible.) Cantonese would be my third language. But I had never heard it before arriving in Hong Kong.

In addition to the language, everything else in Hong Kong seemed different from Shanghai. The climate was tropical, humid, and breezy. The sea churned around every corner. Even if you couldn't see it, you could either hear the waves lapping at the shore or smell the salty air. Lush vegetation covered every uninhabited spot—by the sea, on the flat land, and up the mountain.

Even the people of Hong Kong looked different. Most of them were short in stature with dark complexions and very different facial features in comparison with the northerners or Shanghainese. Their eyes were shaped more like half-moons, their noses flatter, lips thicker, and faces thinner. Plus, there were "foreign devils"— the perpetually sunburned British—everywhere. They swaggered like kings when they were not sitting grandiosely in rickshaws pulled by huffing and puffing Cantonese coolies. The British behaved as if they owned the place, and they did!

Going home from school was easier said than done. The school was located in the city of Kowloon, situated directly across from the island of Hong Kong, on the opposite side of the Victoria Strait.

Home was in the New Territories, far away from the urban clutter of Kowloon.

In 1950, the New Territories were pristine and undeveloped. The mountains there were covered with trees; rivers cascaded down toward the sea; estuaries teemed with aquatic life and swarmed with egrets and gulls. The vibrant landscape was dotted with villages here and there, most of them centuries old. Tigers occasionally made their presence felt by devouring a water buffalo belonging to a mountain village.

A single-track rail line connected Kowloon with the New Territories. An old-fashioned, coal-burning steam locomotive that rained soot along its path labored loudly to pull each train between Kowloon and the various stops. It passed through picturesque verdant valleys, crossed over narrow rocky gorges shaped by crystal-clear gurgling rivers, and lumbered along stretches of soothing-green rice paddy.

Being sent home from school in the morning, I had to wait two hours for the next train. With so much time on my hands, I sauntered around the train station and came upon an array of street vendors peddling all kinds of food, ranging from unshelled peanuts, cotton candy, pickled vegetables, preserved olives, and fresh fruit, to barbecued meat, braised seafood, sizzling potstickers, and steamed meat buns. The fruit, displayed in round, shallow wicker baskets carried on each peddler's shoulders, looked colorful and luscious. The simmering meats and seafood in their sauces sent up plumes of tantalizing aromas that whetted the passerby's appetite. The brown potstickers and white meat buns added stimulus to make one's mouth water.

I stood in front of a squid peddler, my eyes riveted on the inviting pieces of squid. They were all cut up. Five cents a piece! Each piece was skewered on a toothpick, ready to be picked up and popped into your mouth. My stomach gurgled in hunger, but I didn't have five cents.

Even though hunger pangs had been familiar to me when my family and I lived in a slum in Nanjing several years before, my particular yearning for the squid that day drove me crazy. As I stood in front of the squid peddler, absorbed in the sweet aroma, all I could think of was grabbing a piece and running away.

"Look, young man, if I didn't have to buy rice to feed my family, I would give you a piece, okay?" The squid peddler read my mind.

I jumped and looked up. He was staring right at me.

I felt ashamed, lowered my head, and walked on. No need to add theft to the day's list of travesties!

When I arrived home, Father was surprised to see me so early.

"Why are you home this early?" he barked in his low voice.

"The school sent me back," I told him. "Here is a letter for you." I handed him the letter given to me by my second-period teacher.

Father was sitting in a large rattan armchair with an English book in his hands. The chair belonged to him exclusively. With soft cushions on both the back and the seat, and covered with tropical-flower-patterned material, it was the most comfortable, and easily the most costly, piece of furniture in our three-room apartment. I often wondered how it felt to sit in that princely seat. But I was strictly forbidden from using it, even if Father went out.

I looked at his huge head, his symmetrical and handsome face that always appeared grim and severe, at least whenever he faced me. Having rarely spent any time with him in my ten years of existence, I couldn't claim to know him at all.

When my aunt had brought me from Shanghai to my parents in Hong Kong a few days earlier, she had instructed me to address this grim-faced man as "Father" and bow to him. At the time, he was sitting at his desk, glowering and not saying a word. I felt awkward when I bowed and called him Father, as if he weren't my real father.

I had not seen Father since I was five years old, shortly after

World War II ended. During the war, I saw him occasionally from a distance when he arrived at home in his long black limousine. We were living in his mansion in the city of Nanjing then.

As his limousine pulled up the driveway, a bodyguard would jump out from the front and open the back door for him to disembark.

In those days Father always wore one of his three-piece suits, all of them elegantly fitted by a renowned tailor whose services were sought by General Douglas MacArthur in Japan after the Second World War. I remembered Father's unusual height, his huge head, and his sartorial elegance.

What fascinated me the most on each occasion of Father's arrival at the mansion, I must confess, was not him. He looked distant and self-absorbed, and I didn't feel connected to him at all. Rather, it was his bodyguard's sidearm that captivated my fascination.

The bulging weapon, half exposed from its leather holster, looked at least twice the size of a handgun. It was a machine pistol, loaded with thirty rounds of ammunition. I had seen Japanese soldiers firing rifles at people once, but I had never seen anyone firing a machine pistol, and I wondered what it could do.

That was when Father was at the height of his power and wealth. Now, residing in the British colony of Hong Kong as a refugee from the newly established People's Republic of China—which Father called, scornfully, "the Communist mainland"—he was translating books from English to Chinese and writing inflammatory articles against the Communist regime.

Life is always difficult when one falls from a great height!

Since my arrival, four days prior, we hadn't had much more interaction than in those early days. In fact, what I primarily remember is being fascinated by my father's egg-eating habit at breakfast, where he was the only one who had such a delicacy. He set the egg in a delicate little cup that held the egg vertically. Steadying the egg with one

hand, he deftly swung a little knife against the upper half of the egg with the other hand. When he lifted the severed top half, the egg yoke surrounded by soft white in the bottom half looked like a rising sun. Since I had never had breakfast with him before arriving in Hong Kong, I had never seen his egg-eating ritual, which he had acquired while studying in England. His little maneuver mesmerized me, so much so that I hardly paid any attention to the fact that my own breakfast consisted of just two slices of thin white bread.

He was Father, and Father always had first claim on everything, including food. That was taught to me as early as I could remember: Your ancestor always ranks ahead of you, and Father, who happened to be the oldest surviving member of our clan, occupied the most exalted rank in the family.

Now, as Father read the missive from my school, his face became grimmer and more ominous. Even though I hardly knew him, I grew concerned.

"You have been expelled from school." Father glowered at me.

"*What?* They didn't tell me!"

"Why should they tell you?" He stood up as he was speaking. "You are nobody. *I* paid your tuition."

How stupid of me! I thought to myself. *Of course, I'm nobody, at least not until I grow up.*

"You started a fight, didn't you?" he said accusingly.

"No, I didn't." It was a knee-jerk response, but I also felt that I was telling the truth.

"You didn't? You mean the principal lied in this letter?" Shaking the letter, Father had begun to holler in his deep voice. It had a chilling effect, and I thought I'd better not argue. "You also insulted your classmate's ancestor and used foul language!"

I noticed that he was no longer tagging his accusations with the rhetorical "didn't you?"

I could feel his fierce glare drilling into me as I looked down at my feet.

"To insult one's ancestor is the worst offense possible," he roared at me. You have not only insulted your classmate's ancestor, you have also insulted your own ancestor by getting yourself expelled. *And on the first day of school!*"

This was unfair! How could he take the side of the bullies who had attacked me? I also felt hurt: after all, I had defended him when they called him a bad name. I kept my eyes on my feet, searching for a suitable defense against his accusation.

After a few seconds I gathered enough courage to look up at him and nearly swallowed my tongue. His contorted face and clenched teeth scared the wits out of me. Feebly I managed to blurt out my defense:

"They started the fight. They called you a dog turd. I was only responding to their insult."

I didn't even see it coming until the back of his huge, bony right hand crashed into my right cheek. The impact sent me reeling backward toward the wall. Barely managing to stay on my feet, I could taste blood in my mouth.

"Get this *wang bai-dan* out of my sight! He brings shame to my name!" he yelled to my mother while I cowered against the wall. As Mother came to steer me out of the room, I saw Father shaking his head in disgust.

Mother didn't say a word. Her hands were steady and her face looked unperturbed.

"No dinner for him tonight!" Father called after us as Mother matter-of-factly shoved me out into the garden.

———

The moist and pleasant smell of the tropical flowers and trees in the garden helped me to recover from my daze. I was glad that Father had thrown me out! This way he couldn't hit me anymore. Wandering aimlessly in the garden, I tried to understand what had just

happened. My head ached, my body was sore from the beatings I'd endured that day, and it was hard to think.

Did he hit me because I told him that Machine Gun called him a dog turd or did he hit me because I got expelled from school? There was no doubt in my mind that I had done something wrong—I just couldn't figure out what it was. I had defended him against the foul mouth of the bully. I had fought back out of desperation. After a while, I gave up. Too complicated!

The garden was much more interesting. It was a spacious garden belonging to the house, not just to us, and it covered a large area, bordering on a river at the mouth of an estuary. The tropical climate of Hong Kong provided the moisture and nutrients for every plant to grow feverishly. Some of them sported big leaves, and some leaves glistened with rainbow colors, shades of purple, red, yellow, green, and white polka dots. Among the trees was a gigantic magnolia of the Oriental variety whose finger-sized, cone-shaped white flowers yielded a strong, enticing aroma. Along the entrance to the house, there were jasmine bushes, very much like tea plants, petite and robust, emanating the sweetest scent one could imagine. The guava trees a short distance from the entrance were bearing pinkish fruit with a good amount of yellow and green, which offered their own tantalizing, mouthwatering fragrance.

Then there was the bamboo grove. Clean and orderly, it provided pleasant shade from the tropical sun, and its rustling leaves soothed a wounded spirit seeking refuge among their smooth, sectioned green trunks. Their tops, swaying in the tropical breeze, belied their strength and resiliency.

On that fateful afternoon, picking a random spot among hundreds of bamboos, I leaned on a sectioned trunk that rose straight up into the sky.

I wished I were a plant in that peaceful and idyllic setting: no

need to worry about hunger, or bullies, or parents. Just sway in the wind, imbibe the rain, and root into the earth.

After a while, I wandered out of the garden on one side of the bamboo grove along the bank of the river. It was September, the end of rice-growing season, and within a couple of miles I came upon a stack of fresh rice stalks.

I pulled out a few bundles from the middle. The emptied-out space looked like a cave. It made a nice little nest. There I curled up, cozy, comfortable, not too hot and not too cold. In an instant I fell asleep from the exhaustion of a trying day.

When I woke up, it was night, pitch black and moonless. My stomach screamed for food. I could feel it agitating and growling. But the starry sky was smiling with millions of stars, blinking without any interference from man-made lights. I imagined they were beckoning to me.

I wondered why Father was so mean and why he had never spent any time with me. Could it be that he wasn't my real father? I had heard stories of vicious and sadistic stepfathers, and I imagined embarking on a long, adventurous journey to far-flung places in my attempt to find my real father, and in the end, with a stroke of luck, I was united with him. He was smiling, caring, and loving. He was completely unlike the harsh father knew.

Melodramatic fantasy and self-pity enveloped me, and I cried myself to sleep.

PART I

NANJING

1944–1945

1

THE MANSION

To say that my father and I began our relationship on the wrong foot in Hong Kong in 1950 would be a gross understatement.

Both of us bristled with anger and hostility; each of us harbored resentment for the other; and, perhaps most important of all, both of us detested living in a British colony.

Hong Kong was one of the last vestiges of a vanishing British Empire, a place where every Briton, regardless of education and profession, pretended to be an aristocrat. For the Brits, going to an Asian or African colony was akin to being elevated to the House of Lords, if only in exile, of course. But the fringe benefits and pay in said exile far exceeded those belonging to the real House of Lords back in England. Goaded by servile sycophants and surrounded by fawning servants, they wallowed in arrogance, power, and luxury. The worst thing that could happen to a Brit in Hong Kong was to be sent home.

Father, too, was in exile of a sort. By contrast, in his home country of China he had been a man of high status—a once-powerful government official whose opinions had been respected and whose good favor had been sought. His exile was far from being luxurious or pleasant, like that of the British. He was a colonial subject and he resented every demeaning minute of this status.

For my part, before arriving in Hong Kong, I had spent one carefree year in the squalid Nanjing slums, and four pleasant years in the French concession in Shanghai—all safely distant from Father's heavy hand and disapproving glare. Those were happy times for me, especially the year in the slum. Moving to Hong Kong was yet another displacement imposed on me by my elders. I was ten and blamed Father for taking me away from all that was familiar and comforting.

But Father had a million more reasons than I to be angry and frustrated. He was a northerner, ill-equipped to adapt to the Cantonese environment, and he despised everything around him in Hong Kong: people he didn't care for, a language he didn't speak, a culture he didn't understand, and colonial overlords he resented. Unlike the Brits and (though he didn't know it at the time) unlike me, he could never go back to China, his home.

My relationship with my father had been testy from my earliest memory. There in the tropical colony, he and I were destined to continue a wary pas de deux, each of us increasing the other's irritations and disappointments. His were expressed in both words and action; mine were covert and secret. It was the rule of life: a son is not permitted to harbor, much less demonstrate, unhappiness with his father. Not so long ago in China a father could order a son to commit suicide, and the son would dutifully comply.

———

I was born in 1940. Until I was five, I lived in Father's giant mansion in Nanjing.

Father's mansion was surrounded by tall brick walls in a grim shade of dark gray. From the streets, the walls made the entire compound look like a prison. Even more suggestive of a penitentiary was the gate: made of solid iron, it was formidable, forbidding, consisting of two halves with a small door on one side for pedestrians. When both halves of the gate opened up, a bus could pass through with room to spare.

Inside the gate, a row of stately Roman cypresses shielded a meticulously maintained garden from the driveway. The garden was dominated by a spacious, manicured lawn with geometrically shaped borders of colorful flowers; in the center, an ornate, circular fountain with four full-length figures of Apollo, each carved from granite, spouted water from their mouths. The living room of the mansion opened onto the garden through a large veranda and descending marble steps. Behind the mansion were two separate buildings that housed an enormous kitchen and the living quarters for more than a dozen servants.

I was strictly forbidden to step out of the compound—a rule laid down by Father and enforced by the armed guard sitting in the little guardhouse by the enormous metal doors. Even when I got sick, I didn't go out. A doctor came to the mansion to treat me instead.

Hating this confinement is my first childhood memory.

My five siblings, all of whom were many years older than I, went out every day—albeit to their schools, and in limousines, accompanied by bodyguards who were charged with the dual responsibilities of guarding them and preventing them from leaving their school grounds. Bodyguards notwithstanding, they went out of the mansion every morning, chattering, jostling, and laughing. I didn't. This difference brought my confinement to focus in my earliest memory. No reason or explanation was ever given why I couldn't go out.

Naturally inquisitive, I became even more curious about the

world beyond the forbidden gray walls because of the restriction imposed on me. During a stroll inside the compound one day, I told my nanny that I was going behind a big tree to urinate. Instead, out of her sight, I tried to get on top of the wall. A large banyan tree, its trunk consisting of a tangled lattice of thick roots that grew vertically from its branches downward into the soil, stood next to the gray wall. The numerous roots were an invitation for me to scale the top of the wall. Scrambling and scrabbling, my small fingers gripping two vertical roots tightly and my feet pushing desperately against nearby columns, I managed to reach a large trunk and crossed over to the top of the wall.

But the wall was too high for me to jump down to the outside ground. Nai-ma, my beloved nanny, came looking for me while I was still sitting astride it, yearning for the tantalizing world beyond. When I turned to look down at her I saw her lips move as if to say something, but no sound came out. Instead, she held her hands to her face for a brief moment. When she took her hands away, her cheeks were pale and her eyes large and dark.

"Come down immediately!" was all she said.

There was something in her voice that told me I'd better obey.

I scrambled down the tree the same way I had climbed it, scraping my hands and knees in the process. When I reached the bottom, Nai-ma grabbed my hand and marched me back to the mansion, saying nothing. It was the closest she had ever come to scolding me. I was almost four years old.

The only way to allay my yearning for the outside world was to look out from the balcony of my room, which was at the front of the house. That was where I perched most of the time, daydreaming and intermittently surveying the outside world. A wheat field on the left, belonging to a distant village, sometimes harbored animals whose movements made the stalks sway oddly. Straight ahead was a small, barren hill that gently sloped down toward the road bordering the great gates of Father's mansion. On the right, a similar

but even larger mansion often bustled with human activity: caravans of automobiles going in and out, soldiers saluting, and servants rushing back and forth. Nai-ma told me that the mansion belonged to someone even more important than Father in the government. Later on in life I found out that the owner was the vice president of the Nanking Regime in occupied China.

Other than the activities in the vice president's mansion, nothing much happened in my neighborhood, if it qualified as a neighborhood at all. Commerce, which dominates all urban scenes in China, did not exist around the mansion. Father had purposefully had the mansion built on the outskirts of Nanjing to avoid the sight of dirt and poverty that dominated most cities in China at the time.

With nothing to do but watch the wheat grow, I became expert in imagining whole new worlds from my perch: a passing crow became a bomber. A sputtering automobile, a tank. Two farmers working in the field were the disguised scouts of an advancing military column.

It was the Second World War, and Nanjing was the capital of the Chinese "Vichy" government—the Japanese-collaborationist government also known as the Nanking Regime—that governed coastal China, extending hundreds of miles inland. That entire swath of land, with a population in excess of two hundred million, had been conquered by the Japanese several years before the onset of the Second World War. Life in the occupation zone revolved around the war.

The war's occasional spectacles, from my perch, were Japanese soldiers and military equipment passing through the front of the mansion. More exciting but more distant were the American bombers flying by in formation. These sightings supplied some raw material for my reveries. Other material derived from the bits and pieces of adult conversations I overheard: American troops advancing westward in the Pacific; Germany in retreat; Japan running short on war material; atrocities committed by Japanese troops; new

bombers, new weapons. Adult conversations about the war didn't always make sense to me, but I knew they were important from the somber tone with which they were delivered, and I listened intently.

Real excitement, linked with real events unfolding in front of me, was rare. One such memorable experience involved squadrons of American bombers flying in formation and dropping their bombs from great altitude. The bombs looked like miniature rods as they emerged from the bellies of the bombers. From my position, craning my head upward to the sky, I watched the rods righting themselves into a vertical drop and gathering speed as they descended toward the earth, until each disappeared beyond my view. A chain of rumbling explosions followed that shook everything, including the balcony I was standing on. Moments later, black smoke billowed from the horizon and the planes became just silvery specks in the distant sky before disappearing altogether, like the bombs they'd dropped.

Because we lived in the outskirts of the city, far away from anything of strategic value, the bombs never struck our neighborhood. The horrors accompanying such explosions remained far from my understanding. In spite of this, or perhaps because of it, an air raid was suspenseful entertainment that fueled my imagination. I had many questions.

"What does the inside of an airplane look like?" I asked Nai-ma. "What makes it fly? Who is in the planes?"

I knew smoke came from fire. "Do people die because of the fire?"

"Don't know," she answered me each time. "Don't know. Little one, you ask too many questions!"

Other than telling me that explosions and smoke probably meant destruction, Nai-ma didn't have a clue. She had never seen an airplane until she came to Father's mansion. Back in her village, far away inland from Nanjing, aerial bombing was unheard of.

She didn't find the bombing entertaining at all and would've preferred not to watch from the balcony. But since I insisted, she would come out with me, holding me tight in her arms and shifting slightly as each explosion rumbled on the horizon.

One day, as I stood on my balcony, watching the road in front of the mansion, several men ran past, their arms and legs working furiously. They were chased by a squadron of Japanese soldiers close behind. The fleeing men weren't wearing uniforms and had no weapons. They were straining to run fast, and appeared to be gaining ground from their pursuers. When they crossed into the wheat field, the Japanese soldiers halted and raised their rifles. As I watched, I heard a series of small, muffled explosions and saw the runners pitch forward in the field, crumpling in a ragged line. The soldiers went up to the fallen men and dragged them away by their feet while chattering with each other, laughing loudly.

I asked Nai-ma if the runners were dead. She looked ashen; her face was shrouded with fear; her eyes were filled with tears. She nodded her head slowly without uttering a word, then grabbed my hand and pulled me away from the balcony into our room. The scene stuck in my mind for many days. It was my first encounter with death.

———————

I had little interaction with my family in the mansion. My siblings were too old to bother with me. They were already teenagers. My oldest sister was attending medical school; the others were in middle school and high school. They talked and interacted with one another. I envied them.

My parents, too, were busy with their lives. I didn't know what Mother did. It was customary in those days for wealthy Chinese children to be given to the care of wet nurses; aloof and distant, my mother stayed in a different part of the mansion. I rarely saw or thought of her.

As for Father, I was terrified of him. He never laughed, rarely smiled. He was always serious and physically imposing, the kind of man who inspired fear.

In his spacious study in the mansion, he kept a large whip, a disciplinary instrument. Once I heard the anguished cries of two victims being disciplined. Their piercing voices, as they cried out in pain, made me tremble. Decades later, I learned from my mother that it was one of those occasions when Father was "exercising his authority" to "maintain law and order" in his household. The victims were a manservant and a maidservant whose sexual dalliance had resulted in an unwanted pregnancy. After the whipping, both were sent back to Father's village in Shandong, where all of the servants originally came from.

Father was always at work; or at least, that was what everyone told me. He was rarely home, and on those exceptional occasions when he was, I never sought his company.

The living quarters I shared with my nanny were located in one wing of the mansion. We had two rooms with our own bathroom, plus the balcony where I spent so much time. "Nai-ma" was not my nanny's actual name—it was a literal title for what she did.

奶　媽

nai　　*ma*

milk　　mother

I never knew her real name.

Nai-ma was always by my side. She fed me, washed me, played with me, told me stories, sang to me, comforted me when I was sick, and kept me company even when I perched on the balcony to look for excitement in the outside world. When it came time for bed, to which I always objected vehemently, she would massage my face with her fingers. Her magical touch on my eyebrows and tem-

ples dissolved my objections, and soon the soothing rhythms persuaded me to give up the fight to keep my eyes open.

When I woke up in the morning, Nai-ma was usually sitting close by, smiling her wide, beautiful smile at me. The first thing she did every day was to cuddle me in her arms.

Nai-ma had long, thick, pitch-black hair, which she wore combed back tightly and braided into a ponytail reaching all the way to the back of her thighs. Sometimes, I would grab it at one end with two hands and she, firmly grasping it at midpoint, would hoist me up and swing me in circles. I giggled and squealed with delight.

Whenever I felt agitated or scared, Nai-ma calmed me down with a time-honored Chinese remedy. She would break off a strand of strong, thick hair from her ponytail. As I sat facing her expectantly, she would pull down my lower eyelid with one hand, exposing my tear duct. With her other hand, she would carefully insert the hair into the duct, twirl it gently, pull it out, and insert it again. After repeating the process for a minute or so, she would apply the same therapy to my other eye. To Western ears it no doubt sounds odd, but the hair going in and out of the tear duct produced a delightful sensation that soothed my spirit in the same way as getting scratched with just the right touch, not too strong and not too soft, at exactly the right itchy spot on my back. Nai-ma's therapy never failed to restore my calm.

Nai-ma liked to sing and play games with me, and she radiated affection whenever I looked in her eyes. They were almond-shaped and dark brown, watery and bright like the eyes of a doe. With a strong, firm jaw, dark eyebrows, and a sensuous mouth, she invited trust and conveyed quiet strength. Her nose was neither too tall nor too flat, just the way Chinese like it. Most people would not consider Nai-ma a beauty because she lacked a refined daintiness. But her energy, exuberance, and amiable disposition made her wholesome and attractive in her own way—and she was beautiful to me.

One Sunday morning I was pleasantly surprised to wake up in Nai-ma's arms. Sometimes she slept next to me. On that morning, however, she was holding me in her lap, cradled tightly against her, rocking me back and forth. We were sitting on the edge of the bed, and she was humming the folk song that was my favorite. She sang it whenever I was sick or distressed:

> *In a far, far away place, there was a fair maid.*
> *She lived with a little boy*
> *With whom a link had been made.*
> *Their love was a joy*
> *That caused her sorrow to abate . . .*

Content with her singing, I looked at Nai-ma with sleepy eyes. She smiled at me, but it was not the wide, unrestrained beam that normally greeted me. Her mouth was tired; her eyes were sad and somber. Sleepiness fled from me in a rush. Gazing at her, I searched for clues, but found only puzzlement. I had never seen her display such strong emotions before.

"Nai-ma, is everything okay?" I asked.

Tears started flowing down her cheeks. I tried to wipe her tears with my little hands, but it didn't stop them.

Frightened, I began to cry. *That* dried her eyes almost instantly. Regaining her composure, Nai-ma assumed her usual care-giving role.

"Everything is okay, little one! Everything is okay." She dabbed my face with her handkerchief.

As soon as I felt comforted by her, I resumed my questioning.

"Why were you crying?"

A minute of silence passed by as if she were weighing what to tell me.

"Little one," she finally said, "it has been four and a half years since I came to take care of you. You were this tiny little thing

then." Her hands moved as if to measure out a space the size of a tiny infant's body, and she half-smiled at the memory. "Now you can talk, you can run, you can eat everything! You are no longer a baby. You should be with your mother and father."

This was staggering.

"But *you* are my mother and father!"

My response brought a genuine smile to Nai-ma's face.

"I could not be your father even if I tried. I am your milk mother," she said. Her voice cracked with emotion. "I came to give you my milk. But you don't need it anymore. It's time for me to leave."

She dipped her head to hug me close.

"But I won't let you leave," I said softly as I nuzzled her cheek.

"Listen up, little one! Your father has made the decision. It's time. I have to return to my village. Today is the day I leave."

Her words didn't make sense to me.

And why would they? They meant that my world was about to be dismantled.

Nobody had ever explained to me that Nai-ma belonged to a family in a far-away village, or that one day she would have to leave. Many years later, I learned that when she took on the job of being my milk mother a month after my birth, she had just given birth to her own child. In order to take the job to earn an income for her family, she left her baby behind in the village. It had to be heart-wrenching for her. As an infant, I could not witness her sorrow, and by the time I developed conscious memory, she had not only grown accustomed to me but had also bonded with me as if I were her own child.

To be torn away from two children in such a short span of time! It must have caused unbearable sadness.

To me, "Nai-ma" meant much more than "milk mother." She was also warmth, affection, comfort, security, happiness, and companionship.

I couldn't believe Father had decided to send her away. My little brain started churning and came up with a solution.

"You can take me with you!"

That brought a new smile from her, one so full of gentleness and love that to this day, it remains deeply etched in my memory.

"No, little one, you don't want to go with me. You belong to a very special family. I come from a poor village. You are not mine. It's not possible. It's not allowed."

Once again, her words were riddles. *Why* was it not possible? *Who* wouldn't allow it? I thought I *belonged* to Nai-ma. Why did she say that I wasn't hers? But her answer made clear that my "solution" wouldn't work.

We fell into silence.

It wasn't long before someone knocked on our door. A male servant poked his head in and announced:

"The car is ready."

Nai-ma got up, straightened her waist-length cheongsam, which, together with a pair of loosely cut black trousers, served as the unofficial uniform for maidservants in those days. She handed her valise—packed and standing next to my bed the whole time, while I hadn't noticed!—to the male servant, picked me up in her arms, and started to walk downstairs toward my mother's sedan, which was waiting in the driveway. I seemed to have lost my will to fight against her pending departure, momentarily sunk into a daze. Confused and numbed by overwhelming emotions, I could see and hear, but nothing registered.

Nai-ma put me down at the side of the car. Crouching and putting her hands gently on my shoulders, she tried to say something. But she couldn't. Choking in silence on her tears, she focused her gaze on me and did her best to regain her composure.

Suddenly I came to my senses. This was it! Nai-ma was leaving. I began wailing.

"Don't go! Don't go! Nai-ma, don't go!"

Sobs escaped as spasms between my pleas. I held on to her left sleeve, tugging, trying to prevent her from entering the car.

Nai-ma, now standing, broke into a sob.

Attempting to help Nai-ma leave, a male servant grabbed me from behind to pull me away. Without letting go of Nai-ma's sleeve in my right hand, I turned sideways and kicked the servant's shin with all my strength. He yelped in pain. I continued wailing and pleading while holding on to Nai-ma.

Then everyone around me froze.

Abruptly I found myself in the air. Someone had lifted me up by the back of my shirt. Instinctively I kicked with both feet, searching for the ground, to no avail. My body was almost horizontal, one arm stretched out, still holding Nai-ma's sleeve. In the next intant, a hand chopped down on that arm with stunning force, numbing it and causing my grip to loosen. Nai-ma's shirt slipped from my fingers. I twisted to look at my assailant.

It was Father.

He carried me away from Nai-ma like a little dog, kicking and struggling.

"You're a *huai dan*! A *huai dan*!" I screamed at the top of my lungs as my tears sprinkled on the ground. I couldn't see his face but his arm around my rib cage tightened until I began to gasp for air.

Inside the house, he tossed me into a bathroom and locked the door. During the many hours of lockup in the bathroom, I cursed Father, called him every dirty name I knew, and swore that I would exact my revenge someday.

My mother let me out of the bathroom the next morning, after Father had departed for work. She wore a dark, high-necked shirt and had her hair swept back into a gleaming black knot. Pearls glimmered at her earlobes.

"No one in the world would dare to call your Father *huai dan,*" she said dryly. "Much less in front of his whole household. Your father is livid."

Huai dan literally means "rotten egg," but it has the force of something closer to "son of a bitch."

I didn't say anything. After a moment she shrugged slightly and turned away.

Mother's admonition neither chastened nor impressed me. I went into a funk, eating very little and talking to no one, despite my siblings' sudden, once-coveted, solicitations to play in their quarters. After two days, Mother lectured me, saying that a son had no right to be angry with his father. Again, I said nothing, but in my heart I totally disagreed with her.

Father had wronged me. I was sure of that. He took away Nai-ma and with a sort of surgical strike, removed everything that was dear to my heart. He had taken advantage of my small size and young age to subdue me physically. I quietly nursed my anger and dreamed of escaping from him.

A week after Nai-ma's departure, Mother brought home a twelve-year-old girl called Juan-Juan to be my playmate. She was adopted from an orphanage.

In those days, a well-to-do family could walk into an orphanage and leave with an orphan in a matter of minutes. Lacking space for the countless homeless children who were regularly abused, kidnapped, sold, murdered, or left starving to death on the streets, an orphanage welcomed on-the-spot adoption, especially from well-established families. There was no application, no paperwork, no interview, no questions asked, no intervening and investigating social worker. The orphanage assumed that a good family wouldn't be involved in buying and selling children—a booming business all over China throughout the nineteenth and the first half of the twentieth century. Besides, an adopted orphan meant one new space for another homeless child.

Juan-Juan, my newly adopted playmate, turned out to be glum and lethargic. She was nothing like Nai-ma: not only didn't she know how to care for me, she didn't want to. She couldn't tell a

story. She didn't like playing games or singing songs. She had no interest in anything. Her favorite pastime was sitting catatonically.

Yes, really: just sitting.

As you might have guessed, if there was one thing I couldn't stand, sitting or lying down would be it. I preferred to stay on my feet even during the long hours of watching the outside world from my balcony. I was approaching five years of age, hyperactive and curious about everything; for me, life was, or should be, continuous motion—until one fell asleep from exhaustion.

Once I asked Juan-Juan if she was engaged in thought while sitting.

"No, I don't have any thoughts," she replied. "I'm just resting."

Why would a normal person rest while awake during the day? I couldn't believe Juan-Juan's response. Only illness and the darkness of the night required us to rest. Nightfall, the undesirable opposite of daylight, forced people to sleep, I thought. Sometimes I wondered why the sun did not shine twenty-four hours a day so that I could avoid sleeping altogether.

Yet here was Juan-Juan, who wished to rest at all times, as if she longed for perpetual darkness, as if she didn't want to see and hear and feel what was around her. Her penchant for inactivity and idleness so astonished me that I thought of her more as a seated statue than a living being.

After she came to share my living quarters, I spent more and more time on my balcony alone, indulging in wild fantasies about war. Periodically the American bombers came to drop their loads, but air raids no longer held any interest for me because I had seen them too often. I longed to see something exciting, like the Japanese soldiers shooting the runners many months ago. Though the incident had frightened me, it also stirred my curiosity about death: Was death like falling asleep? Did it hurt like losing Nai-ma? Did death just happen, as when one drifts off to sleep? I didn't remember if the men running away from the Japanese soldiers had

screamed or cried out as they were shot. In my memory, they just fell. Now I wanted to see the entire incident again. Perhaps I would be able to find answers to some of my questions. But there was no repeat occurrence. Instead, each day flowed into the next with a sameness and regularity that was deadening.

Life was never the same after the departure of Nai-ma. I often felt dejected and angry: dejected because Nai-ma didn't return, angry because Father made her leave. I moped about the grounds, ignoring Juan-Juan and resenting Father. But this status quo didn't hold for long before another change reshaped my life.

One morning, a few months after Nai-ma had been taken away, a jeep drove onto the mansion grounds. Several plainclothes agents jumped out, one of them waving a submachine gun. They had already confiscated our guard's handgun when he opened the iron gate to let their jeep in. I saw the drama unfolding from my balcony perch. The plainclothes agents looked officious and menacing. They disappeared into the house without opening their mouths once.

Several minutes later, they reappeared with Father in their midst. He was casually dressed—one of the few times I'd ever seen him without a tie and jacket—and his face was grim. But he held his head high and looked straight ahead as the agents marched him to the jeep. Nobody uttered a word. Like a scene in a silent movie, the agents boarded their jeep, Father sitting between two of them in the rear, and spirited him away. The last I saw of him for five years was his back, ramrod straight, with the sun glinting from his pitch-black hair neatly combed on his large head.

An hour later, a larger jeep carrying more plainclothes agents rolled into our driveway, trailed by several empty trucks. First they drove away Father's limo and Mother's sedan. Then they started to load our furniture, clothing, suitcases, rugs, hanging scrolls, and everything else in the house onto their trucks. From my perch on the balcony, where Juan-Juan and I sat breathlessly, I saw Mother

trying to plead or argue with their leader, a man wearing a suit and sporting a slick hairdo. But he paid hardly any attention to her as he supervised his minions in carrying out the raid. Occasionally, in response to a particularly impassioned gesture or movement from her, he would wave his hands curtly and say a few words I couldn't hear—all without meeting her eyes, or indeed, even looking at her. Within a couple of hours, they had stripped the house empty, and left, without harming anyone.

That evening, Mother assembled the entire staff of the mansion in the now bare living room. Standing in front of the servants, guards, and cooks, she spoke softly but firmly.

"You have seen Generalissimo Chiang Kai-shek's agents here today," she said without preamble. "Unfortunately, your services will no longer be needed, as the Li family will be departing in twenty-four hours."

There were murmurs and soft sounds of dismay from the assembled group, but none of the servants seemed overly surprised. After all, the emptying of the mansion by government agents could only mean one thing: the downfall of the Li family.

Mother's face was serene, her hands calmly clasped at her waist as she let her words sink in.

"The Li family thanks you for your loyal service," she said. Then she added, almost as an afterthought:

"If any of you wishes to return to the village in Shandong, I will provide the train fare."

This was the first time I learned that most of the staff working in the mansion had been recruited from the same village in northern China where Father and his ancestors grew up. Father had followed an old tradition in hiring his household staff from his birthplace to ensure their dependency and trustworthiness.

When Mother had finished speaking, an eerie silence hung over the cavernous living room as if she had sounded a death knell. It was broken only by the muffled sobs of one or two maidservants.

In the dim light, I could see and feel the sorrow and dejection of the staff. For them, Mother's terse announcement meant the end of an era, the termination of their careers and the loss of their secure livelihoods.

After a few distraught moments, the group began to drift apart. As the assembled staff moved away, only one male servant—an elderly man with white hair—went up to Mother to take the train fare back to Father's ancestral village. The young ones had no stomach for going back to the abject poverty of their rural origins.

I had never seen Mother conducting business before. Standing off to the side, I witnessed her impromptu speech delivered with composure and dignity. She looked a little pale and tired, the only signs of the enormous strain of a crushing ordeal.

I also noticed, for the first time, Mother's beauty.

Nai-ma had typically begun a conversation about Mother with "The beautiful Madame Li . . . ," but it had never registered in my consciousness until that moment. Mother's beauty was not the provocative kind, the kind that commands your immediate attention. It was a beauty that quietly conveyed grace and elegance, the sort that stealthily crept up on you only after you had focused your attention on her for a while.

I had never truly *focused* on Mother before this calamitous event; she was always distant and aloof, and I didn't stop to consider her further. Father was a different story. He might have been just as removed as Mother, but he exuded authority: the way he looked at you, the way he carried himself, and the way he came and went in his limo, all of which commanded my attention and aroused my curiosity.

After speaking to the servants, Mother told us children, with the same even-keeled manner, that we would be moving to a slum on the outskirts of Nanjing because the same people who had ordered us to leave the mansion had also confiscated all of our money. I didn't know what "slum" meant, and asked.

Mother looked at all of us, huddled together in the empty room, and said, "It's an unpleasant and unclean neighborhood," her voice clear and calm. "We will be poor. Life is going to be very different."

One of my sisters, twisting her hands in her fashionable silk skirt, began to cry.

That was September 1945, the end of World War II. Japan had surrendered. I did not know or understand the details until later in life: as a senior minister in the Chinese "Vichy" government, Father had been arrested by Generalissimo Chiang Kai-shek's agents when the Nationalist Party reclaimed the occupation zone from Japan. He was charged with treason. After a brief trial, the court sentenced him to a thirteen-year jail term. Among senior cabinet members of the collaborationist government, he was the only one spared capital punishment—for reasons that no one, to this day, has ever explained to me. In China, the sentence meted out to a politically important prisoner who may impact public opinion is a political decision made at the highest level of the ruling elite. Any notion of a fair trial is a joke; the judiciary serves only as an instrument of those who are in power. Perhaps Father still had some friends in high places when he was punished only with a moderate prison sentence.

During his imprisonment, Father and all of his colleagues from the collaboration government lived in spacious and comfortably furnished rooms away from the common criminals in a prison called Tiger Bridge. The authorities provisioned them with all the books they wanted to read and all the supplies they needed for writing. Every day, the guards brought them quality food from outside the prison. Father's only suffering, apart from the loss of freedom, was his awareness of the execution of his colleagues in the yard outside his room. One by one, each was executed during the first few months of their imprisonment. Twentieth-century execution in China is carried out by a single rifle firing into the head of a

prisoner from behind. On the day of an execution, Father could hear the report of the executioner's rifle early in the morning. Each of those early-morning explosions, which must have reverberated in his ears, meant that the life had been snuffed out of one of his fellow voyagers in the ruthless arena of Chinese politics.

When I was more than thirty years of age, already a university professor in the United States, I read extensively about China's political history in hopes of understanding Father and his life. Only then did I realize the enormity of his political missteps and the narrowness of his escape.

In the early 1930s, Chiang Kai-shek, Mao Ze-dong, and Wang Jing-wei were engaged in a three-way struggle for political dominance in China. Both Chiang and Wang belonged to the Nationalist Party, which had overturned the imperial Qing dynasty in 1911. Wang Jing-wei had the support of the intellectual wing of the party; Chiang Kai-shek, as superintendent of China's most important military school, the Huang-pu Academy, controlled the military wing. The Communists were the weakest in the three-way contention and retreated to the inland provinces.

China was just then emerging from the chaos of the warlord period after a century of foreign invasion and colonization, and politicians often had to depend on the patronage of a foreign government in their bids for power. Foreigners, who controlled the financial and military instruments, held all the trump cards. Chiang Kai-shek of the Nationalist Party won the backing of the United States through his wife's influence and connections. Mao Ze-dong was supported by the Soviet Union because he was a Communist. Wang Jing-wei and my father allied with Japan, since they had established ties with the ruling elite of Japan while attending universities there during their youth. Shortly after Japan seized control of the coastal provinces during the Sino-Japanese War in 1937 and '38, Wang organized and led the Nanking Regime under Japanese

patronage. ("Nanking" is, of course, an earlier English spelling of "Nanjing.") Father, who had always admired and sided with Wang, joined the "puppet" government in the occupied territory as a cabinet minister.

The collaborationist government, regardless of its service to the hundreds of millions of people living under Japanese occupation, was doomed from the start, owing to the horrific war crimes committed by the Japanese army during the invasion. The most notorious Japanese war crime was the massacre known as the "Rape of Nanking." It occurred in December of 1937, when the invading Japanese army engaged in an unchecked orgy of violence and terror for weeks, costing the lives of an estimated 300,000 civilian men, women, and children in the city of Nanjing—often in the most brutal and dehumanizing ways. Mass executions by machine gun were the least brutal. Women and girls were raped and sodomized; pregnant women were bayoneted in the belly. Men were used as live bayonet targets, and infants were used as soccer balls.

In light of such savagery, Father's decision to ally himself with the Japanese occupiers is hard to understand. More than two decades later, during the course of a discussion Father and I were having about the political situation of modern China, he tried to explain himself to me, in an effort to win my sympathy and understanding.

"You must understand that during the 1930s, Japan was the dominant power in Asia," he told me. "It had defeated the Czar's Russia handily thirty-some years earlier in a military confrontation. Having expanded its territory by forcibly annexing Taiwan and Korea, Japan was on the cusp of ascending to superpower status. At the time, especially in Asia, nobody foresaw that the rise of Hitler's Germany as a world power would lead to another world war and, ultimately, the unconditional surrender of Japan."

After the Pearl Harbor attack in 1941, the Sino-Japanese War,

which had begun in 1937, merged into World War II, and Japan's defeat on the global stage signaled the demise of the Nanking Regime. I knew all this. He was obviously setting me up for some important revelation, the anticipation of which whetted my curiosity.

Becoming impatient, I responded, "Everything you've just mentioned, Father, I have no quarrel with. But what's your point?"

He looked out the window, as though he couldn't meet my eyes. Sadness emanated from his face. In a halting voice, he answered my question with a surprising admission of mistake and offered this historical justification for his political career:

"In hindsight, it is clear that Wang Jing-wei and I made a grave mistake by choosing Japanese patronage. But if Wang and I were traitors because we collaborated with a foreign power, so were Chiang Kai-shek and Mao Ze-dong. The difference was that their patrons won in World War II and our patron lost. You see, victory and defeat in the Chinese political arena were determined by international events. We, the politicians in China, could not control our own destiny."

This was the first and last time Father confessed an error to me. Even then, it was a forced error committed in a vexing historical context.

As a rule, a father does not confess to a son. But by this time I was already in my thirties, an established academic in America, safely removed from the traditional framework of Chinese culture. Father almost treated me as an equal when we saw each other in the 1970s and eighties.

I was moved by his emotions and the eloquent defense of his political career, but I knew that no rendition of historical context could expiate his willing participation in Wang Jing-wei's "Vichy" government after the Japanese army had committed unspeakable crimes against Chinese civilians. On that occasion, I did not see any purpose in arguing with him or challenging his spirited self-

defense. He was in the eighth decade of his life, and had already paid dearly for his misguided quest for political power.

In the end, my father would serve only three of the thirteen years of his sentence. In 1948, Chiang Kai-shek set him free before he himself fled Nanjing, ahead of the advancing army of the Chinese Communist Party. That was when my parents went to Hong Kong. A lifelong anticommunist, Father had no choice but to exile himself to the British colony.

2

THE SLUM

THE SLUM OF NANJING WAS NOTHING LIKE THE urban concrete jungle of Harlem or the old, dilapidated ghetto of Watts. Nor did it resemble the banal monstrosities that sprung up on the outskirts of major cities such as Paris to house new waves of Third World immigrant laborers. Unlike those fringe products of modern urbanization, the Nanjing slum consisted of a few hundred makeshift hovels and shanties scattered among several rows of old, traditional farmhouses with black-tile roofs and white lime walls, each of which served as rental homes for multiple families. Those farmhouses, each more than two centuries old, were located about four hundred or five hundred yards apart from each other, some of them still surrounded by small, functioning farms and orchards.

Mother, my five siblings, Juan-Juan, and I moved there the day after Chiang Kai-shek's plainclothes agents appropriated everything owned by my family. When we approached the slum on foot with our meager belongings, my siblings covered their noses with one hand, retching at the sight of human waste and dead rats along

the alleyways. Mother, carrying two suitcases, marched in front, limping slightly, as she always did. My oldest sister, the one who had just started medical school one year earlier, brought up the rear. Walking in the middle, I heard the incessant complaints and grumbling of my siblings and Juan-Juan about the stench and the filth along the way.

"Mother, this is unbearable!" one of my sisters moaned.

"Yes, we are entering hell," another sister agreed.

"I never knew what life was like for the poor," my brother said. "I guess we were really privileged. How can people live like this?"

At this point, Mother stopped dead. She carefully set her luggage down on the hard-beaten dirt path and turned to face us.

"Yes, your father constructed a sheltered world for all of you," she said, more forcefully than I'd ever heard her speak before. "You were more than privileged. What you see now is how most people in our country live. It was how your father and I lived when we grew up in *our* villages in Shandong! You will now have to learn to cope with squalor, poverty, and hunger."

She glared around at us. The pearls were gone from her ears.

Everyone became quiet as we resumed walking.

Unlike my siblings, I was anything but depressed by the poverty we found at the border of the city leading to the slum. On the contrary, I felt liberated: finally out of Father's prisonlike mansion! Everything looked new and unusual. Still too young to be aware of the diseases and other dangers in the unsanitary environment, I took in every sight and lost myself in the thoughts and questions that bubbled up in my head.

Who are the people living in the slum? Did they all get expelled from their homes like we did? Is the slum going to be our home forever? I wished Nai-ma was still with me so that I could ask her while holding her hand.

Something did rattle me along the way, however: the repeated appearance of beggars. They hovered in that twilight zone between

life and death, their physical condition a shock to passersby. Some of them were lame; some had no eyeballs, their eyelids frozen open to reveal two red slits. Some lay in waste and looked dead, with flies buzzing all over them. I could tell they weren't, though, but only because each of them clasped tightly a begging bowl in his hand. Horribly, some had no arms, and held their begging bowls with their feet. All, young and adult, looked emaciated, with bones protruding from their face and any uncovered parts of their bodies.

I wondered what caused the beggars to sink into such pitiful states—and, now that I was moving into their neighborhood, whether I would end up sharing their fate.

When we finally entered the slum, the hovels and shanties dotting the landscape gave me the shivers. Composed of pieces of wood, rusted metal sheets, hemp sacks, and ripped clothes, they were so small and flimsy that I couldn't imagine the eight of us living in one. I began to worry about what sort of accommodation awaited us.

Yet my first impression of the slum was not as unpleasant as that of the alleyways leading toward it. A lot more open space was available in the slum than in the city. Even better, there was vegetation. A few randomly distributed trees, neither towering nor magnificent, provided relief and diversity in an otherwise drab and flat landscape. Clumps of shrubs and grass here and there along the crisscrossing muddy paths added color. Most important of all was the absence of beggars. They knew that the slum residents could not afford to give alms.

When Mother told us to stop because we had arrived at our new residence, we were in front of two doors almost eight feet tall, framed by solid stones that merged into two brick walls, which stretched forty feet to the left and forty feet to the right. Each door was made of a thick plank of hardwood, painted pitch-black.

As Mother pushed one of the heavy doors open, a large court-
yard on the right presented itself. On the left, facing the courtyard
stood one of those centuries-old, long farmhouses, its tiled gable
roof matching the color of the imposing doors at the entrance. My
immediate response upon seeing the farmhouse was relief. We had
been spared living in one of those tiny, makeshift hovels. The farm-
house had not only solid walls, but also doors and windows.

The courtyard in front of the farmhouse almost qualified as a
garden. It was by no means manicured, and didn't have any flow-
ers, fountains, or a lawn like the garden in Father's mansion. But it
carried a rustic charm marked by spartan simplicity.

A worn path paved with large slabs of granite led from the front
door all the way to an opening in the opposite wall, almost a hun-
dred feet away. Five evenly spaced, narrower stone paths branched
out to the farmhouse on the left. On the right, eight mature trees
grew at even distances from one another in a large plot of solidly
packed earth. The earth was clean and smooth, without the filth or
debris that marred the paths outside. Among the trees I recognized
two weeping willows, three mulberries, and one Oriental mag-
nolia.

The old farmhouse was a long rectangular structure, divided
into a row of five midsized rooms, each serving as the home of one
tenant family. Each family had one window and one door opening
into the courtyard, and one smaller door opening into the back.
Facing our small back door was a shed with a wood-burning mud
stove next to a mortar-and-brick countertop. That was our kitchen.
Attached to the kitchen, a small cubicle, flimsily cobbled together
from pieces of metal sheets, with a slanted cement floor, served as
our washing and bathing room. The bathing cubicle had to be used
sparingly. Otherwise, water flowing out from the cement floor
would form a puddle outside before it could seep into the earth.
Without drainage, the large puddle would block the walkway in

front and stagnate. Only my sisters and mother used the bathing cubicle. During the summer months, when the weather was steaming hot, I bathed myself in my underwear shorts by the well in the courtyard where I generously doused myself with buckets of water. There the water flowed in all directions between the large pebbles and into the yard. During the cold months, I didn't bath at all.

We occupied a middle room in the long farmhouse. That was home.

Most of our room was taken up by a "bed" made of many pieces of wooden board nailed on top of three rows of evenly spaced, narrow benches. Mother, my five siblings—four elder sisters and one elder brother—and I slept on it. We ate dinner sitting on the edge of the bed, holding our bowls and chopsticks.

One summer night I wetted the "bed." Since the bed had no mattress or soft, absorbent pad other than a thin tatami mat, my accident woke up my siblings and caused a ruckus. One of my elder sisters, sleeping next to me, woke up screaming from a dream, she told us later, in which floodwater was on the brink of drowning her. The floodwater turned out to be the exaggerated nightmarish version of my urine.

My siblings were not amused by my accident. They howled with anger and clamored that I should be banished to sleeping in the shed behind the room.

The shed, our kitchen, was where Juan-Juan, my erstwhile companion in Father's mansion, slept every night, curled up next to the mud stove. She didn't have a bed. She didn't even have a chair to sit on.

In addition to the shanties and farmhouses, a few simple, recently built small brick homes were scattered here and there in the slum. They were cheap and garish from the outside, made even more unattractive by the metal bars across their tiny windows, though I never saw the inside of one. Their residents claimed to occupy a notch above the prevailing social status of the slum dwellers,

as they had their own house. They resented their economically inferior neighbors and the extreme poverty around them even more than the occasional visitors from the city, who lived in tall, properly built concrete buildings.

———————

Within a couple of weeks, my family and I learned from our neighbors everything there was to know about our new surroundings, including a little history and a little geography.

Situated just east of the Yangtse River delta, Nanjing (which means, literally, "southern capital") became the capital of modern China during the warlord period in the early twentieth century. As Nanjing became politically important, it expanded and swallowed up much of the surrounding farmland. The vanishing farm life in those border villages created a stretch of uncharted land that would quickly have been converted into suburbia if Nanjing were located in the United States. But the Chinese economy in those days did not warrant the creation of suburbs. Instead, the young people of the villages chose to seek their fortunes in the city, where they found more enticing—and less exhausting—ways to eke out a living than working the land with their hands, hoes, and water buffaloes. The remaining elderly peasants supplemented their incomes by leasing their traditional homes to the post–World War II *misérables*, while a few die-hard tenant farmers attempted to cultivate small patches of the land. Over time, squatters, typically migrant workers, invaded the fallow farmland and set up flimsy shanties, and the land of receding agriculture collapsed into a slum.

The entire district my family and I moved to was a hodgepodge of old and new, urban and rural, modern and traditional, poverty being the only consistent and unifying feature. There were no paved roads. Electricity was available in some of the houses, but its availability was as much a blessing as it was a curse, since the wires were often bare and exposed, making electrocution an ominous hazard

for the residents. Electricity often caused injuries, especially among children.

The slum was a microcosm of a post–World War II China, caught between a stuttering march toward modernity and a traditional agricultural subsistence economy. I imagine that from an airplane it looked deceptively bucolic. On the ground, the stench of poverty and lack of sanitation could make you sick with revulsion.

Automobile traffic did not exist, an unintended benefit for the children. The widest road barely accommodated a donkey cart. Narrow and soft dirt pathways crisscrossed the area. Adults complained about the mud and the refuse along those pathways, while children loved them for the freedom to run and play. The network of muddy pathways was perfectly designed for us to play games of police versus brigands, one of those age-old variations on "tag." It was a fun game that needed no equipment and no supervision. To help your team win, you had to have speed, stamina, and cunning.

There was no sewage or drainage system. Farmers recycled human waste as fertilizer. Pits dug in the earth and covered with straw roofs supported on bamboo stilts served as outhouses. A good outhouse, like the one on the side of our farmhouse, had a large rectangular pit with two narrow stone slabs laid across the opening two feet apart. For privacy, the owner had planted bushes around the outhouse. It was the community "toilet" for everyone living in the rectangular farmhouse—close to thirty people, including the eight in my family.

As one approached the outhouse, etiquette required a loud grunt or clearing of the throat. If a person was squatting on the pit, he or she would grunt in response. If the grunt belonged to the voice of the opposite sex, you waited by the bush for your turn.

Once I didn't hear the thin voice of a female at the pit. Perhaps I needed to go so badly that I couldn't hear anything. Diarrhea was a constant affliction suffered by all children, a normal part of life. We never complained, and parents never brought a child to a doctor

because of it. In my urgency to go to the pit, I barged in on a squatting woman. She let out a bloodcurdling scream that so frightened me that I instantly voided my bowels in my pants, right in front of her. My "accident" convinced her that I didn't have the intention of peeking at her anatomy! Although I had to endure the embarrassment of stinking like a dog while rushing all the way to the well to clean myself, the accident spared me from a thrashing by her family.

The neighborhood had one unusual redeeming feature, for a slum: it was not densely packed with residents. The shanties, hovels, and farmhouses had a good amount of space between them.

There was a reason for the sparse population: superstition.

In 1937, the victorious Japanese army had swept down from the north to lay siege to Nanjing, then the capital of China. Most of the Chinese troops had either deserted or were withdrawn because Generalissimo Chiang Kai-shek wished to preserve his elite forces to fight against the Communist insurgents rather than the invading Japanese. The remaining soldiers in Nanjing, together with the civilians in the city, fought against the well-equipped Japanese army for three months without any logistic or material support. The defenders dug tunnels to reach behind the enemy lines and launch surprise attacks on the Japanese troops in the night. The success of the intrepid defenders infuriated and humiliated the Japanese army. When the city finally fell, the Japanese commanding general gave his troops free rein to rape, maim, and kill at will. It was an open invitation for tens of thousands of frustrated and angry soldiers to commit whatever atrocities suited their whims.

When my family moved into the slum, rumors abounded that the northern edge of the city near the slum was the site of a mass grave of the victims from the Rape of Nanking. People believed that ghosts of the dead roamed the area, seeking retribution. Many of the city's poor did not dare to move there because of their fear of ghosts.

Being sparsely populated, the slum was not as unsanitary as it could have been. The fallow farmland absorbed much of the wastewater from bathing and laundry. Trees, bushes, and grass reduced pollution and freshened up the area. Garbage did not pile up in large heaps because nothing was ever thrown away casually: tin cans and scrap metal were collected and sold to metal shops. Wood was treasured as either fuel or home-repair material. If you didn't have immediate use for a piece of scrap wood, you saved it. Used glass bottles served as containers for potable water that had been boiled. Most imperishable garbage found its way to backyard recycling. Litter, although omnipresent, consisted mostly of organic matter. It decomposed easily and quickly during the warm and humid months. In winter, the freezing cold rendered it harmless.

Organic litter and dirt, however, had organic hazards.

Every child in the slum suffered from parasitic infections. Though they were rarely fatal, they made us weak and skinny. When parasites caused death, it was typically due to secondary complications. As a consequence, people accepted parasites as a part of life.

One type of parasite lived on the head. It produced a scaly bald spot the size of a silver dollar on the scalp. A few badly infected kids would have half a dozen such spots on their heads, some of which were raw from scratching. Their parents doused their hair with a purplish iodine solution, the cheapest antibacterial agent available. These kids looked like pioneers of exotic punk hairstyles.

Another type of widespread parasite lived in the skin of the arms and legs. It caused a round, reddish raw patch. Infected with bacteria, the raw patch could swell into a tangerine-size boil that became purple and yellow. It would have to be lanced and doused with alcohol. Kids suffering from it screamed in pain when their family members held them down to treat the infection.

Luckily I escaped those two types of parasites. The kind that plagued me lived in my intestinal tract. Shaped like a large pinkish earthworm, the parasites were long and slimy. Sometimes they came out, against their own better instincts, during bouts of diarrhea. They gave me a bellyache, but the pain was not debilitating. Mother periodically made me swallow a worm-killing, sugar-coated medicine. Vendors sold it on the streets inside the city. Ironically, the medicine caused more pain in my belly than the worms it killed. In hindsight, I understood that the pain was caused by the toxic substance in the medicine, which killed the parasites at the cost of some damage to the host. Unfortunately, the parasites returned inevitably within a few weeks, since I, like every kid, put in my mouth any scrap of edible food I could find without cleaning my hand or the food itself.

During the winter months, all children in the slum suffered from chronic colds. Two streams of yellowish-green snot flowed between the nose and the upper lip constantly throughout the cold season. We did not just suffer from colds. We *were* cold, all the time. In December, January, and February, the wind chill could push the temperature to twenty degrees below freezing. There was no heat anywhere. Our only protection against the biting cold was cotton-quilted jackets and pants, which we wore over several layers of summer clothing. We shivered and sniveled through the long winter months.

When the river of snot threatened to enter our mouth, we lifted our arm and wiped it with our sleeves. Since each kid wore his one cotton-quilted jacket throughout the entire winter, the sleeves would become frozen with nasal mucus mixed with grit. Less than one month into the cold weather, the mucus-and-grit-laden jacket stiffened. It looked horrific and repulsive. Adults commonly winced when they saw us. But beyond inviting contempt, the ungainly frozen sleeve presented a constant hazard: it could cut the lips and nose severely if one inadvertently tried to wipe oneself with it. A

kid who let that happen to him had to suffer not only the injury it-self, which the bitter cold impeded from healing, but also the deri-sion from all the other kids for being a careless fool.

Even though the cold caused us a great deal of discomfort, we still managed to have fun in the winter. In one "game" we often played, everyone crowded into a corner with walls on two sides and then pushed and squeezed each other as if we were trying to merge into the walls. After many raucous and giggling minutes, everyone felt a little warmer from the exercise.

Another winter activity involved making a small fire from bro-ken branches and dry grass. The flickering flame not only warmed our aching hands but also tickled our imaginations. We usually picked a hidden spot between large boulders to make our fire in order to avoid being detected by adults. Concerned that we might lose control of the fire and burn down the neighborhood, the adults would not hesitate to beat us if they caught us. But the danger of being caught didn't stop us at all. It only increased the suspense and excitement of making fire, adding to the mesmerizing beauty of the dancing flame.

Mother worked as a clerk in a government office every day in order to earn money. My siblings attended school. Despite our sharing one large bed every night, my older siblings and I led com-pletely separate lives. We rarely interacted. They went to schools. I roamed the neighborhood and engaged in all kinds of mischief and wild activity with other unsupervised children. For me, each day was an adventure.

It fell on Juan-Juan to fetch water from the well to wash dirty laundry by hand with a wooden board, and to build fires in the mud stove to cook for the family. She looked glum and miserable all the time, worn down by the drastic transformation from an idle life in Father's mansion to washing and cooking every day in a slum.

Juan-Juan was not the only one who suffered. We all had to

adjust to poverty, the most noticeable feature of which was the quality and scarcity of food. When we lived in Father's mansion, food was not only plentiful but also appetizing. In the slum, we couldn't afford to eat very much, and what we did get to eat barely qualified as food.

One of our regular staples was soybean dregs, a fibrous by-product from making tofu. The fiber is what remains of the soybeans after they have been ground and leached in a stone mill. The leached-out, nutrient-rich liquid, becomes tofu upon being mixed with a calcium-rich emulsifier. The fiber is the dregs, usually fed to pigs.

When Mother ran out of money toward the end of a month, we might have soybean dregs for two or three days straight. After filling my stomach with it, I still felt as hungry as if I had not eaten at all. It was a strange sensation: the stomach bloated while hunger pangs pounded.

A luxury dinner at home consisted of rice and bean sprouts. Tofu and vegetables at dinner would bring on cheers from my elder siblings. Meat, fish, and protein-rich food never made an appearance.

My siblings complained bitterly about hunger and our squalid living conditions. They had lived in luxury for more than ten to fifteen years, and it was hard for them to handle the abrupt and dramatic downward shift in lifestyle. In addition, they were all attending schools, which required concentration and energy. Being hungry made it hard for them to study.

I also had had a taste of wealth in Father's mansion, but it had not made the same impression on me. For me, what stood out during my years in the mansion was the restriction and confinement. Hunger in the slum did bother me from time to time, making me irritable. My stomach often growled and gurgled, but on the whole I was too young to have become habituated to cleanliness, convenience, good food, and physical comfort. My siblings claimed that

I was born with a wild streak, plus a natural propensity to seek adventure and court danger. Our different reactions to our new, impoverished life did not endear them to me. They felt I was strange, if not abnormal, for not caring much about material comfort. I considered them on the threshold of adulthood, belonging to a totally different social caste from me. They talked about things and people I knew nothing about. I preferred the company of the neighborhood kids, who bonded with me like a little-league slum gang. Beginning in Father's mansion, my elder siblings and I were never close. Now that I had acquired friends and discovered a new world, the gulf between us only widened.

Mother bore all of the hardship stoically. As usual, she rarely spoke to me. After sending my siblings to school early in the morning, she went to work from eight to five to earn an income to support the family. Before she left in the morning, she would always pause at the door. "Little one," she would say, "remember not to engage in doing wild things!" Then she'd be out and gone.

I was six years old. If we were still living in Father's mansion, I am sure I would have been packed off every day in Mother's chauffeured automobile to a private school. In the slum, Mother was too preoccupied with the burden of daily survival to pay attention to the fact that I had reached school age. For me, in spite of being semi-starved, infested with intestinal worms, and plagued by a chronic sinus and respiratory infection, life was full of fun and excitement.

During the day, I was free to go anywhere I wanted to go and do whatever I wanted to do. I met my friends, mostly under ten years of age, within my first few weeks in our new residence. There was Little Wang, nine years old, who walked with a limp because his leg had never been set properly after an accident. Little Cheng had four sisters and no mother. They lived in the same farmhouse as I did. His oldest sister was charged with taking care of all of the younger ones, and she had long ago given up trying to rein in Little

Cheng from his wild behavior. Tiny Lin was the only one in our gang younger than me. Always dressed in clothes three sizes too big, hand-me-downs from his older brother, he looked elfish. Big Wang was the oldest of our group, a teenager who preferred our company to that of his peers. A bit slow-witted but good-natured, he played the role of our Hercules. When brute strength was needed, like turning over a small boulder, Big Wang fit the bill. He had been living in the slum all his life and never went to school. I liked Tiny Lin the most. Resourceful and indomitable, he and I plotted most of our activities and mischief.

Tiny Lin and I had met one day when I ran into him and Big Wang playing by a mulberry tree near the north end of the slum. He was straddling Big Wang's shoulders, trying to catch cicadas on the branches. Unlike crickets, cicadas could not be made into pets; they died quickly in captivity. But their singing beguiled us because instead of coming from their mouth, the song emanated from their belly. As Tiny Lin carefully aimed his cupped hand at a cicada, at the last second it flew away and landed right on my pants. It was easy for me to grab it.

"Got it!" I cried triumphantly, holding the struggling cicada aloft.

"Good catch!" Tiny Lin grinned at me. "Why don't you climb up the tree and catch more?"

I accepted his invitation and captured two more cicadas. But we got tired of them very quickly because they wouldn't sing while being held between our fingers.

That was all it took for us to become friends. Tiny Lin introduced me to the others in the next few days.

We quickly bonded into a tight little coterie, supporting one another with loyalty and camaraderie. We trusted and depended on one another. We held hands or wrapped our arms around each others' shoulders when we ventured out of the slum, which we considered our "turf." There was a sense of belonging to a group that

comforted and enabled each of us to cope with the physical hardships of our daily existence. My close ties with my friends gave me strength, courage, and a confidence that I had never experienced before. Even under Nai-ma's care, I had not felt as strong and brave as I did with my friends; as much as she and I were bonded, I could only recall her devotion and my dependency. Our relationship was tender and loving, but my relationship with my friends made me fearless. I felt we could do anything and overcome any obstacle as a team. We scaled walls to steal food, climbed tall trees to pick fruit, stood our ground against any adult who dared try to intimidate us, and acquired from one another a wealth of knowledge about everything and everyone in our surroundings. The boys of my circle became my family!

None of my friends had any family supervision. None of us went to school. We had no toys. But we played with gusto and ingenuity.

Aside from playing the brigand-and-police game, we investigated ponds and irrigation ditches for fish and tadpoles, rode on high branches of willow trees, pretending they were airplanes, and stole mulberries and cucumbers from nearby farms to relieve our hunger.

Sometimes we walked into the commercial center of Nanjing to take in the sights of city life. Each time we did, we felt we were embarking on a grand tour, a true adventure. Being a little nervous was part of the adventure. But there were six of us, arms linked, in tight formation, boosting our confidence as we made our way toward the commercial center. Once at our destination, we were rewarded with a visual feast.

Nanjing had more than a million inhabitants in 1946. It was by no means prosperous but it bustled nevertheless with commercial activities. Peddlers lined the sidewalk, selling every food item one could imagine: raw or cooked, fresh or preserved, sweet or

sour, dried or salted. Among the cooked food were meat buns, potstickers, noodle soup, deep-fried twists (*you-tiao*), bean milk, herbal tea, braised donkey meat, and baked or steamed bread. For children starved for decent food, these sights made our mouths water.

Less tempting but more interesting than food were the activities of the smiths, craftsmen, repairmen, medicine men, and artisans hawking their skills and services on the sidewalk. We watched them sharpening knives, repairing furniture, writing letters or petitions, mending broken ceramicware, reweaving old rattan chairs and foot stools, replacing heels on worn-out shoes, repairing used clothing, removing rotten teeth, lancing boils and applying moxibustion, and so on. All services were rendered on the spot, as the customer waited.

A person who needed to have an aching tooth pulled simply squatted down on the sidewalk, threw his head back, and opened his mouth wide to let the street dentist yank the tooth out. There was no anesthesia, no disinfectant, no preparation—and no complaint.

The dentist had a spittoon at hand for his customers to spit out blood and whatever other by-products the procedure had produced. Afterward, the dentist thrust his arm out to the crowd to display, like a trophy, the extracted tooth, held tight in a pair of rusty metal pliers. Then he would lay the extracted tooth next to about a dozen others he had pulled out that day, as testimony to his professional competence. On a piece of dark cloth spread out on the ground, the collection of yellowed and browned rotten teeth looked like an exhibit of hominid fossils.

Where space was available for a small crowd to gather, a traveling artist would grab it as his stage for a performance.

It could be a puppet show, the puppeteer hiding behind a curtain that hung all the way to the ground from the bottom of a

two-by-three-foot collapsible stage. The puppeteer sang and narrated dramatically in different voices as he manipulated the puppets.

Or it could be a martial artist, performing a sword dance punctuated by loud and fierce battle cries. Besides providing entertainment, the martial artist sold his chiropractic skills and a personal brand of muscle-relaxing potion containing a piece of tiger bone. After the sword dance, he would pound his chest to demonstrate his toughness, which, he claimed, derived from the medicinal potion he sold. Occasionally someone with an aching back would have his muscles and spine massaged and manipulated by the martial artist. As he worked on the patient with his tiger-bone-enhanced potion, he would explain to the onlookers the principles and rationale of his craft, in hopes of selling more.

Farther down the street, a magician was performing sleight-of-hand tricks with a glossy silk handkerchief and a deck of cards, all the while entertaining his spectators with jokes and outlandish tales.

At another spot, a mountebank was selling a "magic potion." The potion, which he claimed was made from the gall bladder of a cobra, was a guaranteed cure for asthma, rheumatism, arthritis, and palsy.

A Chinese city, no matter how poor or backward, was always hustling and bustling. It demonstrated the quintessential, irrepressible spirit of entrepreneurship. Nanjing in 1946 was no exception.

If we were not exploring the city, my friends and I would be engaged in all kinds of fun activities within the confines of the slum. One entertainment that we never tired of involved playing with crickets, a traditional hobby that also attracted idle adults.

A good cricket was a valuable possession. Once captured, they were kept alive with scraps of vegetables that we scrounged from the farms and the refuse. They were so important to us that we often identified with them. We gave them our names, spent a lot of

time looking at them, talking about them, comparing them with respect to their size, color, ferocity, and personality. I had up to three at a time, including a large and fierce one that was my most prized possession, much coveted by the other boys of my group.

Now and then two boys would pit their crickets against each other in a cricket battle. When that happened, we were as ego-involved as if we ourselves were engaged in a fistfight! Sometimes one cried because his cricket lost.

In a fight, two crickets were placed in a neutral container that neither combatant recognized as its home territory. The neutral fighting ground ensured that neither cricket had a psychological advantage.

It might seem strange to attribute psychology to crickets. But all the boys knew that a cricket in its own container fought much more ferociously than an intruder. A small cricket on its own turf could easily overcome one that was much bigger.

Once two combatants were placed in the neutral arena, each owner used a little brush made from a grasslike plant to tickle his cricket's head, thus guiding it to confront and fight the other cricket. We would stand and cheer as they battled head-on with their fore-legs and jaws. Sometimes at the end of a charge toward the oppo-nent, the combatants leaped in the air like acrobats. Sometimes they rushed at each other, colliding like sumo wrestlers. The fights never lasted long, ending in a few seconds. The triumphant cricket "celebrated" its victory with a vigorous bout of singing—in actual-ity, an auditory communicative behavior signaling the insect's claim over a new territory. The owner of the victorious cricket would beam with pride and satisfaction as he scooped up his gladiator and returned it to its cage. The defeated cricket scurried away as fast as it could. Its owner would have to try his luck another day.

We kept our crickets in little cagelike containers woven from pliant green bamboo bark. These containers, which opened on the top with a hatch, both kept the crickets from escaping and protected

them from being eaten by the geckos that came out every night, everywhere. We never harmed the geckos, however, because they fed on cockroaches and mosquitoes, which were ubiquitous and odious. I spent an inordinate amount of time peeling off identical strips of bamboo bark and weaving them carefully into cricket cages that opened on the top with a hatch.

Everyone ranked his captive crickets according to their ferocity. They were our gladiators; we, their masters and owners. I kept my top gladiator in a special cage under the bed, always checking it before going to sleep and immediately after waking up.

My friends and I also spent a good amount of time turning over rocks and boulders in search of the treasured insect. It was important to distinguish the males from the females, which we always let go, as they didn't sing.

When hunting for crickets, we frequently encountered centipede burrows. Centipedes in Nanjing were maroon-colored, sinister-looking creatures with formidable pincers at their mouth. Up to twelve inches in length, a mature centipede packed a venomous bite that could leave its victim writhing in pain for days. Everyone jumped whenever an overturned rock exposed a large centipede burrow. It signaled danger, and, more than anything else, danger excited us.

As we focused on the burrow, one of us would poke a stick into it. If a centipede emerged, another boy would quickly place a heavy rock on its tail-end section. Pinned down, the centipede would struggle to free itself, its myriad legs pushing furiously and its body swinging from side to side as we checked out its pincers, its eyes, its antennae, and the number of segments of its body.

Forming a circle with heads lowered as in a rugby scrimmage, the boys all pushed against each other and leaned forward to gawk at the captured menace.

"This one is enormous! Look at its legs go."

"Yes, it's much bigger than the one Little Cheng captured last week."

"No, you're wrong, it's the same size—but darker! It's fiercer."

In our superstitious imaginations, we believed that the centipede's maroon color derived from the blood of its victims. The more victims it had killed, we thought, the darker its blood-red color grew.

After some time, as the initial excitement and the debate of the centipede's size, color, and venom subsided, we would proceed to the highlight of the drama.

Several of us would volunteer to round up a rooster from a nearby farm and bring it to the scene. I was always eager for the job because I relished the soft, warm, and smooth feeling of the rooster's underbelly feathers in my hand. The rooster seemed to sense my good intentions when I scooped it up in my hands. It never struggled as I carried it to the centipede.

Once the rooster had the centipede in its sight, it clucked softly as if to say that it was going to relish a sumptuous meal. At this point, we all stopped talking. Tension and excitement reached a crescendo as I placed the rooster a few feet in front of the pinned centipede.

Facing the centipede, the rooster scratched the earth with its claws, kicking up dirt and debris to display its readiness for combat. Then, with wings slightly raised, the rooster would launch its attack.

In terror of its natural predator, the centipede now struggled with a renewed burst of energy to free itself from the rock. But the repeated pecking and shaking by the rooster soon spelled the end of the centipede's futile attempt. As the rooster devoured its prey, some sections of the centipede's body continued to wiggle and convulse.

A somewhat more civilized business occupied us during the spring and summer, when everyone raised silkworms. It was a kinder, gentler activity, involving the nurture of another creature. Like all my friends, I raised silkworms in paper boxes retrieved from trash piles inside the city.

A silkworm started out as a tiny speck of black lint. It ate mulberry leaves incessantly. Several times a day, I covered them with mulberry leaves collected from trees in the neighborhood. The little specks of worms munched and munched and munched. At night, when quietness prevailed, their munching made a soft rustling sound, like the music made by pine needles in the wind. It was a lullaby that coaxed me to sleep.

Silkworms grow at an inordinate speed, like bamboo shoots rising up from the earth. It was pure excitement to see them transform within a few weeks from tiny black specks into large, translucent white caterpillars. At that stage, soft and lethargic, they were not only beautiful but also cuddly. Then one morning, we woke up to find the caterpillars disappeared, replaced by snow-white silk cocoons in each box. During the previous night each caterpillar had started spitting silk as its body began to morph. All of the translucent silk inside its large body came out as the caterpillar spun it into a cocoon around its depleted and shrunken body. The caterpillar inside the cocoon then metamorphosed into a chrysalis.

Many days later, a moth emerged from each cocoon. It buzzed around the box until it found a mate. Within a few hours, the mated female moth would lay thousands of eggs clustered together on the bottom of the paper box, each egg the size of a sesame seed. As tiny black specks hatched from the eggs days later, the entire life cycle of the silkworm began afresh.

When the weather began to cool, the last batch of silkworm eggs stopped hatching. I kept them in a safe corner for the next spring.

While we children played happily in the bright open spaces of the slum, shady characters emerged to conduct their furtive activities during the twilight hours. At early dawn and evening, the dim light concealed a person's identity at a distance. Those were the suitable times to execute a vendetta, ambush an enemy, or spirit away the foolish quarry in a kidnapping scheme.

People generally paid no mind to these violent ambushes and con-

frontations, so long as their own family members were not victims. There was no room for good Samaritans. Self-preservation dictated that anyone who stumbled upon a violent crime scurried away as quickly as possible. We all knew that the criminals would not hesitate to eliminate a nosy onlooker who could potentially cause them trouble in one way or another. But if your home happened to be close to the location of the crime, you couldn't avoid hearing the sounds of violence: the thuds, the moans, the victim's cries of despair.

There was no such thing as police in the slum.

Nanjing did have a police department, but the policemen were just as dangerous and unpleasant to deal with as the criminals, if not worse. Most of them were either connected with opium dealers, or directly engaged in robbery and other crimes. Plainclothes security agents, including police detectives, were the most unsavory and sinister of all the corrupt officials. They preyed on people with impunity, beating up anyone who crossed them, even for so mild an "offense" as making eye contact with them on the street. Utterly merciless, they would not even spare children from their ruthlessness. It didn't take much to provoke those monsters into thrashing a helpless kid who chanced to have annoy them or to get in their way.

As young as we were, my friends and I never failed to recognize plainclothes agents, regardless of the government ministry they worked for. In cool weather, they wore dark-brown leather jackets, a luxury garment, and in warm weather, stiffly ironed short-sleeved white shirts that hung loosely over their dark pants. They wore "plainclothes" only in the most technical sense. Everyone knew that those swaggering thugs owned the streets and everyone gave them a wide berth. An old Chinese saying captured people's reaction to them:

敢	怒	而	不	敢	言
Gan	*nu*	*er*	*bu*	*gan*	*yan*
dare	angry	but	not	dare	say

Racked by anger, [we] dare not express it.

In cases of noncapital crimes, such as burglary and assault, people never sought help from the police. If a victim was foolish enough to go to the police, the best result would be that nothing happened; in other words, the police felt charitable at the moment and merely waved off the victim. In case the police did respond, they would most likely extort money from the victim before doing anything else.

In order to survive in the slum and the streets of Nanjing, a kid had to be a quick study when it came to the people in his environment. My friends and I qualified as experts in that domain of perception.

One common type of furtive character who frequented the slum were kidnappers, though it might be something of a misnomer to call them that, since they never used force to kidnap a child. Slums were their favorite hunting grounds. Like a con artist, a kidnapper relied on his slippery tongue to persuade an unhappy child to leave with him by promising good food and a better life elsewhere. It was kidnapping by enticement.

A kidnapper was usually an unemployed single adult, male, affable, modest, and doing his best to be inconspicuous. Moving into a neighborhood with nothing more than a small suitcase, he would spend his days sauntering around, making friends with the neighborhood kids, giving away candies to them.

Despite all his efforts, though, a kidnapper never really blended in to a neighborhood. He never hurried to get anything done. He didn't seek employment. He didn't have the woeful look of being weighed down by the burden of survival. He was too casual, too leisurely, in a neighborhood where everyone was noticeably tense and desperate. My friends and I could spot a kidnapper in an instant.

Six months after I arrived in the slum, a man who fit the stereotypical description of a kidnapper moved into our neighborhood. Middle-aged and in poor health, he posed more of a psychological threat than a physical one to the children. His presence triggered

my nightmares of being taken away and sold as a slave. Like my friends, I feared and despised this assumed kidnapper.

It might seem terribly unfair and unreasonable that a person should be condemned as a kidnapper without any proof. But self-preservation had dictated an attitude of stereotyping criminals in the Chinese society since antiquity. Even today, people in China and East Asia continue to maintain a view of criminal justice that is the exact opposite of the Western principle that a person is to be considered innocent until proven guilty. In Asian countries, anyone arrested for an alleged crime is considered guilty until he or she is proven innocent. If a person is innocent, an important piece of Asian logic goes, why has he been arrested?

A few weeks after the kidnapper moved in, my friends and I started taunting him by calling out loudly wherever and whenever we saw him:

"Kidnapper is here! Kidnapper is here!"

He was not amused. But his complaints to our parents did nothing to help him: our parents were as convinced as we were about his criminal identity and evil intent.

One day, exasperated by our harassment, he took matters into his own hands during a confrontation initiated by me.

Leading a coterie of my comrades, I followed him close behind as if we were his cheerleaders, calling out loudly, "Kidnapper! Kidnapper!"

Suddenly and unexpectedly, he wheeled around, grabbed me by my shirt, and slapped me hard before I could get away.

The humiliation of being caught unawares and being slapped infuriated me. A degenerate weakling of a kidnapper, a piece of scum among bottom feeders, had slapped me, right in front of my friends and companions! What a travesty!

I schemed for revenge.

Middle-aged, physically unfit, and suffering from arthritis, the kidnapper had difficulty squatting. His quadriceps were too weak

and his knees too stiff. He moaned every time he had to bend his knees in order to squat, which was the common position of rest. As a rule, he avoided squatting as much as possible. Once, when I saw him getting up from an attempt to play marbles with a group of kids, he had to lean forward and push against the ground with both hands. His weakness did not escape the attention of the neighborhood kids who were keenly observant of any nonconformist behavior.

Because of his weak knees and feeble legs, going to the outhouse every morning tormented him. There he had no choice but to squat. Holding on to a bush in front of the pit, he managed to squat precariously when he had to relieve himself. In the morning, he made sure he was the first person to use the pit so that he could hang on to the bush without being disturbed.

One day I got up before dawn, taking care not to wake up Mother and my siblings. Going swiftly to the outhouse, I dug up the bush that the kidnapper habitually held on to for support and replanted it in loose dirt, making sure that neither the bush nor the dirt surface showed any sign of disturbance. Then I hid myself behind a boulder some twenty paces away, where I could peek at the pathway leading toward the pit.

Before long, the kidnapper showed up, ambling toward the outhouse. I held my breath as he disappeared behind the bushes.

Moments later, when I heard the kidnapper's anguished scream, "Aiyah!"—immediately followed by the sound of a thick splash—I knew my trap had snared its prey.

Running toward the farmhouse, I yelled at the top of my lungs:

"The kidnapper fell into the shit pit! The kidnapper fell into the shit pit!"

Everyone rushed out to the pit. Luckily, the kidnapper was not badly hurt. I only caught a glimpse of him dripping with urine and feces.

A couple of days later, just as I was beginning to feel a little

remorseful for my treachery, we woke up to find that Juan-Juan had disappeared. She was not in her shed by the stove and could not be found anywhere else. The room rented by the kidnapper had also been emptied out and deserted.

Juan-Juan was a natural target for the kidnapper's sweet talk. She no longer had the physical comfort that she enjoyed so much in Father's mansion. We had been in the slum for almost six months now, and her role had changed from that of an idle playmate of a little boy to an unpaid servant working long hours in a poor household. It did not surprise anyone that she had fallen prey to the kidnapper, who, like a hyena, had surely locked on to the most vulnerable quarry in the hunting ground shortly after he arrived.

A few weeks after Juan-Juan disappeared, I heard gossip in our neighborhood that she had been sold to a brothel in another part of Nanjing. Information passed quickly from one person to another through the slum's gossip network. In this case, it started from a neighbor who frequented brothels. No one doubted the veracity of what he said about Juan-Juan.

She was barely fifteen at the time.

Preoccupied with my friends in our fun activities, I did not give much thought to Juan-Juan's disappearance at the time. Death and disappearance occurred frequently in the slum, and we had learned to accept them as part of life.

Without Juan-Juan, Mother suffered tremendous hardship. She already had a day job; now she also had to cook and do laundry for the family. The workload overwhelmed her. With Juan-Juan gone, Mother thought that I should go to school, and my siblings agreed. I overheard their deliberations, which I disliked heartily. To send me to school was to take away my freedom! But being the youngest in the family, I was not in a position to oppose or argue against their decision.

Two weeks later, Mother took me to a newly established neighborhood school to attend the first grade.

When Mother took me there, I found that the school was a large, corrugated aluminum tube sliced horizontally in half and placed in an open field not too far from the slum, reminiscent of a tiny airplane hangar. A brick wall with a centered wooden door closed off each of the two ends of the tube. A number of glass-covered squares inserted along each side of the aluminum tube let in light. The dirt floor made the inside of the structure damp and musty.

This contraption was an attempt by the Nationalist government to make low-level education available to the children in the slum. Four teachers showed up every morning to teach four grades, each occupying one corner of the tube. School started at nine in the morning and ended at noon.

Apart from the large metal tube and a roofed outhouse nearby, the school had no other facilities: no dividing walls, no blackboard, no table, no chair, no office, and, not surprisingly, no books. Each pupil brought his or her own seating. It could be a piece of wood, a tiny footrest, a small bench, a piece of woven mat, or any contraption that shielded a child's bottom from the damp ground. One child came every day with the seat from a wooden chair that had lost its legs and armrests. Equipped with a back to support the upper body, it was everyone's envy.

The first day of my attendance, I stood behind my classmates, watching as the teacher paced back and forth, expressing her random thoughts and telling us stories for most of the morning. Some of her ramblings made sense. Some didn't. Even though she was a fairly good storyteller, most of what she said bored me. Didactic and edifying, her stories resembled Aesop's fables, designed to inculcate the moral principles of honesty, diligence, courage, kindness, loyalty, generosity, and so on.

On the second day, I showed up with a small wooden stool

Mother had cobbled together from three pieces of scrap wood the evening before. Mother tried, but she wasn't exactly handy. The contraption was rickety at best.

At the end of the school day, a kid whom I had made fun of during class decided to attack me in retaliation. He raised his stool to hit me. I countered with my own. One stool met the other with a loud crack. Unfortunately, mine, not my opponent's, disintegrated from the impact. That ended the fight. When I returned home, I carried only two pieces of wood. The third piece got lost in the confusion after the fight.

That evening, Mother looked at the two pieces of wood and sighed.

"Okay," she said in resignation, "if you don't want to go to school, you don't have to."

It was music to my ears. I immediately resumed my wild expeditions around the slum with Tiny Lin, Big Wang, and the rest of my gang. Life was good!

But Mother had a trick up her sleeve. One week later, she told me that I was going to Shanghai to live with my aunt.

Instinctively and immediately I wanted to say no. There was no way I would go to another place to live.

"Why should I go to Shanghai?" I asked myself. It would deprive me of what I treasured above everything else in the world: my friends, and my playground. The words were on my lips—only I did not say them.

Mother had never controlled me as Father did. She didn't need to exercise control when Father was around, and by the time Father went to jail, she didn't have the time or the energy. She was counting on the filial loyalty and obedience that had been drilled into me—and every other Chinese kid—from birth, but I had never feared her.

Still, the absence of fear made no difference. It was impossible for me to disobey her command. If I tried, she could withhold food

from me. She could also forcibly put me on the train to Shanghai (I didn't know that she had already arranged for a former domestic employee of the family to take me there).

Unwilling to leave my friends and playground, and unable to rebel against Mother, I started moping. I became uncommunicative, and burst into tears at the slightest provocation.

Mother, mild-mannered but clever in her quiet and unobtrusive way, began to coax me into agreement by saying that my aunt lived in a nice apartment in Shanghai. "Aunt Helen is a spinster," she pointed out calmly. "She yearns for the experience of raising a child. She will dote on you."

Then she added the kicker: "Aunt Helen will give you good food every day."

That got my attention.

Food, especially good food, looms large in Chinese culture. Good food creates good karma and claims priority over all other material needs in life. Whenever and wherever Chinese people congregate, food and eating take center stage. When friends meet, they even greet each other with the expression "Have you eaten?"

During the year in the slum, the lack of tasty food was the one thing that irritated me. Though I didn't complain very much, I yearned for it constantly. Food stalls inside the city always made my mouth water and sent my mind adrift, even to the point where I must have looked almost catatonic at times. I preferred to avoid them rather than seem a complete drooling idiot.

"Well?" Mother prompted a few days later. I saw the gleam of triumph in her eyes.

I hesitated a bit longer, but I knew how impractical my resistance was. At least the temptation of good food made it easier to accept the undesirable and inevitable.

"That's settled, then," said Mother, and a week later I was in Shanghai.

PART II

SHANGHAI

1946–1950

3

THE METROPOLIS

Aunt Helen was a professor of economics at Fudan University of Shanghai, one of the elite institutions of higher education in China. She was tall, with sloping shoulders, and she tied her hair back into a little bun at the nape of her neck, typical of so many spinsters. People who came to visit showed a great deal of respect and deference to her because of her position, yet the logic of her speech and behavior always struck me as unusual and quixotic even though I was just a little boy and she an adult in her late forties.

"Jesus loves us. The Communists will die!" she proclaimed to me, completely out of the blue, shortly after I started living with her.

It was 1946, and at the time the Communists were unexpectedly scoring one victory after another against Generalissimo Chiang Kai-shek's much better-equipped, U.S-supported army. The generalissimo had tanks, armored vehicles, a fleet of naval ships, and an air force with cutting-edge P-50 fighter planes and B-23 bombers.

The Communist army consisted of poorly equipped foot soldiers. No navy, no air force, no mechanized divisions. Their foot soldiers didn't even have helmets; instead they wore the green cotton cap with a red star made famous decades later by Chairman Mao during his cataclysmic Cultural Revolution. They couldn't afford boots, either. Marching and fighting in hand-sewn cotton shoes, they carried old-fashioned grenades that looked like phallic batons with a bulging head. Most of their guns were captured from the generalissimo's troops.

Yet the generalissimo couldn't muster his superior army to defeat the Communists.

The Communists had started from the north, from the so-called Manchuria where Soviet troops gave them a head start after the surrender of Japan at the end of World War II. Within two years, they were sweeping toward Shanghai, the most sophisticated metropolis of modern China. The majority of the city's population were against the Communists, and were tearing their hair out in fear and frustration. Being the financial capital of China, Shanghai was full of capitalists, industrialists, entrepreneurs, and the political thugs associated with the generalissimo's Nationalist Party, all of whom faced possible liquidation in the event of a Communist takeover.

Aunt Helen did not approve of Chiang Kai-shek's corrupt and inept government, but she opposed communism even more strongly because it violated her religious beliefs.

A devout Evangelical Christian, she prayed before going to bed and before every meal. She made me memorize the Lord's Prayer, Psalm 23, and the Ten Commandments. Sometimes as she bowed her head before a meal, she would unexpectedly ask me to say the mealtime prayer. I hated it: Not only could I barely wait to eat once food was placed in front of me, but prayer made no sense to me. Embarrassed that my prayer merely repeated formulaic expressions I had learned from her, I felt like an idiot reproducing from my memory bits and pieces of what she said to her "Lord."

Every Sunday morning, Aunt Helen attended service in an Evangelical church. Of course she brought me with her. The service took place in a huge tent with hundreds, if not thousands, of people. It was the most boring exercise imaginable to a six-year-old boy, involving various iterations of standing up, sitting down, closing eyes, and singing dull songs. The only break from the stifling tedium came toward the end of the service, when a velvet bag was passed through the congregation. Aunt Helen always gave me a coin before the service so that I could put it in the bag. When the velvet bag reached my hands, I had an overwhelming desire to take a handful of money from it. I didn't think anyone would know. But it was a mischief that I dared not commit.

The most trying part of the service was the sermon. As the pastor droned on, I sometimes found myself seized by an urge to scream. Instead, trying not to squirm in my seat, I would indulge in wild fantasies about what I could do back in Nanjing's slum with my buddies.

When Aunt Helen said—not infrequently—"Jesus loves us. The Communists will die," I couldn't for the life of me figure out the connection between "love" and "death." On the love side, I had heard enough mention of it in the pastor's sermons and in Aunt Helen's prayers to know it was good and desirable. On the death side, I witnessed it frequently in the slums of Nanjing and on the streets of Shanghai. Although the sight of death no longer unhinged me, I knew instinctively that it was bad and undesirable. Why did Aunt Helen lump the good and the bad together?

Once in a while, Aunt Helen, reading her mail, would opine:

"The banks rob us. But we need them!"

That one went right over my head. She could be talking to herself for all I knew, and sometimes I thought she was.

Of course, if she looked me in the eyes as she spoke, I had no choice but to conclude that I was the intended target of her communication. After all, there was no one else in our one-room apartment.

Most of the time, I nodded my head to indicate agreement with her. Often I didn't understand what she said, but I figured that profound statements naturally flowed from a learned person such as a professor and I told myself not to question her logic or doubt the truth of her statements.

One evening, out of the blue, she muttered, "Poor boy! Your father is in jail. It's good for you."

I didn't know what made her say that. Secretly, I didn't regret Father's absence. The year in the slum of Nanjing, away from his watchful and unforgiving eye, had been liberating. But it was a secret I kept in my heart. I didn't tell anyone, least of all my family members. Otherwise I would be guilty of violating filial loyalty—a crime of the vilest moral turpitude that called for social banishment.

That was something I certainly didn't need. I was already aware of the oddness of my situation, since I had to avoid mentioning Father in school. Every boy in school bragged about his father, making one claim after another about his lofty status and accomplishments. Sometimes, the bragging degenerated into a contest of one-upmanship, with one boy arguing that his father was greater than the other's. When kids started to talk like that, I immediately slipped away as inconspicuously as possible in order to avoid being dragged into a discussion of my father. Certainly, I would like to brag about him, but I couldn't let people find out that he was languishing in the Tiger Bridge prison in Nanjing. To be known as the son of a prison inmate would be, at best, embarrassing!

It was shocking to hear Aunt Helen say that Father's imprisonment was a good thing. But she said it without malice, and I assumed that it wasn't a put-down, just another of her odd pronouncements.

On some Sunday afternoons, as a reward for my patient attendance at church, Aunt Helen would take me to the waterfront by the Huangpu River, a tributary near the mouth of the Yangtse. There, in the busy harbor, a flotilla of ships stirred my wanderlust: sampans, junks, schooners, trawlers, motorboats, steamers, tankers, cargo

ships, tugboats, even a few naval frigates and destroyers bristling with long guns. I gazed at them, following their wakes with my eager eyes, and dreamed of getting on one to explore far, far-away places.

Aunt Helen read my mind. "The sea is a gray void, and sailors are animals!" she intoned, cocking an eyebrow in warning.

From a distance, sailors looked like normal human beings to me, and I felt pretty confident in my ability to detect unsavory characters. I thought Aunt Helen was rather harsh.

"The sea also swallows ships," she avowed, seeing me unconvinced. "You go on a ship only if you have no choice!"

I had never seen *any* ship being swallowed on all of those Sundays at the Huangpu waterfront. So I simply didn't respond to her admonition, didn't even nod.

Aunt Helen never missed a chance to tell me something that she thought was edifying. Like Mother, who was her younger sister, she was not an aggressive and intimidating type. Still, she usually had my welfare in mind, and I appreciated her concern, even though I didn't always understand or agree with her.

Since childhood, Aunt Helen had been mortally afraid of drowning. Her fear began after hearing gruesome stories of flooding in her village. Floods from the Yellow River have plagued northern China regularly since antiquity. The river coursed through Shandong, the native province of my parents and Aunt Helen. When it overflowed its levees, which happened quite often, tens of thousands of peasants might die.

Later, when she was living in a frontier town called Lanzhou, not far from the Gobi Desert, in the west, she had an experience that in her mind solidified the terrifying danger of any body of water, be it a river, a lake, or a sea.

In those days, the upper stream of the Yellow River tumbled through the center of Lanzhou with fury every spring. When people needed to cross the river, they did so on a ten-by-ten-foot floating platform, tethered to a wire anchored on the two banks.

Once when Aunt Helen was on a crossing, the tether snapped. The platform hurtled downstream over the rapids, quickly becoming lost behind a river bend. No rescue attempt was mounted—all of the passengers on the platform were assumed lost to the river.

Miraculously, the platform hit a large rock on a bend several hundred meters downstream. The impact sent the passengers flying into a shallow eddy along the bank. Everyone survived, albeit with cuts, bruises, and shattered nerves.

According to Aunt Helen, that rollercoaster ride on the explosive rapids of the Yellow River was a frightening journey to the gates of hell.

Water phobias aside, of course, it was not unreasonable for her to claim that the sea swallowed ships. She knew about the *Titanic* at the time. I didn't.

———

Years later I learned from my relatives that Aunt Helen had behaved eccentrically ever since she suffered a severe bout of smallpox at the age of seven in her native village in Shandong Province.

Few children lived through the scourge of smallpox in rural China. They were racked with high fever, were isolated to prevent contagion, and lacked any medical care, so death came fairly quickly after the onset of the disease. Now and then an infected child would miraculously survive, but abandonment during the devastating illness, when the child desperately needed support, inevitably scarred the child's psyche. The pox also scarred the child's face; a female survivor of smallpox almost never had a chance to marry because no man would want a "scar-face" for a wife.

Aunt Helen was one of those "lucky," scarred survivors.

But the most startling of all the revelations about Aunt Helen came to me several years later from a surprising source: Father.

For reasons that were never known to me, Father absolutely detested Aunt Helen. He might have told the story to me in order to

prevent me from feeling beholden to her; it seems the kind of thing he would have done.

In the 1930s, with the help of an American missionary, Aunt Helen had attended the University of Pittsburgh. After five years of hard work and a mighty struggle with the English language, she earned a bachelor's degree in home economics, a common prewar program in many American universities, preparing young ladies to become competent housewives while earning a college degree for respectability. Upon returning to China, she managed to delete the word "home" from her hard-earned diploma and presented herself as a specialist in economics.

After the Second World War, economics became a hot discipline that attracted a great deal of attention as a new promising science. Armed with a fake American degree in the glamorous new discipline of economics, Aunt Helen won a post at the prestigious Fudan University.

She didn't know economics from a hole in the wall, but her proficiency in English allowed her to escape detection. After translating pages and pages of an American introductory textbook on economics into Chinese, she taught her class by reading her translation to the students.

As she loudly read her translated material in class, students diligently scrambled to write down every word. Most of the time, neither she nor her students understood what she read. But it didn't matter—the students blamed themselves for not understanding the words of the authority. If the authority's words sounded like riddles, it was because the audience was not smart enough to grasp them—an attitude that still prevails nowadays in some situations. Of course, in Aunt Helen's case, no one suspected that the "authority" didn't understand her own words!

For four years Aunt Helen taught economics at Fudan University. The income from her teaching sustained us during the turbulent years of the civil war.

In spite of her bewildering non sequiturs, the four years I spent
with Aunt Helen were delightful. She was easygoing and never im-
posed undue constraints on my freedom. She also carried herself
with confidence and dignity, showing no signs of the psychological
scars from her brush with death during childhood beyond her
strange pronouncements. Unlike most women, who tried their best
to appear demure and delicate, she walked with big, long strides
and spoke with an air of authority. She tamed me with delectable
food and deep affection, and I appreciated her gentleness.

Since the beginning of the twentieth century, Shanghai, in addition to
being a center of finance, had also been the undisputed crime capital
of China. It was plagued by more thieves, thugs, predators, unscru-
pulous merchants, and underworld gangs than any other Chinese
city. A major harbor at the mouth of the Yangtse River, it was the hub
of international trade and the primary entry port for European colo-
nialists. By the twentieth century, most of the city had been ceded to
various European colonial powers as foreign concessions. Each con-
cession had its own colonial government, legal codes, and security
forces; the Chinese exercised no jurisdiction whatsoever in those con-
cessions. If a crime against a European or an American occurred, the
foreign authorities would cooperate with each other to capture and
punish the criminal. But if a crime was committed against a Chinese
native, nothing was done, since the colonial authorities themselves
regularly engaged in looting, larceny, and the kidnapping of young
men to serve aboard their ships in subhuman conditions.

Most people living in other parts of China regarded Shanghai as
a sophisticated metropolis populated by slippery and cunning peo-
ple. After World War II, even though the Chinese government re-
gained sovereignty over the foreign concessions in Shanghai, the
city did not lose its reputation for lawlessness, and the people of
Shanghai always evoked an unsavory reaction from everyone else in

the country. Several years later, I was humiliated in Hong Kong when the Cantonese boys there erroneously identified me as a Shanghainese because I made the mistake of speaking that language to a fellow student whom I misjudged to be a boy from Shanghai.

During my first few months in this fast-paced and unforgiving metropolis, I concentrated on picking up the local language. Aunt Helen did not speak it, and as a result, she was always overcharged when she went grocery shopping. There wasn't any remedy or recourse. She accepted the situation as the price she had to pay for not being able to speak Shanghainese.

I, on the other hand, had to learn Shanghainese, because it was the language of instruction in school and the language of other children. Before the Communists founded the People's Republic of China in 1949, Chinese people did not have a national spoken language. China had hundreds of mutually unintelligible languages. In those days, the overwhelming majority of people never moved from their birthplaces during their lifetimes, and therefore never had to cope with different languages. But if you happened to belong to the small minority that moved around the country, you had to learn a lot of local languages.

By the time I was fluent in Shanghainese, a couple of months after my arrival, I had become accustomed to a rather solitary routine, dominated by attending school and doing homework. In my aunt's neighborhood, which was in the former French concession, there weren't many children, and those who did live there mostly stayed home after school. Parents didn't allow their children to hang out on the streets in Shanghai, which had a reputation of being unsafe. So I wouldn't have had much in the way of social contact even without the language barrier.

I missed my friends and our playground—the slum of Nanjing—terribly. Shanghai was a metropolis of paved roads, concrete buildings,

bustling commerce, and a sea of people. There were no crickets, no centipedes, no silkworms. So, not only was I friendless in Shanghai, I wouldn't have known what to do in the streets even if I had friends and went out with them.

For fun I relied on daydreaming, sometimes spending hours staring out the window. It was during those solitary days in Shanghai that I began to imagine going to faraway places, although I didn't know what those places would be. My imagination tended to be limited to soothing pastoral scenes with trees, flowers, meadows, animals, a lot of space, and, of course, plenty of food. I wanted to fly away and embark on adventures. But most of all, I yearned to have a group of close-knit, loyal buddies devoted to one another and sharing the same interests and adventurous aspirations.

I should say that Aunt Helen was never the cause of my desire to fly away. She always treated me kindly and didn't have a speck of cruelty in her.

My desire to go to faraway places was another oddity that did not escape my awareness. No one else in my school shared my aspirations. They liked to talk about their families—how accomplished their parents were, and how they planned to spend their entire lives within their extended family. Their life "goals," if revealed at all, were always closely connected to parents and family. A typical boy wanted to follow in the footsteps of his father, most likely in the same profession, and aimed for the same level of success that he claimed for his father. Nobody wanted or planned to go away after growing up. The contrast between their desires and mine made me feel weird and solitary. Among the boys I knew, it was bizarre, if not abnormal, to harbor wild sentiments and fantasies to fly away.

I was aware of my eccentricity and felt a tinge of sadness that I did not share the worldview of my peers. Being different had been my fate, I thought. Even in Father's Nanjing mansion, when I lived with my immediate family, I never felt a sense of belonging. The one year that that I spent in the slum of Nanjing was the sole exception.

There I identified with my "gang" of buddies. We called ourselves "little people," because we were little in size, age, and importance. But we were not afraid of the "big" people, and felt that we owned the world despite our insignificance.

I must admit that when I first arrived in Shanghai I felt like a country bumpkin. I was humbled by the swift, roving, calculating minds and the myriad customs and practices of the Shanghainese children. Fittingly, my first lesson in assimilation at school had nothing to do with academics—rather, it had to do with business and commerce, as practiced by my schoolmates.

At the time, the most valuable possession of any schoolchild was a piece of graphite for making ink. Immediately after the Second World War, schools still required students to write essays in class once a week the traditional way: with a calligraphy brush and freshly made ink, and a family was obliged to buy a student at least one piece of graphite for that purpose.

Making ink by grinding a piece of graphite on a stone inkstand requires some skill and practice. Too thick, and your ink congeals on the brush hairs. Too thin, and the ink spreads uncontrollably across the thin, absorbent rice paper.

Making ink was as important to a Chinese scholar as mixing oil paints was to a Western artist. The difference is that artists constituted only a small fraction of Western intellectuals, whereas every scholar in traditional China was required to be proficient in brush calligraphy and ink-making. To emphasize the quality of a good piece of graphite, the manufacturer often decorated it with gold and carving. The best-quality pieces could be, truly, as expensive as silver or gold.

After my first essay-writing class, during which I learned how to make ink from my piece of graphite, a fellow second-grader proposed a trade: my piece of graphite for his piece, *plus* his spare calligraphy brush. It sounded like a good deal to me. Not only was his graphite bigger in size, but I also got a spare brush!

When I went home and told Aunt Helen what transpired, she looked at my newly acquired graphite and sighed.

"You have been conned!" she told me laconically.

The larger piece of graphite I received in the exchange turned out to be a dud, whereas mine, although small in size, was of much higher quality, and greater value.

Good-natured, she didn't punish me for my stupidity. But I never forgot this lesson of commerce taught to me by a seven-year-old sharpie.

Most children in Shanghai began honing their business skills in grade school. They didn't just trade in graphite, they traded everything in their possession: marbles, stamps, old coins, pencils, boxes, notebooks, rulers, erasers, sometimes even clothing.

During class breaks, the school playground looked like a bustling bazaar, with kids bartering, selling, buying, coaxing, enticing, hustling, examining, and disparaging one another's goods, disputing the value of one another's belongings.

What was most notable about the crowded school playground was that no one played. The seesaw lay still; the slide sat empty; the sandpit was deserted. Every pupil, from first-graders to sixth-graders, was engaged, on some level, in some sort of business transaction. They were all sharpening their verbal skills, assessing one another's savvy, perfecting their ability to split hairs, and learning to control their facial expressions so that others couldn't read their true emotions.

Kids who lost money never cried or threw tantrums. A loss was viewed as a kind of tuition for this playground business school. Kids who made a profit gained status and prestige. They were respected for their skillfulness in negotiation.

It's not surprising that Shanghai businessmen inspired fear in merchants everywhere in China. According to Cantonese businessmen in Hong Kong, who generally play second fiddle to their

Shanghai colleagues, dealing with a Shanghai merchant is like play-ing high-powered tennis. If you blink, you have lost a point!

By the time the Communists took over China, four years later, many of the Shanghai entrepreneurs had moved to Hong Kong. They were the driving force behind Hong Kong's development into a prosperous hub of commerce, transforming it from a nondescript Third World colonial city into a glittering, world-class metropolis, beginning with the textile industry in the 1950s and followed by electronic manufacture and, ultimately, financial services in the 1960s and 1970s.

And although Shanghai lost its business elite after the Commu-nist takeover and private enterprise was forbidden during the first thirty years of Communist rule, its potential for business leader-ship never died out. The entrepreneurial spirit of the people of Shanghai merely lay dormant for three decades. As soon as China's supreme leader, Deng Xiaoping, reintroduced private enterprise with his famous aphorism "I don't care whether the cat is black or white as long as it catches mice!" entrepreneurial activity exploded out of its dormancy with a vengeance in Shanghai.

The man who succeeded Deng and presided over thirteen booming years of spectacular economic development in China, President Jiang Ze-ming, was a native of Shanghai. He rose to prominence in the Shanghai Communist Party hierarchy and took several of his Shanghai colleagues to the Politburo when he gained control of the party in the early 1990s. I often wondered if he wasn't a prodigy in what I called "the playground business school" of Shanghai.

But while other children busied themselves honing their busi-ness skills, the humbling loss of a valuable piece of graphite in my first playground transaction only highlighted how different I was from the other kids my age. I had been in the city for three months now and spoke fluent Shanghainese; I had settled in with Aunt

Helen and grown used to, and even comforted by, her predictable eccentricities. But I still missed my Nanjing friends desperately.

One cold winter afternoon, walking along the edge of a lily pond on the school grounds at the end of a school day, my attention was caught by a patch of color. It was money, a valuable-looking banknote, approximately five feet out on the ice. Shanghai's winters could be frigid, but it had not been cold enough to make the ice on the pond's surface very thick. The only way to reach the bill was to take the risk of stepping out on the thin ice.

I wanted that banknote, but the water below the ice was deathly cold and dangerous. I stood considering the thickness of the ice very carefully. Then I saw a bigger boy about ten paces away, also eyeing the money. He carefully maintained his balance on the edge of the pond, reached out gingerly with the tip of one foot, tapping on the ice like a cat. Observing that, although he was much bigger and heavier than I was, the ice didn't crack under the weight of his probing foot, I ran toward where he stood and from there darted onto the pond, retrieved the banknote, and returned to solid ground, in one swift action, like a whirlwind.

Astonished, the boy clapped his hands in applause. "Congratulations! What nerve!" he said. "You know, you could've fallen into the icy water. You could've drowned."

"Well, I saw you probing the ice with your foot," I explained. "After assessing the difference between your body weight and mine, and the fact that the ice under your foot did not crack or make any noise, I decided that it was a reasonable risk for me, being such a featherweight, to dart out on the ice."

He nodded his head without saying anything, but his facial expression and body language conveyed to me that he was impressed.

We exchanged our names and started a conversation as we walked home together. Chen Fu-yun was a fifth-grader and five years older than me. Of medium height and good-looking, he had a

smooth manner of speech and appeared incredibly knowledgeable, making intelligent comments on everything we passed by.

"How long have you been here?" he asked, taking note of my nonnative Shanghainese.

"Three months."

"Wow, only three months? Your Shanghainese is not bad!"

"Well, I am still learning my way around," I confessed. "It hasn't been easy."

"I'll help you," he volunteered unexpectedly. "Shanghai is never easy for a newcomer to adapt to. But once you've learned the ropes, it is a great place!"

My heart skipped a beat. Here was someone savvy, bigger, and more knowledgeable than me offering his friendship out of the blue. I was elated.

That evening at home I couldn't stop thinking about my good fortune in meeting Chen Fu-yun. I wanted to tell Aunt Helen but was unsure of how she would respond to my sudden adoration of a stranger. Besides, it would definitely be foolish to tell her that I dashed out on the thin ice of the lily pond at school. So I kept my newfound friendship to myself and went to bed filled with hope and optimism.

It soon became a habit for me to wait at the school entrance to walk home with Fu-yun. We walked slowly and gawked at everything in the shops and on the street, all the while chatting incessantly about what we saw. I always felt the walk was too short when we reached the point where we turned off in opposite directions. The walk was my daily treat. I looked forward to it in the morning and savored every step we took together.

A couple of weeks after we met, I started calling Fu-yun "Da-ge," which means "big elder brother," using it both as a term of endearment and as an expression of respect for his seniority.

Da-ge and I loved to talk. The topic of our conversation could be anything or anyone: school, teachers, shops, merchandise, weapons,

street vendors hawking their wares, plainclothes security agents riding in their jeeps, unsavory characters loitering in the streets, police and soldiers patrolling the street. We also shared a propensity for irreverence, and an enjoyment of belittling or ridiculing anyone with authority over us.

One type of authority figure that always irritated us was incompetent teachers. To begin with, we resented the unquestioned power and authority held by a teacher, though it was relatively less annoying if that authority was at least backed up with some smarts and scholarship. The ones who really riled us were the dimwits—who, paradoxically, always tended to be the most authoritarian. Some of them bordered on the sadistic. Yet the tradition we were schooled in, the behavior expected of us, was one of blind obedience

In those days, in China, a teacher could hit a student at will. Many carried a short, inch-thick wooden slat for just that purpose. The more reasonable teachers applied the slat only to the palm of a victim. If we said or did something improper, the teacher would ask us to extend our palm toward him, and he would slap it with his slat once or twice. One time, a teacher decreed that I had to suffer three slaps for wisecracking. To prepare my palm for the pain, I rubbed spit on it before extending it toward him. I believed, from my experience in the Nanjing slum, that spit was an analgesic because animals licked their wounds to heal them. Now I know it is just a superstition that produces the psychological effect of an analgesic as long as one believes in it. When the teacher saw me preparing my palm with spit, he went ballistic. Instead of three mild slaps, he brought down his slat on my hand five times, as hard as he could, causing my hand to burn and swell for more than a day.

More unreasonable teachers employed a variety of techniques to punish students physically: face slapping, ear twisting, head bashing. One sadistic teacher loved to press into the soft spot behind the pupil's ear lobe, between the top of the jawbone and the skull. He would approach a pupil from behind and suddenly

pounce, squeezing the two soft spots behind the kid's ears with his thumbs like a vise. The pressure made you feel that your head was going to explode.

Da-ge and I also frequently commiserated about the endless number of Chinese characters we had to memorize in class. In written Chinese language, there are no letters. Instead, each word is a single character, or logograph, composed of brush strokes varying in number from one to twenty or more. In order to learn a character, you had to memorize not only the correct combination of all of its brush strokes but also the correct *sequence* and *angle* in which the strokes are put together. If you don't, the logograph ends up weird-looking. A teacher—and anyone who knows how to write well—can always tell from the shape and form of a logograph if the writer did not follow the correct sequence in putting down the strokes.

To become proficient in reading and writing, we had to memorize several thousand logographs. It was a heavy burden on all schoolchildren. When the Communists established the People's Republic of China in 1949, they systematically simplified each logograph in order to facilitate universal literacy. Since then, to use the old set of more-complicated logographs—there are more than 50,000 and they are still in popular use in Hong Kong, Taiwan, and overseas Chinese communities—is thought to smack of elitism.

Da-ge had a wry and biting sense of humor. He frequently made sacrilegious comments or disparaging remarks about the people we saw, calling a man with a lump of a nose "garlic nose," and describing an official with a swaggering walk as "he who has shit in his pants." To Da-ge, a coyly pouting lady was a "sufferer of constipation," a sanctimonious policeman a "parasite," a soldier on patrol an "android." Under his tutelage, I developed my own truculent wit and acerbic tongue.

On several occasions, Da-ge and I had to run for our lives because passersby, after overhearing our obnoxious remarks

about them, threatened to teach us a lesson by thrashing us phys-
ically!

Da-ge was extremely knowledgeable about material goods and
their values. From him I learned how to assess not just graphite,
lacquer boxes, brushes, fountain pens, clothing, and shoes, but also
furniture, bicycles, rickshaws, and even automobiles. He taught me
the difference between softwood and hardwood furniture, lac-
quered and painted furniture, oiled and stained, imported and do-
mestic. In front of different furniture stores on our way home,
pointing at a piece, he would tell me all about its materials and
value. A fountain of knowledge, he commanded my respect and
admiration. In fact, I worshipped him.

When we passed by a bicycle, the vehicle we aspired to own af-
ter growing up, he would launch into a discussion of its manufac-
ture and relative value—the structure of the frame, the shape of the
handlebars, the quality of the ball bearings in the hub, and the
spokes of the wheels. I learned that domestically manufactured bi-
cycles were the least desirable, that the British-made Raleigh was
the best among the imported ones, while Schwinn, from America,
was just "okay."

Even though owning an automobile was beyond our dreams, Da-
ge knew their brand names, body design, country of origin, and en-
gine size. I learned to identify each vehicle as it passed by: Morris,
Austin, Vauxhall, MG, Jaguar from England; Ford, Dodge, DeSoto,
Rambler, Studebaker, Chevrolet, Packard from America . . .

For the first time, I realized that Father's limousine in his Nan-
jing mansion had been a Buick, although I didn't tell Da-ge about it
because I didn't want him to know that Father was in jail. For me,
Father was a taboo subject. Da-ge sensed this, and never probed.

A few weeks after learning about automobiles, I observed: "The
value of a Buick corresponds to the number of chrome-lined holes
on its fenders above the front wheels. The more holes a Buick has,
the fancier it is."

Da-ge confirmed my observation, and in doing so satisfied my long-held curiosity about the four holes on each side of Father's Buick.

The coming months passed in a pleasant haze of acclimation. Under Da-ge's wing, I became more outspoken and comfortable with the bustling metropolis than I had ever thought I could be. Though I remained a bit distant from my other schoolmates, they knew who I was and no one picked on me. Gradually, I stopped missing my friends from the Nanjing slum so desperately. I still thought of them, but I had settled into the rhythms of life: Aunt Helen, school, Da-ge, and the myriad sights of the Shanghai metropolis.

One day, about a year after Da-ge and I had become friends, as I was waiting for him to walk back home with me, he showed up suddenly in a panic.

"Li Na, you have to help me," he said frantically. "Come, let's run!"

I had never seen him in such an agitated state. He normally exuded calm and confidence.

"What's happening, Da-ge?" I asked as he tried to catch his breath.

"I'll explain later. For now, just follow me, and run as fast as you can."

We dashed out of our school like two miniature running backs, sprinting along the street, cutting in front of bicycles and buses, slicing left and right to avoid pedestrians, getting cussed and screamed at by everyone along the way, until we reached a crowd converging into a building I did not recognize.

"Get to the front of the crowd. Slip between people's legs if necessary!" Da-ge ordered.

We did, by dint of being small—though the crowd could have easily trampled us to death. But nothing was going to stop Da-ge from accomplishing his mission—whatever it was—and I wasn't

about to abandon him, regardless of the danger. My loyalty to him was unwavering.

Inside the building, a cavernous hall was packed with people yelling and screaming, their arms waving in the air. Standing among a forest of legs, Da-ge and I could no longer move forward. The legs were as tight as sardines in a can, and I was squeezed between them. My chest hurt and I began to feel faint. After a minute or so, I began to have trouble breathing. Luckily, Da-ge realized that my life was at risk. He jerked his head around and yelled, "Pinch their crotches!"

I did so with both hands to people around me, both male and female. There were screams, and soon the pressure on my body began to ease.

"Let's get out of here." Da-ge had changed his mind about moving forward.

Little by little, we moved to our right, and finally broke free of the funnel-shaped crowd near the entrance.

"Shit! This is a disaster!" Da-ge grumbled.

He was dejected, his color ashen. I had to summon all of my power to hold back from asking him questions.

We walked without exchanging any words for several blocks.

All of a sudden, Da-ge stopped at an ice cream parlor.

"Let's console ourselves with ice cream," he muttered as he led me into the parlor.

Da-ge always had money in his pockets. I never asked him where his money came from, and he never volunteered any explanations. I thought it was a matter of fate—he was fated to have money, and I wasn't. Simple as that! I also thought that perhaps he had some magical power and as a consequence money grew in his pocket!

Ice cream was a fashionable, avant-garde luxury item in 1947 Shanghai. It hadn't existed in Nanjing when I was there one year before, Nanjing not having caught up with the new fashion yet. In Shanghai, ice cream parlors tended to be furnished with sofas and

glass-top tables. They were fancy establishments, catering to the au courant, the rich, and the privileged.

Da-ge ordered two ice cream sundaes for us.

As far as I was concerned, the chocolate sauce and vanilla ice cream might as well have been ambrosia. That was what the gods would eat, I was sure, if there were gods. After finishing my ice cream, I licked my cup clean with the aid of my index finger.

"Well, Li Na, this is a catastrophe!" Da-ge said gloomily as he swirled his spoon through his rapidly melting sundae. "The place we tried to squeeze into was a bank. It was closing down. This morning an upperclassman at school told me about banks shutting down. I had hoped that if mine was one of those banks, I could get my money out before it shut down altogether." He sighed. "But we arrived too late. All those people are in the same boat as I am. My money has gone down with the bank."

"Why did the bank shut down? Won't it reopen sometime in the future?"

I wasn't sure that my questions made any sense. In fact, I wasn't sure that what he told me made any sense.

"I don't know exactly why the bank folded," Da-ge mused. "I only know that it offered a very high interest rate. That's why I put my money there."

I had no idea what an interest rate was.

I knew a bank was a place where some people kept their money. Several of Aunt Helen's friends had argued with her on different occasions that a strongbox at home was preferable to a bank for keeping money. Aunt Helen disagreed. Her friends claimed banks were untrustworthy, which she did not dispute. But after some bantering, she inevitably concluded, "A strongbox at home does not yield any interest!"

That statement, plus her status as a U.S.-trained "economist," always ended the debate.

From those conversations I knew that "interest" was something

desirable. I figured what Da-ge now called an "interest rate" was related to interest and therefore also desirable.

Feeling Da-ge's distress, I decided not to bother him with further questions. It was not the first time I failed to understand what Da-ge said.

"You know, Li Na, the money I put in the bank was my tuition," Da-ge began to explain to me. "My father told me to bring it to the bursar's office at school at the beginning of the semester. Pretending that my father had some unexpected financial difficulties, I successfully talked the school official into granting me a grace period. That's how I happened to have money in that bank. Now the money is gone. I don't know what my father will do to me."

He spoke like an adult, in a somber tone, his mood pensive.

I gazed at him, full of admiration, not knowing what to say. I, too, was afraid of what might happen to him.

But, more important, I began to realize that adulthood did not hold any magical mystique. Here was a twelve-year-old who understood the world of grown-ups, took practical action, and earned money like they did. Yes, calamity had befallen him, and I didn't fully understand what had triggered the calamity. Nor did I fully understand the intricacies of what he did. But grown-ups were not immune from calamity, either, I reckoned—look at Father. One day he was Mr. Big Shot; the next day he was spirited away by security agents.

Before my association with Da-ge, I had always assumed that grown-ups constituted a special, privileged caste, segregated and distinct from children. We children had to be respectful of them, and were taught to be obedient to them. They could dismiss us any time they wished. Every child was indoctrinated from birth to believe that being disobedient or unfilial to your parents was immoral. But there was no moral lesson that prescribed how grown-ups should treat children. They could give us away or sell us in time of distress. Even in good times, adults claimed priority when it came

to the good things in life: food, comfort, and freedom. Children must live under the arbitrary constraints set by them. In short, they had power and authority. We were at their mercy.

Da-ge showed me that the distinction between grown-ups and children was neither intrinsic nor mysterious, and what they did, we could do as well. The key was knowledge. It was knowledge that enabled grown-ups to have power and prestige. Da-ge's action and confidence made that clear.

That day, as we were about to split up after the ice cream, Da-ge still looked out of sorts, cheerless and downcast. I wanted to comfort him but didn't know how. After he turned and slowly walked away, I stood still on the street. My eyes followed him until he disappeared at the next turn. Sadness overwhelmed me.

The next day, Da-ge didn't show up in school. I never saw him again.

4

THE FALL OF SHANGHAI

FOR MONTHS AFTER DA-GE VANISHED, I YEARNED for his company. At the end of each school day, as I walked toward the school gates where we used to meet, my hopes would rise a few notches. But my eyes always searched in vain.

The sorrow of losing my dear friend made my spirits sink, but it also prompted me to resolve that I should soak up knowledge and aspire to be like Da-ge.

After Da-ge's disappearance, my life, like everyone else's life in Shanghai, was consumed by the impending arrival of the Communists. The Chinese civil war, between Chiang Kai-shek's Nationalists and Mao Ze-dong's Communists, had been raging in other parts of China, but the residents of Shanghai never saw the fire or smoke of any battles.

Yet the absence of military action did not lessen the suffering of the residents of Shanghai. During the years before the city's fall, people endured unbridled inflation, social chaos, and random vic-

timization by local thugs, as well as at the hands of Chiang Kai-shek's government agents.

In a single month, the currency could lose thirty percent of its purchasing power. Chiang Kai-shek's government responded to inflation by printing more money. In the absence of a dependable currency, people hoarded grain, oil, nonperishable food items, and other dry goods, which in turn fanned the inflation further. The cycle of inflation and hoarding spiraled up at breakneck speed. At one point, peasants from the surrounding farms refused to sell their products for money and resorted to bartering for their farm produce. Shanghai residents ended up using silver, gold, jewelry, clothing, and other valuables to barter for basic food items.

Aunt Helen and I were luckier. She relied on her connections with American and English missionaries to secure canned food. On the first day of each month, as she received her salary, she would spend the entire day hauling food to our apartment from different places. Toward the end of the month, we ate mostly U.S.-made Spam, sardines, and canned vegetables that she obtained from her white Christian friends.

Most people lived in fearful anticipation of Communist rule. Aunt Helen, still lecturing in economics at Fudan University, was wary and apprehensive. She knitted her brow, reduced her social activities, and stopped mumbling aloud her wish for the Communists to die. Instead, she asked questions to the air, typically while she was reading newspapers:

"Why is Chiang Kai-shek so incompetent?"

"Why don't the Americans send their army to help?"

"Could Mao be a miracle worker?"

"Is God abandoning his flock?"

Her questions, though not intended for me or anyone else, always jolted me. I might be doing homework when, all of a sudden,

a question blurted out of her. I would look at her, totally bewildered, but she never noticed my reaction.

Several weeks before the Communists reached the northern edge of the city, the Nationalist government began to disintegrate. Water, electricity, and gas supplies were periodically cut off without warning. Buses and trams would suddenly suspend operation for hours. Schools closed down on random days without notice. Some days at ten o'clock in the morning my teacher would tell everyone to go home.

But I never did. Aunt Helen normally expected me at noon for lunch break. During those couple of hours I wandered the streets, seeking to catch sight of drama and spectacles.

The most frequently occurring spectacle was a seemingly harmless person being arrested by plainclothes security agents. Upon being stopped by the agents, the victim would loudly, frantically declare his or her innocence for the benefit of everyone nearby:

"I am not a Communist! I have not committed any crime!"

Irritated, the security agents would start cursing and beating the victim until he or she was handcuffed and led away.

A more dramatic sight was the execution of suspected Communists in the streets, deliberately staged in public for the edification of citizens. Usually a hog-tied prisoner was brought to an intersection where traffic was halted. The execution team, consisting of soldiers and security agents, announced the name and the "crime" of the alleged Communist through a handheld megaphone before the prisoner was shot with a rifle at point-blank range as he lay on the ground. I always cringed involuntarily when the prisoner's body bounced up in reflex to the impact of the bullet before falling back down into a spreading pool of blood.

Also captivating was the sight of platoons of grim-looking soldiers carrying rifles with bayonets fixed and machine guns, marching by in formation, their synchronized steps thumping the street

rhythmically. I imagined they were on their way to the front lines to engage in battle.

Sometimes, a mechanized army column, including tanks, artillery pieces, and armored personnel carriers, passed. This was the most impressive spectacle. Pedestrians stopped in their tracks to gawk at the weaponry of Chiang Kai-shek's elite troops.

Less scintillating, but more frequent, were the caravans of police-escorted black limousines speeding through the streets, sometimes with blond Westerners inside. My curiosity was aroused only if the limos were Buicks: I wondered if one of them might be Father's old car.

Most pedestrians on the streets were always looking about, wary. They scurried out of harm's way whenever some unexpected noise or sight caught their attention. I tended to do the opposite, always rushing toward the place where noise or gunshots were coming from.

Occasionally I saw people being shot without knowing where the bullet came from. A person would suddenly drop ten or twenty feet away, blood spreading into a pool. No ambulance or police would arrive on the scene. Everyone simply walked around the blood and the body. Later, when I would walk back the same way, the body would be gone.

Rumors abounded to the effect that the Communists would execute everyone associated with Chiang Kai-shek's Nationalist government. Christians, merchants, and capitalists were also at risk, according to the gossip. Toward the end of 1948, bankers, industrialists, textile tycoons, and rich property owners began their exodus to Hong Kong and various overseas destinations. By then, most government agencies were barely functioning.

One late afternoon, a fire broke out in the ground-floor kitchen of the house Aunt Helen and I shared with six other families. The

structure was a three-story concrete building in the former French concession. I was roused in the middle of a nap and didn't fully wake up until I had been evacuated out onto the street with all the other residents. As they watched black smoke gush out of the windows on the ground floor, several residents of our building sat on the sidewalk, sobbing, overwhelmed by their fear and anguish.

The concept of insurance didn't exist at that time in China. If your home burned down, you simply lost everything. There would be no assistance from the government or any other organization.

Five minutes after everyone came out on the street, a fire engine arrived with its siren blaring. The captain jumped down from the engine, the rest of his crew behind him. But they didn't spring into action. They didn't take out their hoses or set up their pumps. They didn't even look at the burning house. Instead, they walked straight toward us, a group of frightened and panicking residents watching our home ablaze.

"How much will you pay us to put out the fire?" the captain asked in a leisurely fashion, almost smiling.

We were in shock. There was no time for deliberation, no time for negotiation, no time for bargaining. Every second of delay meant more burning, and more burning implied a greater likelihood of losing everything we owned. The fire captain held all the cards as he demanded ransom.

"We will give you what you want. Please extinguish the fire!" several residents pleaded. The captain smiled and nodded to his crew.

After the fire was put out—which turned out not to be a very major undertaking—the captain told us that he had to charge a fee equivalent to five percent of the value of the house. Five percent sounded reasonable, except that it was up to the captain and his crew to establish the value of the house. He looked around, measuring the structure and its inhabitants with a practiced eye, and came up with an estimate.

"Have the money ready by tomorrow afternoon," he told us. "We will come to collect it. If you don't pay up, we will set your house on fire!"

With those departing words, the captain and his firefighting crew drove off.

That evening, the residents spent hours arguing how to divide up the payment. There was a lot of shouting and exchanges of angry words. At one point, a couple of males among the group almost came to blows. When they finally reached an agreement, Aunt Helen told me that she would have to hand over fifty percent of her savings.

As the civil war inched toward Shanghai, corruption and scams perpetrated by officials like firemen and police were neither the only nor the worst plague people suffered. The absence of law and order inflicted more harm and damage on people than corruption.

Faced with the approach of the Communists, the Shanghai agencies of the Nationalist government began to break up. Three days before anyone had so much as glimpsed the Mao cap of a Communist soldier, the metropolitan police and city government closed shop. Chiang Kai-shek's heavily equipped army, which had helped to maintain law and order in the city, also vanished.

As the police, soldiers, and functionaries abandoned their posts to retreat southward, they took with them the most valuable equipment from their offices and bases.

Once they departed, mobs gathered in the streets. It was open season for looting.

At first, the mobs targeted public buildings and government offices. Then the looting spilled over to commercial establishments. People poured into banks, police stations, fire departments, post offices, department stores, and shops to take whatever they could strip and carry away. The streets around government buildings and

commercial zones were filled with men, women, and even children, carrying chairs, desks, benches, food, clothing, tools, lighting fixtures, office supplies, even toilet seats. The generalissimo himself set the example by evacuating the gold bullion of the national treasury, as well as the most valuable art and antiquities from the national museums, to Taiwan on his warships.

For three days, the enormous metropolis of Shanghai was an open city without a municipal government or law enforcement. Anyone could use force to do anything and commit any crime with impunity. Gangs, thieves, and the mafia, which the Chinese called the "dark society," murdered, robbed, raped, carried out revenge, and committed gratuitous violence at all hours without fear of retribution.

It was hell and mayhem. Each day, ordinary citizens, taking refuge inside their locked homes, shook with fear.

At our house, the grown-ups bolted all the windows, locked the front door, piled heavy armoires and desks behind it, and prayed for protection from the Buddha, Christ, or God. Every few hours, Aunt Helen would get down on her knees in our room and call out to the Lord to deliver us from evil.

Fear in the house was contagious and mutually reinforcing. Tense and teary, every adult spoke with a cracking voice and seemed like a bundle of raw nerves ready to snap. I passed time by playing marbles on my bed. When I had to get out of the room I shared with Aunt Helen, I tiptoed among the edgy and irritated adults.

During those hellish three days, no one ventured out. On the first day, the adults huddled in front of a short-wave radio belonging to one resident, listening for news.

Chiang Kai-shek's radio stations broadcast mostly propaganda and falsified news about the civil war. They claimed that the Nationalist army was fighting courageously and the tide would soon turn against the Communists. The Communists didn't control a

radio station at the time, but everyone could tell that Mao's troops were approaching because the Nationalists were fleeing in front of our eyes. The question was only when the Communists would arrive. Some people, including Aunt Helen, hoped in vain that the United States, the perennial backer of Chiang Kai-shek and his Nationalist Party, would intervene and prevent a Communist takeover.

On the second day, electricity went out and the water supply stopped. The adults in the house, deprived of their radio news, became unbearably nervous and fearful. They were silent and listless. Many suffered from uncontrollable twitches. Some tried to read. Some paced the floor. Some looked almost catatonic. The entire house, sealed like a fortified bunker, reeked with a disgusting human stench.

At about six a.m. on the third day, a loud banging woke me up. When I got out of the bed, the adults in the house were already nervously scurrying toward the blocked front door.

People living on the second floor could look out on the street from their windows. They yelled out that Communist soldiers were knocking. We had to open the door. No one could refuse entry to the victorious, conquering soldiers!

Trembling, the adults started reluctantly to move the furniture blocking the door, their faces betraying the paranoid thoughts and worries they had been repeating to one another incessantly during the previous three days:

"We Chinese have a rotten fate!"

"Communists, Nationalists, they are the same! All they want is to kill and rob innocent people like us."

"Why don't the Communists and the Nationalists simply divide up the country and stop fighting?"

"Are we going to survive?"

"Have mercy on us, Buddha!"

After the hallway was cleared, most of the adults cowered in the

farthest corner with a view to the door. There was a moment of embarrassing silence.

Who should open the door?

Luckily and rightfully, the oldest man among the six families stepped forward and volunteered on account of his seniority. He drew a deep breath, visibly steadying himself, unbolted the door, and put his hand to the doorknob. Aunt Helen sucked in her breath and pressed me to her side.

When the door opened, everyone was stunned. Framed by the door, three smiling Communist soldiers—dressed in tattered uniforms, with their rifles on their shoulders—bowed.

It was unreal. No one could possibly imagine armed soldiers of a conquering army smiling and bowing to ordinary citizens. Normally, they pillaged, killed, and committed atrocities of one kind or another.

"Please, could you kindly give us some drinking water?" one of them asked with the utmost politeness.

Confronted by this totally unexpected civility, while at the same time gripped by inordinate fear, everyone gazed at the soldiers and stood motionless, mouth agape. From my perch on the stairway halfway between the door and the shocked adults, the scene looked like a frozen frame of a motion picture when the wheels of the projector inexplicably jam. Many long and agonizing seconds ticked by as I cranked my head to look at the soldiers on one side of me and the group of petrified adults on the other side. Finally a young woman, as if she had just woken up from a dream, saved the day by rushing into the nearest kitchen to bring out a bottle of boiled water.

After the soldiers shared the water, one said, "Thank you so much. We don't wish to intrude. But if you could spare some food, any food, we would really appreciate it. If you don't have any, we will move on. It is not our intention to disturb civilians. Since yesterday we have been on a forced march for sixty miles without

food, water, or rest. That's why we are thirsty, hungry, and exhausted."

We could hardly believe what we saw and what we heard. The soldiers didn't bark any orders. They didn't force their way into our house. They didn't take anything from us. They didn't wave their guns at us. They could've done all those things and more. Instead, they pleaded with us to give them water and food!

We were not only shocked by what had transpired but also confused by our own feelings. Communists were supposed to be evil, given to wanton killing. That was the street talk and what the Nationalists told people every day in newspapers and radio broadcasts. Now, confronted by three armed Communists, we felt sympathy and respect even before our fear had subsided.

We invited the three soldiers into our house and brought out steamed bread, rice, pickles, and leftovers from the evening meal of the day before. Beaming with pleasure, the soldiers wolfed down the food and thanked us profusely again. Before they went on their way, they assured us that no other soldiers would show up at our door to beg for food and drink because their entire army had split into groups of three to make sure that no household was visited by more than one group.

After the soldiers departed, the tension that had been building for three days finally gave way to some relief. All of a sudden, words started tumbling out of everyone:

"This is unbelievable!"

"I have never seen armed men as polite and disciplined as those Communists. If it had been Chiang Kai-shek's soldiers, they would have robbed us—at the least!"

"Communists might not be so bad!"

"What do you mean? They are nice! Didn't you see how civil they were?"

"An army divided into teams of three to ask for water and food. It's impressive how disciplined and well-organized they are!"

"They might be a blessing in disguise."

That night, the women in the house gathered together whatever food that was left and cooked a communal meal to celebrate the remarkable fact that everyone in our house, all six families, had survived the civil war. Nothing was lost. Nobody was hurt. The house was undamaged and we had a surprising but reassuring encounter with the Communist soldiers. The men of the house took out their *mei-gui lu*, a rose-flavored liquor, and toasted our survival.

The Communist soldiers were, indeed, a godsend for terminating the three days of terror and anarchy. As more and more troops streamed into the city, they started imposing order, posting sentries everywhere, taking over government buildings, and directing traffic. Their civilian counterparts worked efficiently to restore water and electricity, public transportation, and garbage collection. Within a couple of weeks, the city had ceased being a lawless hunting ground for gangsters and the underworld.

It was not long after the fall of Shanghai that the Communists took all of mainland China. For Chiang Kai-shek's Nationalist Party, the loss of Shanghai and Nanjing was a devastating blow. Nanjing, less than two hundred miles west of Shanghai, was the seat of the Nationalist government, and Shanghai was the most important and prosperous metropolis in China. Their loss to the Communists signaled the end of the Nationalists, who ultimately retreated to the island of Taiwan. Without a navy or an air force, the Communists could not pursue the Nationalists across the strait separating Taiwan from the mainland.

On October 1, 1949, Chairman Mao declared the founding of the People's Republic of China at Tiananmen Square, and designated Beijing its capital.

Within a few months, Communist rule transformed Shanghai.

In these early days, everyone was pleased that law and order had replaced anarchy and corruption. Communist soldiers per-

formed their duties as peace officers, serving and protecting citizens. There was accountability. Government agencies no longer engaged in extortion. The chicanery and flimflam schemes that had dominated the world of commerce vanished. Ordinary citizens stopped hoarding food at the order of the government. Inflation ended. Rice, flour, oil, and meat were sold in government stores at fixed prices. The ration allotments weren't generous, but nobody starved. After decades of chaos, unpredictability, and random predation by government agents and criminals, people began to feel secure for the first time.

Unfortunately, the good feelings among the people didn't last long.

In less than one year, the residents of Shanghai came to understand that the Communists were obsessed with control: control of the nation, control of the individual, and control of the mind. They didn't just run the government and the public sector—they ran everyone's personal life and aspired to create a homogeneous mental framework for every citizen. Their expertise at instituting and exerting control was truly mind-boggling. A new kind of regimentation, a new kind of state operation hitherto unknown to people, began to emerge.

The government dictated where you lived, how much food you ate, what you wore, what you read and wrote, what entertainment you could have, when to get up in the morning, when to nap, regardless of whether or not an individual wanted a nap. There was a governmental bureau or an agency for everything imaginable in life, and there were rules, either written or oral, for every aspect of human behavior. The Communist Party, in the form of district offices, street alliances, and neighborhood committees, created a bureaucracy that penetrated every nook and cranny of society. Party cadres collected minutely detailed information on everyone. They knew who you met with, what you read, what you ate, what you

said, and what you did. They even tried to determine what you were thinking. Nothing escaped the eyes and the ears of party cadres. Every person was held accountable for his behavior, words, beliefs, habits, and everyday mundane activities that seemed inconsequential and innocuous before the Communists came to power. People began to refrain from talking and stopped volunteering information, any information, even that which seemed completely harmless and irrelevant. If there were a God watching from high above, he or she must have been taken aback, if not shell-shocked, by the dramatic transformation of Shanghai from a noise-filled, transaction-bound metropolis with one of the chattiest populations on earth into a new kind of human habitat where people scurried to perform their chores in silence, like ants.

While the people were being watched and listened to, all private enterprises were shut down and all private ownership was suspended. The government, by fiat, laid claim to everything: homes, land, banks, commerce, transportation, labor organizations, food and drink supplies.

Capitalists and Nationalist sympathizers "volunteered" to attend weekly seminars for "thought reform," which involved confession, public criticism, and humiliation. Studying Communist propaganda material was the most benign of requirements for all adults.

Religious leaders publicly renounced their beliefs after "studying" the works of Marx, Lenin, Stalin, and Mao. They were not allowed to preach or meet with parishioners. Organized religion ceased to exist.

People caught gambling, playing cards or mah-jongg, reading *Reader's Digest* or other foreign magazines, were labeled degenerates and had to undergo thought reform. They were singled out during weekly Neighborhood Committee meetings and publicly humiliated. Second-time offenders were punished with one week's imprisonment, during which they were put to hard labor, regardless of their physical condition.

Making statements that were deemed critical of the Communists, listening to radio broadcasts from the BBC or Voice of America, would be condemned as counterrevolutionary activities. First offenders were required to attend biweekly sessions of political education and indoctrination classes. Recidivists risked being sent to labor camps at unknown locations for indeterminate durations.

Suspected criminals, gangsters, and hooligans were arrested and summarily executed without a trial.

The elaborate social organization created by the Communists required every citizen to report on every other citizen within his or her residential unit, supervised by a battle-hardened cadre. The cadre, a veteran party member, most likely had worked as a former underground organizer in Shanghai. He/she made it his/her business to know everyone and everything within his/her unit. In short, citizens were corralled into a seamless net of social and political structures under the control of a faceless and merciless bureaucracy.

Everyone became paranoid. It was realistic paranoia, however, not the imagined kind. Everyone suspected everyone else of being a government informant. With amazing speed, the great metropolis of old Shanghai died. For the people who continued to live there, fear and anxiety dominated daily life.

A measure of the effectiveness of the bureaucratic control was the changes in common speech patterns.

For eons, Chinese had addressed each other with a vast array of titles to show respect according to relationships. Educated people even referred to each other's family members with special honorific names in order to show deference. For example, if you wished to inquire about your friend's father, you didn't refer to him as "your dad" or "your father." You used the term *ling zun,* which means, literally, "the honored authority." Under Communist directives, all such social conventions were abandoned at once. In order to underscore the putative equality among people, everyone

was to be addressed as "Comrade." But the universal title did not eradicate inequality, since some, namely members of the Communist Party, were patently more equal than others.

Aunt Helen continued to lecture in economics at Fudan University. Three times a week, she looked forward to her lectures. They provided an anchor for her life as everything else around her began to crumble. She still prayed, but only in the evenings, when all of the lights were turned off. No longer did she cry out for the Lord. Her prayers were delivered softly. Sometimes even I, at a distance of a few feet, couldn't make out the words of her muffled mumblings to God.

Six months after the Communists took control of Shanghai, Aunt Helen's Evangelical Christian church, which had held services attended by hundreds of worshippers every Sunday for decades, was disbanded. The loss of the church distressed Aunt Helen immensely. The Chinese pastor was sent to a labor camp. Her American missionary friends were expelled from China. Some went to Hong Kong, and some returned to the States. Aunt Helen didn't dare to write to them.

I did not experience any radical change in my school. All classes resumed within a month after the change of government. When I returned to school, aside from Chairman Mao's portrait, which made its appearance in every classroom, the only new feature was the singing of political propaganda songs in classes. Among the many songs taught to us was the new national anthem, which exhorted all to sacrifice their lives for their motherland; "The East Is Red," a sycophantic song extolling Chairman Mao as our savior; and "You Are the Beacon," which urged us to follow the Communist Party. The lyrics of many other "revolutionary" songs could be unintentionally entertaining. One went like this:

> *Oh, the gang of Chiang's bandits!*
> *Oh, what a mess!*

What a mess,
What a mess . . .

One thing that remained unchanged from the old days was the omnipresence of plainclothes government agents. Chiang's agents had worn dark-brown leather jackets in the winter, and in the summer, starched white short-sleeved shirts that didn't need to be tucked in. The Communist security agents wore exactly the same outfits, the only difference being that in winter they had a Mao jacket underneath their leather jacket. For all we knew, they might even have been the very same individuals who had simply switched allegiance. It was obvious that they wished to be identified, because they enjoyed inspiring fear in people.

I continued to travel to school on foot. The streets had become calm and uneventful. They held no more surprises or spectacles; no gunfire, no executions, no chase scenes, no fistfights, no columns of soldiers marching through the city. Most of the gangs and riffraff disappeared. Commerce, which had formerly defined the streets of Shanghai, by and large vanished. Shops, except the few taken over by the government, closed down one by one. With sadness and nostalgia, I witnessed the demise of the ice cream parlor where Da-ge treated me to a chocolate sundae.

The adults might have been worried and paranoid, but my life became, in a word, boring.

As the doldrums overtook my daily routine, I stopped frequently by the lotus pond in school, where I had met Da-ge a couple of years ago.

A delicate mixture of pink and white, the lotus flowers were enchanting as well as captivating. I liked to splash water on the large, muted-green lotus leaves. Because of their fuzzy surface, water formed drops like silver beads, rolling toward the center of each leaf, combining into a shiny, large, elliptical ball that could easily be mistaken for quicksilver.

Some days, I spent fifteen or twenty minutes squatting on the edge of the pond, gazing at the lotus and the water beads on its leaves, wondering where Da-ge was and what he might be doing.

I missed him.

———

Toward the end of the summer of 1950, after four years of being my surrogate parent, Aunt Helen abruptly announced that we were leaving Shanghai for Hong Kong.

"Where is Hong Kong, and why are we going there?" I asked.

"Hong Kong is a British colony in southern China. I am taking you to Hong Kong because your parents live there."

Her answer took me by surprise.

"I thought Father was in Tiger Bridge jail in Nanjing."

"Not anymore! He got out before the Communists took Nanjing in 1948. Chiang Kai-shek released him. In Hong Kong, you will live with him and your mother."

I didn't probe any further; she was the adult and knew best. Besides, in 1946, when Mother sent me to Shanghai, she *did* tell me that the arrangement would be temporary.

A few days later, Aunt Helen and I boarded a southbound train for Guangzhou, better known as the city of Canton. It was an overloaded train pulled by an overworked coal-burning engine. The engine chugged and puffed, spewing great billows of gritty black smoke full of soot. It jerked back and forth while making a great deal of banging noise whenever it stopped or started to move.

In the train, only the adults had seats. Children lay underneath the wooden benches on which adults sat shoulder to shoulder, forming rows from one end of a coach to the other end.

It was a hot and humid summer. The adults sitting on the benches removed their shoes and socks to cool off. Lying on the floor, I was surrounded by a wooden board on one side, separating me from another child, and bare feet on the other side.

Those feet, I swear to you, stank worse than the outhouses in the slum of Nanjing. They made the smell of sweat, farts, and rotten food in the train seem almost innocuous. Some of the feet suffered from oozing fungus infections, reminding me of the parasite-infested leg of a fellow child in the slum. That kid died from blood poisoning.

For three days and two nights, the train strained to cover the six hundred miles from Shanghai to Guangzhou. It crawled on the flat and barely moved on the grades. I thought I would be asphyxiated— there was no escape from the stench. I had to spend the entire time curled up under the seat. Luggage filled the aisle in the middle of each car between the two rows of benches. Whenever I picked my way through the luggage to reach the toilet at the end of the car, the adults eyed me suspiciously, as if I planned to grab their valuables and jump off the crawling train.

Arrival in Guangzhou, I thought, spelled relief.

But in Guangzhou, we had to catch another train to reach the border of Hong Kong, seventy miles away. A horde of people waited on the platform to board the Hong Kong–bound train. There was hardly any space to set your feet. Being squeezed in the crowd reminded me of my attempt with Da-ge to get into the bank that was closing down a few years ago. The crowd was just as unruly and unforgiving.

Aunt Helen held a suitcase in each hand. I carried a small sack of my belongings, trying to hold on to her arm as we shuffled toward the Hong Kong train amid a sea of moving bodies. At each boarding area, a huge pack of people converged toward the narrow entrance of the car. The closer to the entrance, the tighter the pack pressed together. Each person, loaded with baggage, pushed, squeezed, and struggled to board.

I held on to Aunt Helen's arm as tightly as I could. But the converging crowd split us apart. While Aunt Helen was being carried farther toward the car by the relentless crowd, I fell behind. She

couldn't turn back and I couldn't catch up. "Li Na!" I heard her cry out as she was swept inside by the mass of moving people.

While shrieking "Ah-Yi!" (Auntie!), I pushed and pushed at the bodies surrounding me, but no one would budge.

She was in the train, gesturing and yelling toward me. I could see her mouth moving and her frantic eyes, but was unable to hear her amid all the noise of the crowd and the train. Then the train jerked back and forth a couple of times and took off. The people who failed to push through now retreated away from the moving train, knocking me down in the process. By the time I got up, Ah-Yi and the train were gone.

All around me on the congested platform, exhausted people slumped despairingly across their luggage, everyone on edge and in distress, not knowing when the next train would come. Standing in that sea of people, I had never felt so alone and so frightened.

Nearly catatonic from panic, I started to wander aimlessly around the train station, still clutching the small sack of my belongings. I lost track of time and became oblivious to my surroundings as if I had been condemned. This was it, I thought. Without any adult protection or means of survival, I would be kidnapped, sold, murdered, and chopped up as filling for meat buns in this strange place!

I started to shiver uncontrollably.

Then, suddenly, I heard a voice saying something that sounded like my name. I thought I was hallucinating. Then it rang in my ears again.

"Could this be Li Na?"

Turning around, I saw one of Aunt Helen's old friends from Shanghai. I recognized him because he had visited Aunt Helen at our apartment many times. Rotund, elderly, and dressed in traditional Chinese garment, he was gazing at me, looking very surprised and puzzled. When I was sure that he was Aunt Helen's

friend, my eyes filled with so many tears that I could barely make out his silhouette.

"Where is your Ah-Yi?" he asked.

As much as I wanted to answer him, I burst into an uncontrollable sob. He walked up to me and, placing his hand on my shoulder, asked gently again about Aunt Helen. When I finally managed to tell him what happened, in between gushes of tears, I was completely spent and exhausted, as if I had just emerged from a seizure, my teeth chattering and my entire body shaking. In a firm and comforting voice, he assured me that everything would be fine and he would temporarily take custody of me.

Then, much to my embarrassment, I couldn't recall his name. But he didn't seem to mind my addressing him as "Bai-bai" (Elder Uncle) without attaching his surname to it. He told me that he was doing exactly what Aunt Helen and I were doing: heading to Hong Kong in order to escape the Communists.

"Don't worry, Li Na! We will find your Ah-Yi in Hong Kong," he comforted me.

Fortunately, Aunt Helen was waiting at the Hong Kong border when her friend, with me in tow, arrived a few hours later on the next train.

There was no relief or joy or celebration at the end of our brief but traumatic separation. Both Aunt Helen and I were tired to the bone. We had yet to cross the border, and didn't know what to expect there.

Miraculously, we entered Hong Kong without having to pay any bribe or suffer any harassment. It was just a few days before the British closed the border to Chinese refugees.

As we walked across a bridge over the river that separated China from Hong Kong, I noticed that the Hong Kong policemen wore a completely different uniform from that of the Chinese soldiers. Instead of the green Mao uniform, they wore khaki shorts, short-sleeve

khaki shirts, pale-green knee socks, polished black boots, a sidearm in a black leather holster, and a stiff, round hat with a black plastic brim in front. Standing behind the policemen, surveying the refugees pouring across the bridge, was an inspector in a bunkerlike office. He wore a smart uniform with a military jacket displaying a row of evenly spaced, shiny buttons, a stiff white shirt, a black tie, and long twill pants with a sharp crease on each leg. He carried a thin, black baton under his left arm. His hair was blond.

Above the office, a thin British flag fluttered in the wind.

PART III

HONG KONG

1950–1957

FATHERS AND SONS

FROM THE TRAIN STATION IN KOWLOON, AUNT HELEN hired a taxi to take us to my parents' residence in the New Territories. Viewed from the narrow and winding road, the tree-covered mountains and verdant valleys, with few houses and people, impressed me. Compared with the bustle and dirt of Shanghai, the New Territories looked like unspoiled wilderness.

Father and Mother lived in a big, rectangular apartment house made of cement and surrounded by bamboo. The building was perched at the mouth of a river emptying its crystal-clear water into a bay of the South China Sea. The taxi stopped on a dirt road by the riverbank. Aunt Helen and I had to walk across a long and narrow stone bridge spanning the river's wide mouth in order to reach the gray cement house.

This was going to be my reunion with my parents after nearly five years of separation. Strangely, I was neither anticipating nor dreading it. But it was not nonchalance that kept me from feeling cheerful or depressed. Far from being blasé, I felt numb as I followed Aunt

Helen up the cold, hard cement stairs leading to my parents' apartment. Perhaps I had grown accustomed to upheavals, changes of venue, and metamorphoses of life, beginning with the hurtful loss of Nai-ma, followed by my new life in the slum of Nanjing, which had ended with my removal to Shanghai. Sometimes I felt like a pawn being moved about on an invisible chessboard. Coming to Hong Kong meant, to me, just the latest maneuver by the adults who had control over me.

After four years in Shanghai, I could barely remember my parents. They never came to my mind unless Aunt Helen brought them up, which did not happen frequently. My image of Father, a tall, thin and serious man, was dominated by his stern countenance. I couldn't say that I knew him. Even more so than Father, Mother was a mystery to me. She never looked severe by any measure. Like a star, she was enticing, but far, far away.

Mother let us into the apartment. Father was sitting at a table in his small bedroom, which was connected to an even smaller living-cum-dining room where Aunt Helen and I made our entrance. The living-dining room was half the size of the entrance hall in Father's Nanjing mansion. Upon entering, I bowed deeply to both of my parents—my mother in the entranceway, and my father through the door to his bedroom—addressing them respectively as "Ba-ba" (Father) and "Ma-ma" (Mother), as required by tradition for a child to demonstrate his respect and obedience. There were no hugs and kisses, no show of emotions, no inquiries about my trip, no sighs of relief upon seeing either Aunt Helen or me arriving intact and unharmed. In fact, Father never got up from his rattan chair at his table in the next room, even though we were clearly in his sight.

Mother and Aunt Helen exchanged greetings while I stood by the door like a stranger, feeling totally disconnected and uncomfortable. Within a few minutes, Aunt Helen departed, as if she had

completed a business transaction. I watched her go with an unexpected pang of sorrow, but without any outward question or protest.

It surprised me that Father didn't speak to Aunt Helen, and she wasn't asked to stay for tea. Of course, they operated in the world of adults which I, as a child, was not supposed to understand. Nevertheless the brevity of their interaction, which seemed icier than what normally occurred between strangers, was stunning.

Minding my own business, I turned to assess my new world—in particular, Father and Mother, and tried to connect them to my faint memory.

Father still looked tall, lanky, and imposing, even sitting. He hadn't changed. His gaze was intimidating; his attire, spartan; his manners, austere. He barely acknowledged my presence with a few glances in my direction.

Mother had not changed much, either; still beautiful, still silent and distant.

Both looked ageless, even though they were in their fifties and had recently been through hell. Their hair was still pitch-black; their faces were still free of wrinkles. Miraculously, neither jail nor the slum had left any visible marks on them.

As Father turned back to writing at his desk, Mother gestured for me to follow her out of their living quarters to a balcony that led to another small room. Inside were two narrow beds and two tiny study desks.

"Your Ge-ge [elder brother] and Si-jie [elder sister number four] sleep here," Mother explained. "You will have to sleep on the floor until a bunker bed can be made for you and your brother."

For the first two weeks after my arrival, I slept on a mat under my brother's study desk. The three small rooms constituted our apartment: one for my parents, where Father had a study desk facing their bed; one for my sister and brother; and the third, connected to my

parents' bedroom, for dining and sitting, though there was hardly any space for that. The rest of the building housed the landlord's family and several other tenant families.

That evening, Father lectured me brusquely in a deep voice, wearing his usual grave expression. Without mincing any words or offering any preamble, he delivered his instructions.

"Our family is passing through a difficult period," he intoned flatly, looking at the ceiling. "Hopefully the hard times will be brief. Every member must do his best to help extricate our family from this unexpected hardship."

I didn't fully comprehend the implications of "extricating our family from this unexpected hardship" and didn't dare to ask for an explanation. I was disappointed that he did not inquire about my time in Shanghai and said nothing about our years of separation.

He concluded his instructions with this command:

"I will send you to a Chinese middle school." He fixed his stern eyes on me. "You must help the family by distinguishing yourself academically."

This was ominous.

I had only completed the fifth grade in Shanghai. Even in fifth grade, my young age and small stature disadvantaged me socially and academically. In addition, I always suffered from hyperactivity, which made it tremendously hard for me to focus during the long school day. Sitting immobile in a chair for seven fifty-minute classes every day was pure torture. Most of the time, I wanted to run away, as I did in the slum of Nanjing. Since running away was out of the question in Shanghai, I felt a desperate need to move in my wooden chair. But moving about during class was a serious breach of discipline, punishable by detention and hand-slapping. Even inadvertent squirming could provoke a humiliating reprimand from the teacher. A pupil had to sit stone-faced, like a statue. I managed to accomplish that by drifting off into my private fantasy world. That was how I survived school in Shanghai.

Now Father wanted me to skip sixth grade and attend middle school, which had *eight* fifty-minute classes per day. I knew trouble loomed ahead.

And I was right. When I did go to the middle school Father picked for me a few days later, disaster struck quickly. Within hours, I got into a fight and was expelled. That was the beginning of my stormy relationship with Father in Hong Kong that would last through my teen years, dominated by his disappointment and anger, plus my anxiety and fear.

When I lived in Father's mansion in Nanjing, he never mentioned his job or talked about his work in front of his family. I often saw him leave in his black limo early in the morning, but my knowledge of his work did not extend much beyond the fact that he was an important government official. After he fell from power, he spent three years in Tiger Bridge prison, away from the family, before arriving in Hong Kong with Mother. When the Communists established the People's Republic of China in 1949, while I was with Aunt Helen in Shanghai, several of my siblings followed Chiang Kai-shek's government to Taiwan. By the time my parents and I were reunited in Hong Kong, after five years' separation, we had all undergone much trauma. Yet not a word came from Father about those intervening years, even though he knew that the family had suffered immensely from the collateral effects of his disgrace and imprisonment. There was no discussion of our life in the slum, just as there was no discussion of his life in jail. It was as if nothing extraordinary had ever happened to the family. Everyone pretended that life had been going on normally, as though we were skilled practitioners of the art of forgetfulness perfected by Joseph Stalin.

Nor did Father ever talk about his past to me. There was an unspoken, unwritten Chinese tradition: You don't discuss your life and your upbringing with your progeny. It's perfectly fine to talk

about your past with close friends or relatives of your own generation. But to have such discussions with your children is to breach the all-important generational line, an absolute taboo in Confucian ethics.

Within the Confucian framework, the older generation should always look and behave differently from the younger generation. "Old" implies "steady, patient, reliable, knowledgeable, sagacious." It is why the old are venerable and deserving of a younger one's respect and deference. That is also why the old have to maintain their dignity at all costs, even if it means keeping their own children at a distance. To have an intimate chat with your offspring that is neither didactic nor edifying is *not* conducive to maintaining your status and dignity.

In Hong Kong, Father wrote every day. His desk was cluttered with thin sheets of Chinese manuscript paper, each covered with tiny printed squares lined up in vertical columns. One of his treasured possessions was a gold Parker fountain pen, which he used to fill up those tiny squares with logographs, from top to bottom and right to left, page after page, all day long. He never uttered a word to his family about what he was writing. Sitting at his desk for hours on end, he wrote, and wrote, and wrote. Once he told me, during a break:

"Power comes from the fountain pen!"

Ten years old, still remembering the recently stifled commercial fever of life in Shanghai, I honestly thought this had something to do with the fact that his fountain pen had a shiny gold cap. Gold was valuable; Chinese people hoarded their wealth in gold because no one trusted paper currency (with good reason). It was not until several years later, when I returned to Communist China to undergo yet another metamorphosis of life, that I came to understand that Father was making a sly reference to Chairman Mao, who had written, famously, in the 1930s:

"Power comes from the gun barrel!"

Sad to say, Father did not mean to poke fun at Chairman Mao with his paraphrase. At the time, Father was writing political commentaries for magazines and journals in Hong Kong, analyzing trends in international diplomacy and expressing his opinion on how China should be governed. He actually believed that words and ideas, effectively expressed and properly disseminated, could win him political influence in war-torn China—even though our nation had never borne a trace of democratic tradition in its entire history.

With respect to power, Mao was a realist, Father a dreamer.

In spite of Father's reticence and our distant and contentious relationship, I was consumed by the same burning desire to find out about him that had gripped me ever since I was a child. Even when I was still under the care of Nai-ma, my milk mother, I peppered her with questions about Father. But she didn't have a clue and told me only that I should obey him or he would beat me. This had the desired effect, as I was deathly afraid of him in those days—even before he first laid his hands on me the day Nai-ma was sent back to her home village.

Paradoxically, my fear made Father even more enigmatic and intriguing. I wanted to find out how he grew up, who his father was, how his father treated him, why he landed in jail, and above all why he was so cold to me, his youngest son.

Sometimes I caught glimpses of his early life from overhearing the raucous conversation between him and his close friends who came to our humble home in Hong Kong for dinner. Father was always affable and garrulous with good friends, especially after a few rounds of 130-proof "Rose Dew," a popular Chinese liquor. During those social interactions, his rise to prominence from a humble village often took central stage in their wide-ranging dialogues and reminiscences.

"Hail to Minster Li for rising from the peasantry to intelligentsia!" one friend would say, raising his glass, and everyone would down the Rose Dew.

"May your journey and struggle be a guide to all of us and our children!" another saluted.

Once in a while, someone would cry out, "To our return to power under Minister Li's leadership!"

At which point they all tossed their heads back, downed their drinks, and then, tilting their wine cups forward to show that they had drained them, looked at each other intently to show their determination and appreciation of such an important exhortation.

This homage and their exhortations suggested stories behind them that fascinated me. I wanted to know the power they sought, the journey and struggle Father went through in his youth.

Sometimes Mother would reluctantly answer a few of my queries about Father, although she found my inquisitiveness baffling.

"Why do you want to know? You don't even like your father," Mother would say, looking at me quizzically.

I had never told her that I didn't like Father. In her quiet way, she was certainly observant and perceptive.

But the most important source of information came from the servants formerly in my father's service. They unveiled to me many of the secrets of Grandfather and Grandmother's lives, and of Father's youth.

When Father became rich and powerful, he brought to his Nanjing mansion dozens of men and women from his native village in Shandong Province and had them trained as his retinue to serve him and his family. The practice of staffing your entourage with clan members or fellow villagers is an old Chinese tradition. When a native son becomes successful, he spreads his good fortune among his clan and friends from his place of origin. He brings them to the city where he has forged his successful and prosperous career. They serve him and take pride in his ascendance to prominence as if it were their own. They are unswervingly loyal and dependable because they are bonded by a common ancestral home. Such a bond separates "us" from "them." If you ask where a Chinese person

comes from, the answer is always the place of his ancestral roots, the place where his father and ancestors grew up, not necessarily the place of his birth, which may be only a place of convenient happenstance. On my official identification card, I was described as a person from Shandong even though I was born in Shanghai, spent the first five years of my life in Nanjing, and had never set foot in Shandong Province.

Most of Father's retinue of bodyguards and servants knew his family intimately in their impoverished village in northern Shandong. There was nothing that they loved more than telling stories about him, their master and benefactor. Talking about him or his parents made them feel closer to the glory and power of his achievements. To them, Father was always the Honorable Minister of the Chinese Government, even after he lost his position, went to jail, and ceased to be their employer. When they talked about father, they always began with, "The Honorable Minister Li . . ."

In 1946, in response to Mother's request, one of Father's former loyal male servants accompanied me to Shanghai from Nanjing. Lao Liu, or "Old Liu," was no longer in our employ, but it didn't stop him from keeping in touch with us while we lived in the slum as he eked out a living in Nanjing. Seeing himself as a member of our extended family from Father's ancestral Shandong village, he didn't hesitate to take me to Shanghai when Mother called on him for help and provided the funds for our train trip.

In Shanghai, rather than returning to Nanjing, Lao Liu struck out on his own. He thought Shanghai offered more opportunities for earning a living than Nanjing. But in accordance with his loyalty to the Li family, he came by on most weekends to help Aunt Helen clean, buy rice, and haul heavy items, as well as taking time to play with me and regale me with stories from Father's home village. Lao Liu was a gifted and natural storyteller, narrating vivid and colorful events, featuring Father, Grandfather, brigands, and the pitiful life of peasants in Shandong. From Lao Liu's narrative, I learned more

about early-twentieth-century rural life in China than I did in all of the schools I attended.

———

Because China is a land of filial ties, where the fate of a son is marked sometimes before birth by the fate of his sire, to understand Father you must understand Grandfather—and to do that you must understand their native land, Shandong.

Shandong is a northern coastal province that juts into the China Sea toward the Korean Peninsula. It has a long and illustrious history: Confucius, who laid the philosophical and moral foundations of East Asian civilization two and half millennia ago, was born a few miles from Father's village. Laozi, the founder of Taoism, was also a Shandong native. So was Mengzi, the intellectual heir of Confucius.

At the time of the great philosophers, Shandong prospered. It was a land of farmers, the soil was fertile, and natural resources were abundant. But over the centuries, as the population expanded beyond what the land could sustain, the soil became depleted of its nutrients and poverty came to dominate the region. By the nineteenth century, Shandong was one of the poorest provinces in China. It didn't matter how diligently or ingeniously the peasants cultivated their land—their efforts always yielded meager harvests.

"Your grandfather was a rare bird in the village," Lao Liu once told me. "He was not a farmer but a lawman."

A lawman in a rural area during the Qing (Manchu) dynasty was equivalent to a county sheriff deputy. Grandfather lived on the edge of his village near the Tai Shan (or Tai Mountain), where his parents had lived, and his grandparents before them, and his great-grandparents before *them*. It was his place of origin, his ancestral home.

Like most of their fellow villagers, Grandfather and his family occupied a hovel made of mud and straw. When the Yellow River

overflowed its levees, which was not infrequent, the villagers' mud homes would melt away in the swirling flood like cubes of butter on a hot plate.

Yet even such a humble home did not come easily to Grandfather. He had to overcome considerable prejudice and opposition in order to claim his rightful inheritance in his ancestral village. This was because he was a lawman, and lawmen were universally despised.

The main function of law enforcement in rural China at that time was the collection of taxes for the imperial Manchu court. As the nation was being deprived of its already meager resources by the European colonial powers, the government levied one tax after another on an already overburdened peasantry: head tax, harvest tax, grain tax, war tax. Few peasants earned enough to meet these obligations. When a peasant failed to pay his taxes, lawmen were sent to confiscate his land or bring him to jail. From the perspective of the peasantry, lawmen were indeed a curse, the scum of the earth. In fact, many lawmen found their jobs so unsavory that they would have gone into a different line of work if they could find one. Collecting taxes at that time was not a well-paid profession; like the people they sometimes had to arrest, the lawmen were struggling to eke out a living. They did what they had to do for survival.

As a young boy, Grandfather was fortunate to be adopted as a houseboy by a local martial artist living in the nearby mountains, away from the villages. His own father had laid claim to a tiny spot at one end of the village, barely large enough to accommodate the shack in which he raised his family. Adoption by the martial artist took Grandfather away from abject poverty and spared him from the short, harsh life of a tenant farmer. Such farmers bore the double burdens of heavy taxes and owing their landlords half of their harvests, no matter how meager. Tenant farmers rarely lasted more than ten or fifteen years before collapsing of malnutrition and

physical exhaustion. Their children were unlikely to survive beyond infancy. Death always hovered nearby the home of a tenant farmer.

For fifteen years, while the rest of his biological family died, one by one, of disease and starvation, Grandfather was a loyal servant and an obedient acolyte of the gongfu master in the Tai mountains, living in the master's house, practicing martial arts, and faithfully performing the daily chores of cleaning, cooking, and running errands. His mastery of the martial arts was what led him to be recruited by the law-enforcement agency of the local government, at which point he left the gongfu master's household.

When Grandfather, the lone survivor of his family, rebuilt the shack on the spot his family had occupied, villagers resented his presence among them. For the villagers to have a lawman as a neighbor was akin to a flock of sheep accepting a wolf into their pen. The villagers tried to drive him out with hostility and ostracism. They made clear to him that they loathed him because of his profession.

But it didn't take them long to change their minds.

By the mid-nineteenth century, brigands had infested Shandong as well as many other poor regions of China. The Manchu dynasty, defeated and bankrupted by the powerful, colonizing nations of Europe, provided no services, no educational opportunities, and, worst of all, no protection from marauding bandits in the rural areas, where poverty and disease kept the colonialists away. Pillaging and causing mayhem, brigands roamed the countryside, preying upon the peasantry at will.

Most bandits who infested rural Shandong in Grandfather's day were former peasants who had lost their families and any other means of survival. Forming bands of marauders to pick on other farmers, they were neither armed nor trained in combat; it was rare for them to own even a traditional weapon such as a sword or a spear. When invading a village, they relied on hideous screaming

and brandishing sharpened wooden sticks for intimidation. They robbed but rarely murdered. The worst of them raped and kidnapped women.

As a lawman, Grandfather owned a broadsword, the official weapon issued by the county government. It was by far his most valuable possession. Usually he carried it as a sidearm, hanging from his belt, much like a modern policeman carries a handgun. He was not a large man with bulging muscles, but he was strong and blessed with catlike speed. He handled his broadsword with immense skill and dexterity, being deft at leveraging power from his legs and coordinated movements. In combat he could easily lop off an arm, a leg, or a head with a lightning stroke.

Shortly after Grandfather settled into his native village, a gang of four brigands came during the early hours of the morning. At the time, Grandfather was practicing shadow boxing in an open space near the village entrance, part of his daily exercise routine, to keep up his strength and fitness. Unfazed by the bandits' shouts and curses, he assumed a standard gongfu position and waited. He didn't even unsheathe his sword.

It didn't take long for the bandits—armed only with sharpened sticks—to add up all that they saw and conclude that it might be unwise to tangle with an armed martial artist. So they stopped hissing, quit their antics, turned around, and took flight.

But they did not forget their humiliating defeat. Five days later, the four bandits returned with reinforcements.

I heard the story of that confrontation many times from Lao Liu and other members of my father's former household staff. It had assumed almost legendary significance among them.

"It was evening," Lao Liu would begin. "Several villagers who were still weeding in their vegetable plots saw a gang of seven brigands marching toward the village. They called for your grandfather."

Seven was a formidable number for a bandit group, and their

expressions and manner—silent, clutching freshly sharpened bamboo sticks in their hands, looking purposeful and menacing—made the villagers fear that a disaster was about to descend upon them.

"When they arrived at the open field where villagers dried their wheat during harvest, your grandfather was waiting for them in his martial-arts stance," Lao Liu said. He demonstrated: feet apart at shoulder width with the left leg in front, slightly bent to facilitate quick movements while maintaining balance.

"He had drawn his sword." Lao Liu added dramatically. "Lined up shoulder to shoulder, the seven bandits halted at ten paces from your grandfather and leveled their sticks like lances. It was clear that they had come to kill, to exact revenge for the humiliation they had suffered a few days before.

"This time, your grandfather did not just glare at the bandits with disdain, nor did he wait for the bandits to attack. With a blood-curdling scream, he charged with his sword cocked sideways in both hands for a sweeping strike from left to right. As the bandits saw the glittering sword advancing toward them with lightning speed, fear came over them. Panic-stricken, they looked at each other for a split second. Like a herd of zebras surprised by a charging lion, they turned in unison and ran for their lives!" Lao Liu flicked the spread fingers of his hands outward dramatically.

After those two encounters, word spread around several counties in the vicinity of the Tai Mountain that Grandfather's village was guarded by a ferocious tiger named Li. Brigands avoided the village ever since.

From the villagers, Grandfather acquired the nickname "Benevolent Lawman." They gave him the nickname not just because he had defended them against brigands, for which they were immensely grateful, but also because rather than immediately acting on an order to arrest a tax delinquent, Grandfather took it upon himself to persuade the magistrate to grant the offender a grace period. It was good for everyone, he argued, because the offender

avoided the humiliation of imprisonment while the county treasury stood a better chance of collecting the unpaid taxes, albeit a few months late. Often the magistrate found Grandfather's arguments sensible. Why throw the poor tax delinquent in jail? If he couldn't pay his tax bill while farming, he surely wouldn't be able to pay it while languishing in prison.

Each peasant Grandfather saved from imprisonment was beholden to him. One by one, members of the village became his loyal fans. In this highly unconventional manner, Grandfather had created a niche of survival for himself and his family. They had food every day, which was more than what most people could hope for.

BLIND AMBITION

MY FATHER WAS THE YOUNGEST OF GRAND-father's children. Already blessed with two sons, Grandfather had wanted another as insurance against the excessively high infant-mortality rate in rural Shandong. Every Chinese knew that the most heinous offense against one's ancestors was a man's failure to continue the male lineage.

But Grandfather and Grandmother had another reason to want a third son. Since Grandfather did not own land to bequeath to his sons, three sons were safer than two to bear the burden of provid-ing for him and his wife in their old age, should they be lucky enough to live into old age.

Sons, not daughters, were rural people's "social security." Daughters of rural families were sold or given away at a young age to a family with a young boy, where the girl would grow up as a virtual indentured slave, given less food and burdened with most of the household chores under the watchful eyes of the future mother-

in-law. Only sons were sure to remain in the household by the time the parents reached old age.

Grandmother nearly bled to death giving birth to father in the late nineteenth century, probably in 1898, although no one knows for sure. Without medicine, physicians, or hospitals, childbirth in a village was always an "organic" affair, with organic risks. At birth, Father weighed more than seven "jin," a whopping nine pounds, with an unusually large head. It was a miracle that Grandmother survived.

To the pleasure of his parents, Father grew to be a handsome boy.

He had a symmetrical and chiseled face with high cheekbones and full lips. His eyes were lively and almond-shaped; his nose was straight as an arrow. As he grew up, he exuded intelligence and energy.

Everyone in Grandfather's village thought Father's most impressive features were his eyebrows. Delicate and symmetrical, they formed two arcs like two bold calligraphy strokes, bent in a perfect angle two-thirds of the way toward the temple. They conveyed the elegance of Chinese calligraphy where the "strength" of each stroke, the geometric balance and symmetry of the lines, dots, and hooks, and the glistening black ink on white rice paper, constitute the essence of grace and beauty in Chinese aesthetics.

Father was not only good-looking but also tall, his six feet of height affording him a commanding presence among his peers. His physical attributes and his mental alertness left a deep impression among all of the villagers. He was without a doubt the pride of the family, and he grew up with a self-confidence that was rare in a village boy.

Even though Grandfather and Grandmother doted on him, they did not depart from tradition in bringing up their youngest son. When Father was ten years of age, in 1908, they took in a girl of the

same age from a farmer's family in a neighbor village to be his future wife. She was referred to as his "village wife"—a common and embarrassing burden for many of Father's male contemporaries who rose to prominence.

Father's self-confidence served him well in competitive exams. He became the only boy from his village awarded a full scholarship to attend a newly created boarding school in the capital city of Shandong Province.

By the time he completed his secondary education, he already belonged to the educated elite in a country of 400 million people, most of who were illiterate. He could choose a job with an excellent salary, a salary that was beyond the dreams of anyone in his native village. Among the choices available to him was a position as a teacher in his high school. The principal offered it to him because of his superb academic standing. The job was not only well paid but also highly respected.

But to everyone's surprise, he refused. A steady job with a good salary was not enough for him. He was more ambitious than that.

Rather than take a good job, he wanted to attend Peking University, the crown jewel of the developing Chinese educational establishment—so he quietly informed the principal of his high school.

Peking University was, and remains, the preeminent university in China. It was peerless in the beginning of the twentieth century. Its exalted status in the late 1910s was enhanced by the presence of internationally celebrated intellectuals on its faculty, such as the greatest poet and writer of modern India, Rabindranath Tagore; the renowned English mathematician, philosopher, and pacifist Bertrand Russell; and the American founder of the philosophical school of pragmatism, and an influential educational reformer, John Dewey. Tagore, Russell, and Dewey were among many progressive thinkers and scholars who came to Beijing to witness the birth of a new nation after the 1911 fall of the Manchu dynasty, the

last of the 2,200-year-old dynastic cycle in Chinese history. They wished to partake in the awakening of a people that had been long subjugated by the colonial powers of the West.

Peking University admitted only a few hundred students each year. Applicants had to sit for a fiercely competitive entrance examination that lasted for several days. The lucky students who won admission were guaranteed privilege and prestige in a country where more than ninety-eight percent of the population never attended a school at all.

Gaining admission to Peking University was chancy for anyone, no matter how brilliant and hardworking. It required more than talent or luck. An aspiring young man needed money to carry him through the one or two years of intense preparation for the entrance exam, which was no less formidable and daunting than the examination for the highest degree called *jin-shi*, held in the imperial court during the dynastic days. Finally, the applicant also needed money to finance the trip to Beijing just to sit for the entrance exam and then wait for the results.

As far as money was concerned, in 1917 Father had none. Neither did his family.

In order to have study time, Father could not commit to the numerous career positions that were available to him after he earned his high school diploma. He had to find a way to make a living while simultaneously conserving time to study for the entrance exam.

Even in my generation, growing up in the 1940s and 1950s, only teenagers from well-to-do families attended both primary and secondary school; otherwise, they worked. No one could do both at the same time. The opportunity for a work-study combination simply didn't exist. It was true in Father's youth, almost a century ago; and it remains valid in modern China.

Undaunted by the dilemma facing him, Father told his family that he planned to go to a small city twenty miles away from the capital of Shandong to work as a rickshaw boy in order to earn money while studying for the entrance exam to Peking University. It was an unbelievable plan, unheard-of for someone who could choose from a variety of respectable and well-paid jobs, not to mention that the plan was also a highly risky gamble.

Grandfather and Grandmother were shocked and outraged that Father had sunk so low as to choose to be a rickshaw boy. They expected a monetary subsidy from Father, as any proud traditional Chinese parents of a successful son would—not to mention that he would be wasting years of precious education if he took work pulling a rickshaw, something any illiterate village boy could do. To them, Father's desire to enter Peking University was not only overly ambitious but also foolish to the point of absurdity.

"Have you gone out of your mind?" they admonished him. "You might just as well dream of becoming emperor!"

"Why do you give up what you have in your hand in order to pursue something that you will never have?"

That was the question my grandparents asked. It was also the question voiced, unanimously, by their fellow villagers.

But Father did not flinch from pursuing his goal, even in the face of universal condemnation. He had made up his mind. Casting aside the opposition of his parents, his clan, and their friends in the village, Father embarked on his grandiose mission.

He toiled as a rickshaw boy for nine months, laboring intensely during the day and studying with equal intensity by night. Practicing the utmost frugality, he saved enough money to follow through on his grand enterprise.

In the spring of 1918, Father traveled to Beijing, and lived there for two weeks, during which time he sat for the entrance exam to Peking University and awaited the results.

Peking University announced the results of its annual entrance

exam in wall posters on the main administrative building on campus. The lucky ones would find their names handwritten in elegant calligraphy on the posters.

On the day of the announcement, an anxious and nervous crowd gathered at the site before dawn. The tension in the air was palpable. People barely spoke. Silence reigned.

As the posters were tacked up on the wooden boards enclosed in glass cases on the wall of the administration building, the crowd surged forward, bodies pressed against each other, each person searching for his name in suspenseful silence. Those who found their names moved quickly away to inform their friends or family members who had accompanied them to the site. A successful candidate then became the center of a small island of elation, the sweet joy of success shared by everyone in his family and his tight social group.

Those who didn't find their names continued to press forward, necks craned as each new poster went up. By the time all two hundred or so lucky names were posted, the failed candidates began to drift away, accompanied by their friends and family, all sunk in dejection. Grim and tight-lipped, some wept from the anguish of their failure, a bitter disappointment after years of intense preparation.

Father made the list.

After finding his name on the poster, he didn't have anyone—or any money—to celebrate with, so he went back to his cheap hostel and lay down in his bunk bed. The tension of the past year began to dissipate, and he drifted off to sleep.

When he woke up, his body was on fire. His head ached. Drenched in sweat, he tried to get up, but his legs were wobbly and the world seemed to be spinning around him. He lay down again and passed out.

When he woke up, he found himself in a room dimly lit by two oil lamps. One wall of the room was covered with dark lacquered

drawers from floor to ceiling. Not far from the wall stood a long counter with a scale, a pile of packaging paper, and one oil lamp providing a faint light. He was lying on a bed in the middle of the room next to a chair and a side table, where a second oil lamp provided more light. A bespectacled old man stood next to him, smiling.

"I am Dr. Song," the old man announced as Father struggled to have a clear view of him. "I've been treating you for the past two days—since the owner of your hostel brought you here. You were comatose, but herbs and acupuncture are restoring you to life."

Only then did Father realize that he was naked except for a small towel covering his pubic region. Scores of acupuncture needles stood out on his body like a forest of shiny little metal trees. The bespectacled herbal doctor was still twirling some of the needles intermittently.

The doctor told father that his channels of energy, his meridians, were almost blocked by toxins accumulated over a long period of tension, malnutrition, and overexertion. The doctor applied acupuncture to most of Father's acupoints in order to clear the channels so that his *qi* (energy, sometimes romanized as "chi") could circulate again.

"When you were brought in, your life was hanging by a thread," the doctor told him. "What have you been doing to yourself?"

In a feeble voice, Father briefly recounted for the doctor his struggle as a rickshaw boy while he prepared for Peking University's entrance exam, eating nothing beyond millet and pickles for the past year. When the doctor found out that father had passed the entrance exam, he announced to his staff that they had in their midst a *zhuang-yuan* of the new age.

Zhuang-yuan was the title awarded to a person who earned the top honor in the ultimate civil exam for the *jin-shi* degree during all of the imperial dynasties. Part of the award given to a *zhuang-yuan*

was a daughter of the emperor. So, in the old days, a *zhuang-yuan* automatically joined the imperial family to become a son-in-law of the emperor. In addition, he would be appointed to a senior ministerial-level position in the government, with the greatest prestige and a generous remuneration.

After properly complimenting Father, Dr. Song started removing the acupuncture needles and ordered chicken soup for him.

Father had never tasted chicken soup before. It was far too precious and expensive for anyone of peasant stock. The first mouthful sent sparks through all of his olfactory and gustatory neural pathways, like a Christmas tree with all of its lights suddenly turned on and flashing in unison.

"I never knew that food could taste that good," he told me decades later. The experience gave new meanings to the words of Confucius, which he had learned a long time ago in school:

民　以　吃　為　天

Min　yi　chi　wei　tain

People consider eating as heaven.

"Food is heavenly!"

Chicken soup is a restorative and nourishing cure-all in Chinese folklore. It is always made with the entire bird, preferably a full-grown, mature hen, including the head, tail, claws, liver, and gizzard, freshly killed for the purpose. People believed that freshly made chicken soup, if one could afford it, restored health and strength to a convalescent patient.

After recovering from his ordeal, Father attended Peking University and started earning money from side jobs. At first, he showered Dr. Song with dozens of gifts. But he soon forgot the man who had saved his life as he moved on to pursue other goals.

He was a possessed man, always on the go. Anything extraneous

to his immediate objectives was likely to be cast aside. To him, life was nothing but a series of goals to be pursued relentlessly with single-minded determination.

<hr>

The saga of my father's determined efforts to gain admission to Peking University is the only episode of his early life that he saw fit to relate to me. At the time he told me his version of the story, we had reached a period of rapprochement in our difficult relationship. I had sat for the entrance exam to the most prestigious Chinese high school in Hong Kong, Pei-Zhen, and won admission. Father was pleased and rewarded me with the tale of the most significant struggle in his youth. He said that his struggle opened doors that were otherwise closed to the peasantry and changed his life.

Yet many years later I found that my father's story, inspiring and stirring as it was, had been severely edited. While Father's ambition and determination—and the obstacles he'd overcome—were accurately rendered, an important facet had also been omitted.

When Father had decided to pursue his dream of studying at Peking University, the disapproval of his parents and village was due to more than their belief in his overreaching.

By that time, Father had sired two young daughters with his "village wife," the girl taken in by my grandparents as father's future wife when he was ten. The young daughters lived in the village with their mother in my grandparents' hovel. Everyone in the clan and the village expected Father to begin supporting his daughters, if not his clan, once the opportunity of a well-paid job became available after his graduation from high school. In their view, Father's refusal to shoulder his responsibilities was damning, if not criminal.

By sticking to his plan, he not only gave up an opportunity to provide for his parents, but also abrogated his manly duties to care

for his village wife and daughters. His parents came perilously close to disowning him, calling him an unfilial, irresponsible, and prodigal son, inflicting upon him the worst possible shame and rebuke.

Father's insistence on pursuing his ambition amounted to a sacrilegious rebellion against his family and traditional values. The gravity of disobeying his parents' sensible wishes could not have escaped him. His disobedience was particularly offensive in view of the fact that his parents never mistreated him. On the contrary, they favored him among all of their children and supported his infant daughters while making it possible for him to pursue a valuable secondary education. I often wondered what else, besides ambition, gave him the strength and courage to defy China's millennia-old tradition and rebel against his parents.

In his version of the conflict with his grandparents and their fellow villagers, Father claimed that he intended to support his parents all along, and that the only disagreement he had with them was an issue of timing. They expected him to send money to them immediately after high school. He wanted to wait until he made it to Peking University.

But in all our time and conversations together after I became an independent adult, he never, ever mentioned his village wife or the daughters he sired with her. I learned about them more than three decades later from Mother. During one of my academic research trips to Beijing, I arranged to meet my half-sisters and spoke with them at length. They adored their father even though he had abandoned them.

After entering Peking University, Father never again set foot in his Shandong village, not even for a visit. Beyond sending plenty of money to his parents, he completely erased from his mind his village wife, their two daughters, and his rural roots. He never saw his daughters, never wrote to them, never inquired after them until he was well in his eighties. By that time, they had endured unspeakable

agonies at the hands of the Communists in addition to being banished to the banks of the Amur River on the Sino-Russian border. No one knew what drove Father to seek out his old village wife and those two daughters toward the end of his life. Before venturing to the Amur River, he had been living alone in Hong Kong for almost forty years. Could it be his failed relationships with Mother and their six children? Was it a feeling of guilt as death began to loom large in old age? I don't know; I never will.

———————

Mother and Father had met in Beijing through Aunt Helen, who was working for the Nationalist Party in Beijing. She brought Mother, her younger sister, to the city, where the two of them hoped to pursue university studies. Prior to this, Mother had been educated in a missionary school near her Shandong village, which happened to be not far from Father's. Their first conversation, when they met at a social event sponsored by the Nationalist Party of Beijing, was predictably centered on this similarity.

"Oh, you're from Shandong? I am also!"

"Really? How extraordinary. How long have you been in Beijing?"

It was love at first sight for both halves of the handsome young couple. Three weeks after their first meeting, they were married, privately, without involving either family—a monstrously rebellious act by both. By then, Father had renounced his village wife in his own mind with the justification that his union with her was merely a feudal arrangement, not his choice.

It was 1919, only eight years after the last dynasty had been abolished in China. Renouncing arranged marriage, emulating Europeans, falling in love, getting married in simple civil ceremonies, without fanfare or elaborate celebrations, advocating democracy and promoting liberalism—these were the fashionable things to do among the young educated elite of Beijing at that time. Interest-

ingly, and almost without fail, after a short burst of youthful rebel-
lion, these future leaders of China reverted to the old conservative
Confucian system of values. They might have repudiated certain
traditional practices such as arranged marriages and the binding of
women's feet, but their overall mentality remained firmly rooted in
the Confucian framework. Whether they became Communists like
Mao Ze-dong or anticommunists like Chiang Kai-shek, eventually
they all returned to the center, striving for autocratic rule and hav-
ing no regard for the autonomy of the individual.

Father, my mother would later find to her regret, was no excep-
tion.

While at Peking University, Father was driven to excel academi-
cally. Other than their three-week courtship and his necessary job
as a part-time high school teacher, he devoted all of his time to his
academic endeavors. That was the only way of life he knew: always
determined, always in quest for conventional success. He never
changed, even when he became old and the prospect of any conven-
tional success was clearly out of reach.

Secretly, Mother questioned the merits of his single-mindedness.
Coming from a pious Christian family, she never subscribed to the
belief that life was exclusively the pursuit of conventional success
on earth. There was a spiritual side to her that Father did not share.
He belittled her for it. To him, religion, especially Christianity, was
merely a human invention that placed undue emphasis on an after-
life. He preferred *this* life.

Toward the end of his first year at Peking University, a few months
before he met and married Mother, Father was profoundly influ-
enced by the May Fourth Movement, a student-led political move-
ment that metamorphosed into the only true cultural revolution in
the history of China.

In early 1919, the victorious nations of World War I convened the

Paris Peace Conference. (China was included among the victorious nations, not because of its war efforts, but because of its correct alliance.) At the Conference, the representatives of China urged the conferees to renounce colonial privileges in China in accordance with the ideals of self-determination promoted by President Woodrow Wilson. But England, France, and Japan, the dominant colonial powers in Asia, brushed aside the Chinese position and rejected Wilson's ideals. The Chinese government was powerless to fight back.

On May Fourth, thousands of students in Beijing poured into the streets to protest what their government had failed to accomplish at the Paris Peace Conference. They congregated at the famous Tiananmen Square in a demonstration against colonialism, as well as against the ineptitude of their own government. Their protest ignited a spontaneous explosion of patriotic response across the nation. Students and workers in all major cities went on strike to show their support of the protest in Beijing. They demanded fundamental reform of the government and the abolishment of the foreigners' privileges in China, which included immunity in Chinese courts. It was a momentous event for the nation after nearly a century of relentless subjugation by colonial powers.

Strikes and demonstrations notwithstanding, power politics prevailed. Extraterritorial privileges and colonial exploitation of China continued, yet the failed political battle at the international level signaled a democratic awakening of students and workers within the nation. They realized that if they were to stand up against the great powers of the West, they had to reform and modernize their own feudal country. Thus the leaders of the May Fourth Movement decided to begin the modernization effort with a cultural revolution.

One of their first efforts was the abolishment of the use of the fossilized Classical Chinese as the country's written language. Classical Chinese was based on Confucian texts from the fifth century B.C., and was so unrelated to any currently spoken Chinese

dialect that it created an enormous barrier to literacy. Instead of Classical Chinese, the leaders of the May Fourth Movement established a vernacular written language based on Beijing's spoken language, Mandarin. This vernacular language made it possible to introduce a national educational system to combat illiteracy and ushered in an unprecedented burst of literary creativity.

Like most of his educated contemporaries, Father was swept up by the May Fourth Movement and was subsequently determined to participate in the modernization of the nation. He wanted to study abroad after graduating from Peking University in order to learn firsthand from developed nations such as Japan and England. He was preparing himself to be a political leader. In this way, May Fourth shaped the goals of his life.

At Peking University, Father garnered recognition after recognition for his scholarly achievement. After graduation, he won a fellowship to pursue postgraduate studies at the law faculty of the Imperial University in Tokyo, now called Tokyo University. Two years later, while still in Japan, he won another prestigious postgraduate fellowship to further his research in international law at Oxford University.

Mother followed him to both Japan and England. While in England, they had their first child, whom they named Huai-yin, or "Remembrance of England." She was my oldest sister, who attended medical school while I roamed the slum of Nanjing.

I learned about Father's life at Oxford more than fifty years after he studied there, purely by chance. It was an exceptional and highly improbable event that took place in California.

Stepping into a van that shuttled faculty and university guests between the Los Angeles and the Santa Barbara campuses of the University of California one afternoon, I found myself sitting next to an elderly couple, properly dressed, impeccably mannered and

judiciously reserved. I was in my casual California outfit of blue jeans, polo shirt, and jogging shoes.

As a courtesy, the elderly couple and I exchanged greetings.

They were Professor and Mrs. Nibblet from England, as quintessentially English as anyone could be in their demeanor, speech, and name. As the van sped along the coast of southern California, we warmed up a bit toward each other and exchanged our names.

At one point Professor Nibblet remarked, ever so politely, "May I ask if you are of Chinese ancestry?"

"Yes," I told him. "I was born in China, grew up there, and didn't come to the United States until I was twenty-one years of age."

"My goodness! Your English doesn't show any trace of a non-native speaker. Very impressive indeed!"

I had barely thanked him when Professor Nibblet offered an explanation for his spontaneous compliment.

"In the 1920s, I was assigned to be the English tutor of a graduate student from China. His name was also Li. Lacking your linguistic talent, he struggled mightily with English pronunciation. Meeting you made me think about him."

"Ah . . . but Li is a very common surname in China," I said without too much interest. "There are probably ten million Li's." I reckoned that this was probably a conservative estimate.

"If my memory does not fail me, I am pretty certain his name is Sheng-wu Li," Professor Nibblet said. He grimaced. "Please pardon me for my inadequate Chinese pronunciation."

It was shocking to hear Father's name mentioned by a stranger from England in California. It couldn't be, I thought. How was it possible that I ran into father's English tutor on a University of California commuter van fifty years after they interacted with each other in England? The probability had to be close to zero.

"Was this student of yours a lanky fellow with a big head—approximately six feet tall—from Shandong Province in northern China?"

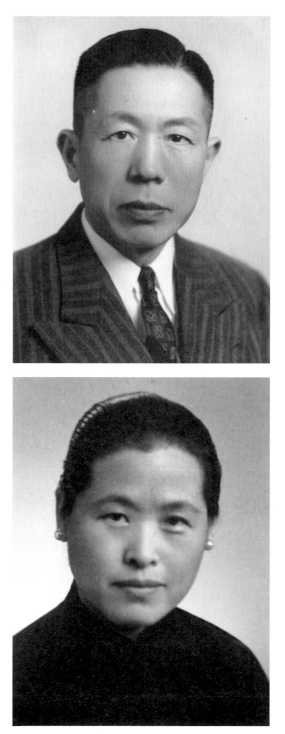

Father at age fifty-four,
in Hong Kong.

Mother at age forty-seven,
in Hong Kong.

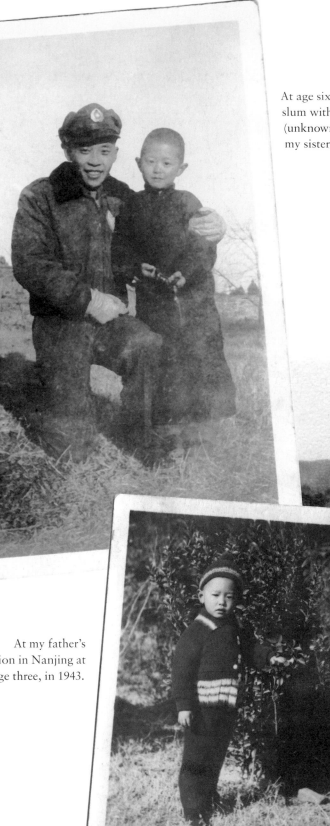

At age six, in the Nanjing
slum with an air force pilot
(unknown suitor of one of
my sisters), in 1946.

At my father's
mansion in Nanjing at
age three, in 1943.

In the slum of Nanjing with some of my gang of friends. The second-smallest, with the huge grin, I was six years old in 1946.

The house my father, mother, and I shared with four other families in Shatin, in the New Territories of Hong Kong, from 1950 to 1955.

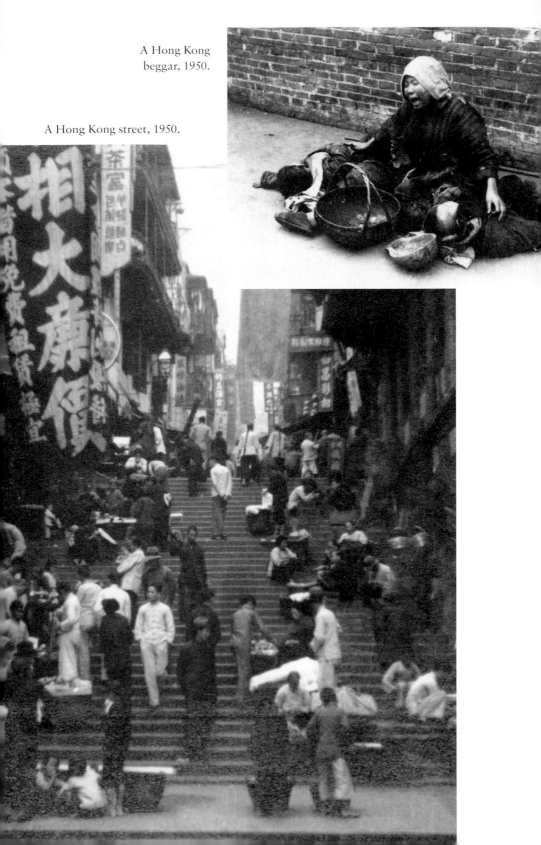

A Hong Kong beggar, 1950.

A Hong Kong street, 1950.

Shatin in Hong Kong's New Territories in the early 1950s. I often went exploring there.

A village in Shatin, early 1950s.

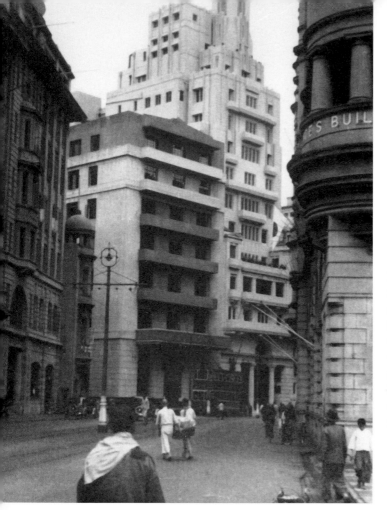

Downtown Hong Kong in 1951. On the right is the Swire Building. Swire is the company that nowadays owns Cathay Pacific Airways, among other assets. It was the preeminent colonial business entity in British Hong Kong.

Chinese coolies toiling in Hong Kong's streets.

Taking a hike in Kowloon, Hong Kong, with Father, who was giving me lessons in politics, 1956.

On a graduation outing of my high school class in 1957. I am on the left. The classmate in the middle is Daniel Chui, who would win the Nobel Prize in physics in 1998.

Receiving the trophy for first prize in an open oratorical contest from the wife of the British minister of education of Hong Kong in 1960.

Winning the 100-meter sprint at Chung Chi College at age twenty, in 1960.

"Yes, yes," Nibblet said, with the gentle enthusiasm that is so typical of a man of his background. "Your description is quite on the mark. I believe he was born in Shandong, though I am not certain. He came to Oxford from Peking University via Tokyo."

"This is unbelievable!" I nearly yelled. "That student of yours is my father. And you are his tutor at Oxford University in the mid-1920s?"

"Well, what a splendid happenstance! I am delighted." Nibblet was clearly on the brink of fully displaying his emotion: he was smiling.

"I don't mean to cast any aspersions on your father," he added. "He simply had a very difficult time with English phonetics."

"I know," I said wryly. "He has a hard time with the phonetics of any language beyond his native Shandong dialect. He's spoken Mandarin with a Shandong accent all his life. He has also lived in Hong Kong for more than thirty years and still cannot speak Cantonese."

Nibblet chuckled appreciatively.

While we both marveled at our improbable and inadvertent encounter, I quickly steered our conversation back toward Father and his time in England. I asked question after question, and Nibblet took pleasure in reminiscing about Father and their interactions.

"We had many interesting and sometimes heated discussions at Oxford on issues that separated the East and the West," he told me.

In my father's view, Nibblet said, democracy was the key to the success of the West. He felt strongly that China had to adopt a democratic political system if it hoped to become a modern nation.

But he didn't find everything in the Western society embraceable. In particular, the Western attitude toward human relationships disturbed him. It seemed to him that Westerners who were related by family ties nevertheless showed very little commitment toward one another.

"Even among family members and close friends," he told Nibblet, "there is a clear distance and psychological separation. For example, here in England, members of an immediate family often borrow money from each other." In my father's view, such financial transactions should be limited strictly to the world of business; it was, for him, completely alien to the sphere of the family.

"I can only infer from this that money means more than family ties and friendship in the West."

Nibblet explained to him that the practice of loaning money among family members did not desecrate family relationships. It was merely a reflection of the desire to foster individual independence.

Father objected. "Now you're making a sophist argument. It's just a clever turn of phrase without any substance."

To Father, the idea of being independent of one's family was oxymoronic. To be independent of one's close friends, if they were *real* friends, not the superficial type he observed in the West, was just as far-fetched in his mind. A family or a true friend was precisely what one should depend on in life. In fact, mutual dependency validated relationships, which in turn provided psychological and emotional security beyond materialistic support. To an Asian steeped in Confucian philosophy, the struggle for conventional success is meaningful mostly because it is for the collective good—for the benefit of his inner social group, which could be a nuclear family, an extended family or a clan, a coterie of devoted friends, or any combination of the above.

Father's view, as expressed eighty years ago to his English tutor, remains valid in the minds of the vast majority of Asians today. To a traditional Oriental mind, if one has to borrow money from a kin or a close friend, then the relationship is no longer kinship or "close friendship." It has become a business relationship.

Father confessed to Nibblet that he did not believe Westerners cultivated or truly valued human relationships. Genuine friendship

in the West did not exist. That was why a Chinese could never feel at home in a Western society.

Nibblet agreed that the East was different from the West, and conceded that in the East human relationships were the foundation of its culture, whereas in the West individualism ruled supreme. But he continued to disagree with Father's conclusion that Westerners did not care about family ties or friendship.

Try as he might—and he did try—Father could not comprehend Nibblet's argument. He was convinced that the West, in creating a society where individual endeavor was the supreme goal, had relegated all human relationships to trivial pursuits.

Professor Nibblet's account of his debate with Father touched me deeply, because the issues he and Father discussed were identical to those I had to grapple with upon my arrival in America in 1961. For an East Asian, the Western world is lonely, harsh, and unforgiving. Stripped of the interdependent relationships that served as his emotional and psychological anchor, an East Asian in the West feels as if he has been cast adrift in the ocean.

I pointed out to Nibblet that "individualism," in its Chinese translation, conveys a negative implication of self-centeredness and selfishness. It is probably the key philosophical concept that separates the East from the West, with profound implications for the psychology, behavior, and worldview of the people of both worlds.

Professor Nibblet laid open for me a whole new understanding of my father in the years when his ideology was still forming.

According to Nibblet, Father studied diligently at Oxford while remaining actively and wholeheartedly engaged in political debates among overseas Chinese students. During the 1920s, those students in England formed rival factions within the Nationalist Party, mirroring the schism plaguing the party back in China. The factions took each other on in fierce debates and polemical essays.

He despised communism. To him, the Bolsheviks were lunatics agitating for chaos and nihilism, and the Chinese Communists were nothing more than lowbrow rabble-rousers trying to emulate the Bolshevik hooligans. He was fond of telling his British colleagues that Chairman Mao didn't possess the smarts to gain admission to Peking University, noting smugly that Mao worked as a clerk in the university library for several years in order to satisfy his yearning for some kind of association with that hallowed institution.

He was equally contemptuous of the military wing of the Nationalist Party. In his opinion the Nationalist Party would be doomed under the leadership of a soldier like Chiang Kai-shek, who was, in his words, "at best, inane and insipid, and at worst, corrupt and pernicious." He wanted a highly educated leader who spoke and wrote eloquently. Wang Jing-wei, a man of letters, a charismatic orator, and a hero of the democratic revolution against the Manchu dynasty, fit Father's ideal. At the time, Wang Jing-wei was vying with Chiang for control of the Nationalist Party. Father sided with Wang and became his loyal supporter.

The political battle ultimately caused Father to return to China just before he completed his doctoral dissertation. He rushed back to help organize the intelligentsia to take control of the Nationalist Party. There was no time to waste, he felt. By then his belief that "power comes from the fountain pen" had already crystallized into a central theme of his political philosophy.

When Father returned to China in the late 1920s, he was uniquely qualified for success. Few people in China possessed his qualifications and educational background. He became deputy chief editor of the Commercial Press, one of only two publishing houses that monopolized all publications in China. He edited the most influential political journal, *Dong-fang Za-zhi*, or *The Eastern Journal*. He wrote books, editorials, and political commentaries. He lectured at public forums and universities, garnered honors

and recognition. In short, he was a rising star on the national scene.

In the early thirties, only a few years after his return from England, Wang Jing-wei, the prime minister and acting foreign minister of the Nationalist government (while Chiang headed the army), invited Father to join the government as deputy foreign minister. Since Father already greatly admired Wang, he accepted the invitation without any reservations.

Thus began Father's political career and his close association with Wang's faction of the Nationalist Party until the end of World War II, when Chiang Kai-shek's branch of the party seized control and he landed in prison as a traitor. Wang was "lucky" enough to die of natural causes in 1944, one year before the end of the war. His status as a traitor in China was sealed, permanently, when the government of Japan ordered all of its citizens to wear a black armband for one day to commemorate his death.

In 1948, as the Communist forces approached Nanjing, the capital of the Nationalist government, where Father was imprisoned, Chaing Kai-shek ordered Father's release in consideration of their shared, lifelong anticommunist stance. Given his politics, Father wisely moved to Hong Kong with Mother to avoid being captured by the Communists.

At the time, I was living in Shanghai with Aunt Helen, oblivious and content.

———

Living in obscurity in the British colony of Hong Kong was the nadir of Father's political life. At first he harbored grandiose dreams that his exile in Hong Kong would be a brief interlude, that the Communist regime in China would shortly collapse, that the Americans might jettison Chiang Kai-shek in Taiwan. He told Mother that the cold war between the Western alliance and the Soviet bloc might escalate into a Third World War, following which a new

China with its hundreds of millions of people would rise from the ashes of a nuclear nightmare to become a powerful nation. In the meantime, he was waiting in the wings for another opportunity in politics while firing volleys from his fountain pen into every part of the media.

As the years went by, the Communists solidified their rule on the mainland, World War III did not materialize, and the Americans refused to open up the Pandora's box of a regime change in Taiwan. Father's dream remained just that: a dream.

Hong Kong turned out to be his final destination. He remained there for the last forty years of his life.

When I joined him and Mother in 1950, he still did not fully accept the dramatic reversal of his fortunes. Angry and bitter, he couldn't understand why he was not called upon to assume the reins of power, for which, in his opinion, he was uniquely qualified.

When he compared himself to Chairman Mao and Generalissimo Chiang Kai-shek, he was the only one who had passed those difficult exams. He was the one who prevailed in all those scholarly competitions. He was the only one who wrote elegantly in both Chinese and English. Yet Mao and Chiang took center stage, while he languished in the political wilderness!

He tried hard to resurrect his career. He wined and dined everyone who had any connection to America or England: academics, journalists, CIA operatives, missionaries, and minor dignitaries passing through Hong Kong. He wrote letters to the American president, Dwight Eisenhower, and his secretary of state, John Foster Dulles, offering his analysis of the political situation in East Asia, hoping to impress them and catch their attention. He published article after article sounding alarms on the political instability of China and the need for regime change in Taiwan. He spent all of his money supporting a coterie of old cronies who shared his political ambitions—and stroked his ego.

But none of it worked. The world had changed. Distinguishing oneself in examinations no longer paved one's way to high office as it had in traditional China.

Power no longer came from the fountain pen, if it ever did at all!

But lest his life look too bleak by comparison, Father had never hesitated to sacrifice our family for his ambitions. Many decades later I learned from Mother that while we struggled on a starvation diet in the Nanjing slum in 1946, Father had more than $25,000 in American Express traveler's checks that had escaped the search by Chiang Kai-shek's secret police. It was a fortune by the standards of the time in China, but he forbade Mother to spend any of that money because it was a start-up fund for his political comeback once he got out of jail.

It was in the slum of Nanjing in 1946, while Mother secretly guarded that small fortune of $25,000, that one of my sisters contracted tuberculosis because of malnutrition. Another sister nearly died of rheumatic fever because Mother didn't dare use any of Father's "political fund" for medical assistance. I remember Mother arriving at our single-room home after carrying my sister—piggyback style—from her school more than two miles away, her veins protruding hideously from her legs because of the strain of the long trek under the burden of my sister's weight. Both were drenched in sweat: Mother, from the physical strain of carrying Sister; and Sister, from her near fatal rheumatic fever, which permanently weakened her heart.

Being much older than I was, the two siblings (my elder brother and elder sister number four) with whom I shared a room in Hong Kong left home within a year after my arrival in September 1950. Even though they were many years my senior, their youth and inexperience made it hard for them to earn a living for themselves.

Because of what he deemed his "period of hardship" in Hong Kong, Father refused to support or provide for his children. The "hardship" that he spoke of at every opportunity was, of course, his doomed mission to launch a personal political comeback. It is ironic that the ideals of family devotion and greater communal good that sounded so lofty and virtuous in his debates with Professor Nibblet were the same that made him feel entitled to use his family to advance himself. On one occasion he tried to push my youngest sister into a marriage with the scion of a rich Hong Kong family in order to gain political connections. That was the final straw that drove her to seek an education in the Philippines.

My oldest sister, Huai-yin, whose name was "Remembrance of England," dropped out of medical school to marry an air force pilot in 1947 while Father was still languishing in prison. She took my third sister, Kathy, with her to Taiwan. At age eighteen, lacking options, Kathy married a man twenty years her senior. He died tragically in a plane accident one year later, leaving her with a newborn daughter who is now a distinguished molecular biologist in the United States.

My second elder sister, Dora, went to work as a sales clerk in Hong Kong while struggling with tuberculosis. Father not only refused to send her to a sanatorium, but also seized her salary with the justification that she lived at *his* home. To extricate herself from Father's control, she quickly married an accountant who could provide her with financial security. Unfortunately, the man was dull and spineless. When she later regained her health and discovered love and passion, the marriage broke up, with bad feelings on both sides.

My brother went to Taiwan immediately after high school to join our two elder sisters who had settled there. He became an engineer.

Huai-yin thought she had found financial security when she left her young children and fighter-pilot husband in Taiwan to marry

an American military officer of the U.S. Military Advisory Group in Taiwan. Shortly after the wedding, however, her husband was transferred from his potentate position in Taiwan to a military base in southern California, where he toiled at a career-ending mid-level desk job. He turned alcoholic, and physically abusive.

Cultural shock, an abusive husband, the banality of life on a military base, and an awakening sense of guilt for having deserted her young children from her previous marriage pushed her into the abyss of mental illness. She spent the rest of her life shuffling into and out of mental asylums in California.

I visited her once during one of her brief hiatuses from schizophrenia. Death, she told me, would be a welcome relief. By the time it finally claimed her, at age sixty-one, she had been waiting for it for some thirty years.

7

TEEN YEARS IN HONG KONG

DURING THE FIRST COUPLE OF MONTHS AFTER my expulsion from school in 1950, Father didn't know what to do with me. He tried humiliation, denying me food, and physical punishment. I responded by escaping to the hills of Hong Kong's New Territories.

At ten years of age, I dreamed of following my siblings in leaving home, a fantasy that was fueled by my wanderings in the pristine mountains. I didn't yet understand the travails of earning a living, and my dream of leaving home was driven mostly by a desire to stay out of Father's reach. But being away from him did not always bring peace, despite the enchantment of Hong Kong's New Territories. I was beset with fears—fears that bordered on phobias.

Darkness frightened me. According to local superstitions, ghosts emerged from the nether world in darkness to exact revenge on those who had wronged them in their previous life. Legend had it that they also liked to punish those who had misbehaved. Having

been expelled from school and ostracized by my parents, I was sure that I would be a prime target for visitation by ghosts.

Every evening, as darkness crept over the earth, an excruciating battle against this fear consumed me. I would pull blankets over my head and tuck them tightly around my body as though they would shield me from evil spirits. "Be brave, be brave," I would mutter to myself through chattering teeth every night until, utterly exhausted, I collapsed into sleep.

But even sleep did not always provide relief, as I was often haunted by a recurring nightmare in which I tried to outrun an enormous boulder that was bearing down on me at an increasing speed. Just as it was about to flatten me, I would scream in despair. Woken up by my own scream, I found myself drenched in sweat. Even though I needed sleep desperately, I fought to keep my eyes open for fear of the return of the boulder.

I often slept during the day in the mountains, where daylight made me feel safer. There were no ghosts, no Father, no bullies. Hiking had not yet come into vogue in the 1950s, and people didn't wander into the mountains in those day. To most people in Hong Kong, venturing into the wilderness was, at best, foolish and dangerous.

To me, the mountains were a refuge. Unmolested and unspoiled by human presence, the plants, animals, and streams of the mountains soothed my frayed nerves and allayed my fear.

Hidden among the uncharted valleys and slopes were enchanting cascades and crashing waterfalls, vernal pools and gurgling brooks, "hanging-bell flowers" (fuchsia) and dazzling azaleas, vermillion birds and iridescent cichlid fishes, fragrant pines and uncluttered bamboo groves.

I learned to swim in the natural pools of mountain streams, progressing from paddling with all four limbs, like a dog, to breaststroke, like a frog. After gaining confidence in the water, I loved to explore deep water holes. They were home to small cichlid fishes,

dark crayfishes, and black, beetlelike water bugs. The cichlids tended to stay in small schools of five or six. They flitted away as I approached them. Crayfish moved gently in rocky crevices, their slender claws leading the way. They were always scavenging. A water bug, ink-black, scuttled like a miniature submarine with all of its legs paddling furiously. Under the water, it was eerily quiet, apart from the muffled sound of water flowing into the pool. I felt like a visiting giant, escaping from the outside world for as long as I could hold my breath.

When hunger made its presence felt—as it often did, since Father was habitually withholding food from me as punishment at the time—I fed on wild berries of a type that I have never seen outside those mountains. Purplish and fuzzy, they grew on small shrubs and tasted mildly sweet and juicy. I always ate my fill, even though they gave me diarrhea from time to time.

Sometimes, driven by hunger pangs, I would steal from orchards belonging to villagers. Papayas were my favorite. Spotting a ripe yellow papaya from a distance, I would crawl on my stomach toward it to avoid detection. At the tree, I always lay still on the ground for a minute or two to make sure that no one was watching, while my heart pounded against the dirt under me from the excitement of a pending feast, as well as from the fear of being caught. In those days, a poor farmer in a mountain village would not hesitate to cripple or maim a thief. I was well aware of the risks of stealing. But I was also cocky, because I knew I was exceptionally fast on my feet since my days in the slum.

This same cockiness almost got me killed once. Lured by a large ripe papaya hanging under the crown of a short tree, I failed to notice a farmer hidden in the shade of a nearby large mango tree as I approached the papaya. Dashing out of the darkness of the tree shade, no more than a few yards away, he came after me with a knife in hand. Handicapped by the large papaya in my hands, I was running much slower than usual. The sound of his approaching

footsteps told me that he was gaining on me. Panicked, I turned to throw the papaya at him. In response, he lunged at me with his knife just as I started to take off again. The tip of his blade caught me on the back of my right thigh and inflicted a long gash as he fell to the ground from his lunge. I escaped to my favorite mountain stream where I washed my wound and dried it in the sun; luckily it was not deep. That incident curtailed my desire for stealing food for many weeks.

Now and then in the mountains I ran into a collector of medicinal herbs. It was always the noise of the collector crashing through the bush that alerted me to his presence. Once we noticed each other, we would stop in our paths, look at each other from a distance, and then move on. No word was ever exchanged. From observing the herb collectors, I learned to carry a stick to ward off vipers and poke through the thickly clustered ferns to avoid falling into a hidden hole.

Through my ventures in the mountains, I developed an inordinate affection for feral dogs and cats. I would find them scavenging in the vicinity of villages. They were scrawny, my buddies. I liked petting them. In return, they licked me and followed me around. When I was stealing fruit from an orchard, their sharp sensory perception protected me. They could detect an approaching human or animal long before I saw or heard anything: their body language signaled me, when necessary, to run away.

From feral dogs and cats, my naïve sentiments and affections extended toward all animals that weren't slithering reptiles; so much so that if I heard a cat meowing in the night, I had to venture into the dark to look for it, even though darkness and ghosts frightened me to no end.

Occasionally a tiger visited the mountains. A half-eaten water buffalo belonging to a remote mountain village served as the tiger's calling card. I always got very excited by the news and tried to find the giant cat in the mountain where the buffalo carcass was found.

I was confident that it would befriend me, and that with a tiger as my friend I would no longer have anything or anyone to fear!

———

Several months after my expulsion from school, Father came up with the idea of home-schooling me for the remainder of the academic year. One evening, before I went to bed, he told me, "From now on, every week you will study an essay or a book I assign to you. In addition you will have to write an essay on some topic related to what you have studied."

A few moments later, he added, "Your mother will also teach you English."

I liked the home-school arrangement, mostly because Father let me do my studying and writing in the garden. By then he was so accustomed to not having me around his tiny living quarters that as long as I completed my assignment, he didn't care where I went. Even on my best behavior, I was probably a nuisance, on account of my incapacity to sit still for long.

He chose a regimen of studying and writing for me probably because by then he knew that I lacked the patience to listen. In fact, I not only lacked patience but also found it difficult to concentrate on any task continuously for more than half an hour. I preferred to be on my feet, moving about and seeking as much stimulation as possible. If attention deficit disorder had been known then, I might have been diagnosed as a severe case, made to take all sorts of sedative medicine, and ended up mentally damaged.

Being permitted to study in the garden turned out to be the best remedy for my restlessness and excessive energy. There, no one scolded me for interrupting my study to follow a trail of ants, watch a praying mantis ambush its prey, examine the enormous leaf of a tropical plant, or take a nap on the forking branches of the giant oriental magnolia tree while inhaling the sweet scent of its flowers. Interruptions did not diminish the quality of my study or interfere

with my capacity for memorization. Not only did I do my work in the garden, I did it well enough to impress both Mother and Father.

During that first year in Hong Kong, from 1950 to 1951, I had little contact with other children. At first, my isolation was due to the language barrier. After learning Cantonese and struggling to adapt to a new environment once again, I remained an outsider. The local children never accepted me as one of them. It didn't matter how native my Cantonese sounded; I didn't look like the Cantonese, because I lacked their Polynesian features. In the eyes of the locals, I was barely a notch better than the untouchable foreign devils, the British, who were viewed by most Hong Kong Chinese as a hairy, pink people reeking of a hideous body odor. That was why Chinese called them "devils."

As for my difference from the local children, nobody explained to me about the great divide between northern and southern China. Most northerners look Mongolian owing to millennia of mixing between the native Chinese and the nomadic pastoralists of the northern steppes, whereas most southerners show traces of Polynesian, Mon-Khmer, Thai-Kadai, and Hmong-Mien features from centuries of intermarriage between the southward-expanding Chinese and the indigenous populations they encountered.

Apart from my northern features, which separated me from the local children, Father contributed his share in preventing me from having friends and companions. He thought of himself, and therefore his family, as superior to the "short and dark native country bumpkins" of Hong Kong. Whenever he saw me in the company of local children, he glowered, as if to say, "Why in the world are you mingling with the riffraff?" I would feel a flush of shame and slink away in embarrassment. Of course, I was never allowed to invite anyone home or go anywhere with another kid.

By the end of the academic year, after nine months of homeschooling me, Father decided I was ready for a regular school again.

When the new school year began, he sent me to restart seventh grade, albeit at a different middle school. I was almost twelve years old.

School did not appeal to me. If I had to study, the garden suited me better. I preferred plants and animals to people in the school. Plants and animals didn't make demands, pass judgments, or scheme to humiliate me, as my schoolmates and teachers did.

But food provided a strong inducement for me to stay in school and do well. By then Father was allowing me to eat regularly because my performance during home school had met his standards, and I did not relish returning to the days of clenching hunger pangs.

In school, I took a perverse sense of pleasure in beating my fellow students at scholastic competitions. I wanted to win, and liked winning, but I liked seeing my classmates lose even more. For me, the pleasure of school came not so much from learning as it did from fighting an imaginary battle on the academic front and inflicting defeat upon others.

It was not particularly difficult for me to excel academically. Father had trained me assiduously with weekly reading and writing assignments. Mathematics and science seemed so logical and sensible that they eased into my brain all by themselves. Mother, who had picked up impeccable English when she lived in England with Father, had taught me so well that I could barely refrain from correcting my school teacher's cacophonic accent and mangled renditions of English sentences.

But I took no pride in my academic success. Performing well in school was a job, an obligation demanded by Father. I never brought him my papers with the expectation that he would glow with pride at my accomplishments; I never expected praise from him, and he never offered any. He and I didn't sign a contract, but we might just as well have had one: I performed academically and he provided

food and shelter. It was an unspoken agreement, and it formed the backbone of our relationship.

———————

Three years of my life passed this way. I continued to perform well in school, and to escape on weekends to the mountain wilderness. Father and I continued in our distant, contractual relationship. My brother and elder sister number four had already left, so it was just him, me, and Mother. My memory of those years are dominated by loneliness.

Conversations between Mother and me were also rare, so when she came into my room one late afternoon looking very serious but without the usual signs of delivering a reprimand, I was startled. Father hadn't come home yet.

"Son, I want to talk to you," she said. Her eyes were tender and sorrowful, which made the occasion even more unusual. Normally when Mother spoke to me, she was either transmitting or reinforcing Father's commands and rebukes. Reserved and reticent, she rarely engaged anyone in animated, personal conversation.

There were exceptions to this reserve, of course. She had spoken sharply to us several times during the hard days in the slum, and sometimes she and Father had heated vocal exchanges that could degenerate into ferocious fights, and these occurred not infrequently after I started living with them in Hong Kong in 1950. During one of their truculent confrontations, I had to restrain Father from attempting to hit Mother with his fist. Even though I was distant—almost estranged—from both of them, and felt no urge to take sides in their fight, their angry exchanges always rattled me and made me feel out of sorts.

So when Mother said, "I want to talk to you," it wasn't her words that startled me. It was her intonation and facial expression.

Those mournful eyes! They communicated a sentiment of care and sadness that I had rarely experienced from her.

"Yes, Mother," I said dutifully.

She came a little ways into my room, looked at my books on the table and my shoes set carefully next to the door. Sitting on my bed, she looked up at me, and again I was struck by the intensity of her gaze.

"I have decided to leave your father, leave this household, leave behind more than thirty years of my life," she said without any preamble. "I want to start afresh. Do you have any objection?"

Her unruffled, matter-of-fact voice conveyed her determination.

I did not think it was within my prerogative to object to what a parent wished to do. I also didn't fully grasp her meaning.

Yes, she wanted to leave, that was clear. But so much more remained unsaid, and I didn't dare to probe. After all, she had posed a question. I had to come up with an answer, or some response.

But what could I say? I was not privy to her thoughts and knew precious little about her marital relationship with Father.

After a blank moment or so, I stammered without much forethought, "No, no objections. . . . What will you do?"

"I will enter a theological seminary in Kowloon. After that, what I do is God's will."

Mother came from a religious Christian family in rural Shandong. Her parents had been converted by American missionaries and spent their life proselytizing among fellow peasants. This is how Mother's sister, Aunt Helen, who took care of me in Shanghai between 1947 and 1950, happened to commit herself to a pious life. When Mother and Father fought, Father had, on several occasions, called Mother's parents "running dogs of foreign devils."

Thus, even though Mother's announcement tumbled out like a sudden bomb, it wasn't her decision to pursue religion that sur-

prised me. I was just puzzled and confused by her "leaving," and even more so by her coming to me to make the announcement.

Did "leaving" mean divorce from Father? Did it mean that I would never see her again? I always thought Father had committed a "leaving" when he went to jail at Tiger Bridge. But Mother was entering a theological seminary voluntarily. She wasn't being sent to jail!

In extraordinary situations like this interaction between Mother and myself, question after question bubbled up in my mind all by themselves, almost against my wish. But they seemed futile and unanswerable. Even worse, they intensified my feelings of despair and helplessness.

But Mother hadn't finished her announcement.

"I have not been a good mother to you," she continued. "I hope I can make it up to you in the future."

I was struck dumb.

Her forthright self-criticism and offer of amends came from nowhere, and stirred up a storm of emotions in me. I swallowed hard, fighting back tears that filled my eyes. My arms ached to embrace her, but I just stood there, paralyzed.

Mother did not betray any disappointment, if she felt it, in my lack of response. She stood up, smoothing the plain material of the light-blue cheongsam she wore, and gave me a tiny smile.

"Well, I hope you will visit me at the seminary."

Just like that, she left.

Without a penny to her name, after thirty-some years of marriage and six children, in 1954 Mother packed a small valise, walked out of our apartment in Hong Kong's New Territories, and never saw Father again!

Much later, I learned that my mother's unhappiness dated back far earlier in her life. In Shanghai, in the late 1930s, she had attempted suicide by leaping from the third floor of her residence onto a driveway. She survived, but broke her spine and shattered

her right leg, leaving her with a limp for the rest of her life. The incident made national headlines in newspapers all over the country—and profoundly embarrassed Father, who at the time was a rising star on the national scene.

Gossip circulated in the society columns that Mr. Li's extramarital affair had caused Mrs. Li's suicide attempt.

The entire incident occurred before my birth. It was a taboo subject, one that Mother never mentioned, and Father certainly didn't talk about it. My siblings who were old enough to remember it told me only the briefest outline of what transpired.

On the day Mother left, it fell on me to deliver the bad news to Father when he came home in the evening.

"Where is your mother?" Father asked as he sat down and took off his shoes.

"She left," I responded blandly.

"What do you mean, 'left'?" Father glared at me.

"She said that she was leaving you, leaving this household, and going to a theological seminary for good."

The color drained from Father's face. He didn't ask another question nor utter another word. He just looked like he was ready to kill someone. Contorted with fury, his ashen face twitched and knotted. I imagined steam rising from his large head.

That evening I went to bed with an empty stomach. Next morning he gave me a few slices of bread and some margarine. We didn't engage in any conversation.

One week later, he told me without fanfare that we were moving out of our apartment in the New Territories to live in his office in Kowloon, the urban center across the strait from the island of Hong Kong.

Father's office occupied the second floor of a medium-sized, three-story condominium building in an upscale residential district called

Kowloon Tong. It was the editorial office of Zhong-hua Shu-ju (China Press), where he was the editor in chief, supervising four other editors, a job he had taken on one year after my arrival in Hong Kong.

The entire editorial staff worked in the spacious living room of the second-floor flat. During working hours, each editor hunched over his desk compiling dictionaries, writing commentaries, and editing magazines. Symbolically, Father occupied the biggest desk at one end of the room, from which he faced and supervised his four subordinates.

At the end of a workday, only one of them had a home to go to. The others lived in the flat. There were three bedrooms. Father had one, which he didn't use before Mother left him. An elderly man just below Father in rank, who was a superb calligrapher, occupied the second one. The two young and junior editors shared the third bedroom.

Even though Father was their supervisor, bringing a young son into the office as a permanent resident created quite an imposition on his colleagues. They expressed their resentment passive-aggressively, by ignoring me completely. In order to avoid unpleasant encounters, I had to find a place in that flat to hide after school and made myself as inconspicuous as possible on weekends.

A tiny room in the back of the flat, used as storage space provided me a surprisingly beneficial escape.

Originally intended as a bedroom for a second servant, the little room now housed books that did not belong to mainstream literature in the Confucian framework, books that did not deserve the title of "classics." They were "lowbrow" books—novels, folklores, mythologies, opera librettos, travel books, ghost stories, martial-art legends, even American magazines such as *National Geographic* and *Life*. Father had never assigned any of those books for me to read. After all, Confucius had decreed twenty-five hundred years ago that any written work other than poetry, philosophy, history,

and didactic essays was to be dismissed as "street talk and alley gossip." But to me the lowbrow books in that little room offered suspenseful diversion and fascinating information. I found them absorbing and entertaining.

Nobody had given me a clue about readable books and magazines before I stumbled upon this little roomful of them in Father's office. Not my teachers, not friends, certainly not Father.

Prior to this lucky discovery, my reading assignments had been exclusively in the domain of classics—mostly didactic essays and philosophical tracts, all written in Classical Chinese. They were painfully stultifying for a young teenager. I could spend hours with a dictionary trying to read a single assignment involving a few pages of a classic text. Even so, my efforts might not succeed. Since Chinese writing is not based on an alphabet, locating an unknown character/logograph in the dictionary depends on your ability to identify its components and count the number of strokes. If you are lucky enough to find the character in a dictionary, you might not be able to pronounce it or even understand its meaning. Often the explanation of an entry includes other characters you don't know (which you then have to try to locate in the dictionary again).

There are other hurdles beyond vocabulary in reading Chinese classics. Grammatical structures are wildly different from modern speech, and can vary from historical period to historical period. Students were expected to intuit the correct grammatical structure from the text—and woe to the pupil who did so incorrectly, as teachers did not hesitate to seize on such mistakes as an opportunity to deride the culprit in loud, humiliating reprimands before the entire class.

Before I discovered the treasure trove of readable and interesting books, I thought, as did all my classmates, that a person had to be either somewhat unhinged or masochistic to enjoy reading. Why should any normal person waste time tackling unreadable texts written with unthinkable pedantry in indecipherable logographs?

In that little room cluttered with lowbrow books, I didn't just read. I also did my homework and spent a lot of time staring at the wall, daydreaming. It became my home. I felt safe and cozy in its cramped space, surrounded by shelves of books and magazines that I browsed intermittently. The musty smell of the books, strangely, conferred a sense of security, as if the books had come to life and become my friends.

In Shanghai, when I lived with Aunt Helen in the late 1940s, the sight of ships in the harbor had led me to fantasize going to faraway places. Those faraway places existed only in abstraction in my foggy imagination; I didn't have any idea what they could be. Now, daydreaming in my book-lined cubicle, I thought of exploring the haunting steppes of western China, diving along the Great Barrier Reef of Australia, trekking through the tropical forest of Africa, climbing the majestic mountains and national parks of America, and exploring the mysterious jungle of the Amazon. My reading gave me something tangible to feed my wanderlust spirit, and made my daydreams infinitely more pleasurable.

Father never asked me what I read or did in his office flat. As long as my report cards contained good grades, he left me alone.

In the evening and on weekends, he often went out. I didn't know where he went or what he did. By the time he returned, I was usually asleep on a folding cot of the kind sold in army-surplus stores. Every evening I pulled it out from a storage closet and set it up in the dining room as my bed.

―――――――

Living in Father's office ultimately proved beneficial in many ways. Besides discovering the pleasures of reading, I embarked on a healthy development both physically and psychologically.

At the office, a highly capable and efficient maidservant managed the apartment on a generous budget provided by the publishing firm. She kept the place clean, the floor waxed, the windows

spotless. Even the glass cases holding the "Si Ku Chuen Shu," an encyclopedic collection of all of the classics consisting of hundreds of hand-sewn volumes that were as important to a traditional scholar as the Bible is to a fundamentalist Christian, were dusted everyday. She was a busy bee, proud of her competence and hard work.

More important to my development was the fabulous culinary skill of the maidservant. Early in the morning, fried eggs seasoned with spices, crunchy salted turnip and daikon, sweet-smelling fried peanuts, spicy dried and shredded pork, and sliced cucumbers marinated in sesame oil and rice vinegar were set on the table, accompanied by hot and soothing rice porridge, for anyone who wished to have breakfast. Various dishes were served also at lunch and dinner: soup, vegetables, meat, and seafood, each brimming with tantalizing flavors from fresh ingredients she bought every day at the open-air market. I had never before in my life enjoyed eating so tremendously. Each meal was a feast, and I always ate until my stomach could hold no more.

The nourishment produced some dramatic results in my life.

For one thing, it brought a magical transformation to my hair.

My hair had always been dry, crackly, and unkempt, a diluted dull black. Contributing to my elflike image, it stood up on my head at various spots as if it had a will of its own, and no amount of combing could coax the upright hair forward, backward, or sideways. I had always envied the shiny, well-groomed, jet-black hair of the well-heeled boys. It made them look smart. I thought I was born with horrible-looking hair on my head; that it simply happened to be my misfortune.

After a few months of feasting in Father's office, my hair became luxuriant and pliant, just like the hair of the smart-looking boys in school. It shone with its own oils and didn't shoot up into the air anymore. Spared the indignity of a street-urchin hairdo, I suddenly felt a whole lot better about myself.

I also began, at last, to grow. For as long as I could remember, I had been short and thin for my age, even among the Cantonese, who tended to have smaller frames than the northerners. After moving to Father's office, I shot up from four-foot-ten to six feet in just a year and a half.

It was a new experience to tower over most people in school and on the street. By tenth grade, I was playing center in every basketball game during physical education class. Because of my relative height, I specialized in rebounding and shot blocking. Every time I moved toward an opponent who was trying to score, his teammates would yell, "Watch out for the tall guy!"

Once, after returning from a two-week winter semester break, a four-foot-six, acid-tongued instructor called Teacher Ding (whom all of us students had nicknamed "Shortie" Ding) took a look at me and quipped, "Li, besides taking magic herbs for gaining height, what other illicit activities have you been engaging in?"

Everyone laughed.

I retorted smartly, "Thank you, sir, for being so astute as to observe my innate desire to avoid a life of shortness."

The class roared.

With a smile, Teacher Ding parried, "Very good, Li Na! You have been sharpening your wit, to overcome the name your father gave you."

In our strictly hierarchical school, students were required to be respectful of teachers at all times. But clever repartee from a student, even tinted with sarcasm, was not only allowed but often appreciated by teachers.

After our exchange, Teacher Ding moved me from the third row to the rear of the class, noting wryly that my elongated torso blocked the view of my shorter classmates.

And in tandem with my growth and physical transformation, my phobias began to abate. For one thing, I came to the realization that an urban environment without a graveyard didn't seem conducive to

ghost visitations. The streets, lined with concrete buildings, were well lit during the night. There was no place for a ghost to hide. Over time, I forgot about ghosts altogether.

The nightmare of being crushed by a tumbling boulder also stopped haunting me. Every night, I fell asleep quickly in my army cot from the day's exertions. There was no time for fear. At six o'clock every morning, when the maidservant woke me up because she had to set up breakfast in the dining room, I couldn't recall any troubling dreams.

The one thing that didn't change was my stalklike, skinny stature. I ate voraciously three times a day. But all that eating only lengthened me.

In spite of these positive developments, however, I still did not blend in with other kids in my school. It was an exclusive school, privately owned, and charged a high tuition. The owner of the school, which included grades kindergarten through twelve, Mr. Lum, was also the titular headmaster. Headmaster Lum used the tuition from thousands of pupils to finance his newly founded bank. He constantly shuffled between the school and the bank, which were conveniently located next to each other.

On the first day of every month, each pupil or a parent had to line up at the bursar's office to pay the monthly tuition. Once, when my classmates and I saw Lum walking briskly into the bank from our school clutching a pouch against his chest, I couldn't refrain from commenting, "Ah, there goes Headmaster Lum, fattening his fast-growing bank with our tuition."

Sarcasm aside, my observation was not off the mark. Headmaster Lum accumulated a fabulous fortune from the school-bank combination and became an important personage in Hong Kong during the 1960s, a period of transition, from an old-fashioned, crude colony to a semiautonomous bastion of free enterprise in the British Commonwealth.

Every month Father grudgingly paid my tuition, reminding me

that it was a great sum of money and that at such a high cost, I'd better get the best possible education from the school. By this he meant that I should perform with distinction.

Father always tried to pound into my head that we were poor, although I didn't have the slightest inkling of his financial status or how much money he earned as editor in chief at China Press. To my fellow students, my economic status was also a conundrum, which didn't help me to blend in, with either the rich or the poor kids.

On the one hand, I lived in an upscale neighborhood where most children were driven to school in private automobiles. Those were the days when owning an automobile implied having a chauffeur, as few people knew how to drive.

On the other hand, I walked to and from school, and had all the appearance of a boy beset by poverty. I didn't dress well, had no pocket money, and never took part in any after-school social activities. Strangest of all, no member of my "family" ever made an appearance at my school, not on Open House Day, not on Parents' Reception Day. Father wouldn't deign to participate in them because he felt he was above rubbing shoulders with other parents attending such mundane activities. To make matters worse, my schoolmates often talked about their families, just like the school kids in Shanghai. I refused to answer any queries or say anything about any of it. There was nothing about Father that I wanted to talk about.

I was an oddball through and through.

From the perspective of my schoolmates, I might just as well have erupted from a rock, like Sun-wu-kong, the mythical monkey in the sixteenth-century Chinese novel *Journey to the West*.

Independent of my nonconformity and my bizarre living situation, I also felt uncomfortable with most of my schoolmates, who belonged to wealthy families. Their wealth was easily recognizable.

School regulations required that every pupil wore a uniform, but everyone knew that not all uniforms were the same. The wealthy students wore uniforms made of superior material. You didn't have to be a fashion connoisseur to notice the sheen of the material and the scarcity of wrinkles. With one quick glance, you could spot the few poor kids with low-quality uniforms as pupils poured out of school to go home for lunch.

In addition to superior uniforms, the rich kids had pocket money. Many of them spent their pocket money on snacks. Strange as it may seem, snacking had just become a new fad in Hong Kong. Fanned by a major new advertisement blitz, the status and desirability of Coca-Cola was enhanced still further by its American origins. Coke was sold in three food stores on campus, newly established by the headmaster in order to rake in even more money. The wealthy kids bought snacks at every opportunity. Before classes, during recess, and after classes, as if they were starving! They gloated before the rest of us, a Coca-Cola in one hand and a meat bun in the other. The penniless kids, who were a small minority, tried to avoid looking at them so as not to show envy.

Personally, I read their gloating as revenge for being trounced academically. For reasons I never understood, students who indulged in snacks typically did not belong to the top academic tier. The high achievers in my class during my three years at that school were a mixed group of rich and poor. None of them, regardless of their economic status, indulged in snacks at school.

Money also helped wealthy kids academically, not to win distinction but to earn passing grades in difficult mathematics and science courses. Our school maintained extremely high academic standards. Teachers assigned the maximal amount of homework everyday and conjured up unbelievably difficult exams designed to stymie students. History and literature exams were typically designed to be too long to complete within the prescribed time, and twenty percent of a math or science exam was often reserved for

problems at such a level of difficulty that the teacher could barely solve them. Exams were a kind of warfare, pitting students against one another for a limited number of high grades, and scoring below sixty—the equivalent of a failing grade—was psychologically devastating for a student. Suicide among failed students was not uncommon. The humiliation and stigma, for both the failed student and his or her family, were too much for some teenagers to bear.

This warlike educational atmosphere spawned an industry of after-school "review" classes in teachers' homes. They were costly for the students but a boon for the teachers, who, underpaid and exploited by the owner of the school, augmented their income through these review sessions. After regular school ended, at 4:30 p.m., the rich underachievers rushed from the home of one teacher to another until 7:00 or 8:00 p.m., attending review classes on different subjects. During these sessions, the teachers mostly helped the students do their homework. More important, the teacher dispensed tips and hints to help them in forthcoming exams. Wealthy kids walked into an exam already knowing two-thirds of its contents. They could hardly fail, even if they tried.

But the system wasn't completely crooked. Even the greediest teachers maintained a balance between fairness and the need to supplement their income. They only gave enough tips and hints in their review classes to allow a student to score a passing grade of sixty or seventy points in an examination. In other words, a student could buy a passing grade, but not an A.

In order to attain the top one or two percentiles of a class, a student had to have incredible drive, discipline, and stamina. The number-one student in my class demonstrated his prowess by earning a Ph.D. in mathematics from Cal Tech four years after graduating from our high school. Number two, who teaches at Princeton University, won a Nobel Prize in physics in 1997. Number three became a renowned neurosurgeon in Cambridge, Massachusetts.

As for myself, after getting home from school around 5:00 p.m.,

I would study for about six hours every night. Except for a thirty-minute dinner break during those six hours, I alternately sat, paced, and fidgeted in the little room of offbeat books as I worked. By 11:00 p.m. I would usually give up. Reading was a pleasure to be savored only on weekends and holidays.

During exam time, a much more vigorous regimen was self-imposed.

For two weeks before and during exams, I studied every night until my vision began to blur. Even then I tried to carry on, rubbing my eyes every few minutes. In spite of my efforts, I never got above number six in a class of 160 during my three years of high school. I was a respectable but not a stellar student, always hovering on the border of being truly outstanding.

Academic ranks in our school were not confidential or private issues. Everyone knew everyone else's academic standing in his or her class. The school, as well as the teachers, made sure that every student's academic rank was widely publicized.

If a student climbed several notches, he would be congratulated in class at the beginning of a new semester. If a student dropped precipitously in the rankings, he would bear the humiliating brunt of the teachers' sarcasm. Every teacher relished the role of singling out a loser for the devastating ritual. One time, my history teacher, Shortie Ding, intoned in class on the first day of a new semester, "We regret that Mr. Yang Hai-zhen has sunk from number thirty to number forty. We hope he will shake the sea this semester like a dragon, not like a snake."

Yang's given name, Hai-zhen, meant "to shake the sea." Dragons symbolize nobility; snakes, ignobility. The teacher's witty dig at Yang drew loud laughter.

Everyone learned to suffer ridicule from teachers and fellow students stoically. If you were a mediocre student, you hid the psychological damage of being the object of laughter and accepted your inferior rank or inadequacy as your destiny. Normally a stu-

dent occupying the bottom rank throughout his high school years could expect the same standing in the broader society for the rest of his life. The school ranking system would have pounded into his head that he was made of an inferior substance! Given people's willing acceptance of their "fate," a student rarely broke down in tears or showed any distress during a public humiliation administered by a teacher. He sat stone-faced while everyone laughed.

My class had approximately 160 students, divided into four sections, each of which had its own classroom. Two of the four sections belonged to the science/math category; the other two belonged to the humanities category. The science/math sections were segregated from the humanities sections in every possible way: different classrooms, different teachers, different students, and different curriculum. Students were assigned to one or the other category according to his or her score in the entrance exam, not according to academic interests. The top fifty percent who passed the entrance exam formed the science/math sections. The bottom fifty percent were relegated to the humanities sections. Students in the humanities sections got out of school one hour earlier than the students from the science/math sections because they had only five, not eleven, hours of science and math classes per week. (School was six days a week, but stopped at midday on Saturday.) A student risked being demoted from a science/math section to a humanities section if his academic achievement fell below a certain standard. Movement in the opposite direction was rare, if it occurred at all.

The two categories of students received separate academic rankings. A student in the humanities sections was automatically stigmatized as second-rate for life. Generally, at least in my school, students in the humanities sections were relatively docile and well-behaved, and aimed for modest goals in life. Those who dared to challenge teachers, especially the more sadistic and sarcastic ones, all belonged to the science/math sections. Many of them harbored grandiose aspirations and many became lifelong high achievers.

This segregation of students according to their aptitude for science and mathematics explains in part why, after World War II, the overwhelming majority of Chinese students studying abroad have been in the fields of science and engineering. Before World War II, secondary schools did not systematically discriminate against "humanities" students. Among Father's generation, there were as many humanists/social scientists as scientists/engineers who won scholarships to study in Europe and America. After World War II, most people in China subscribed to the belief that science and technology provided the only path for a nation, or an individual, to rise to prominence. The belief became so pervasive and firmly entrenched that the educational system automatically shunted high-performing students into science and engineering, regardless of their interests.

Father, who secretly wished me to engage in a political career and never demonstrated an iota of interest in science or engineering, himself bought into that prejudice. He was glad that I belonged in the science/math section.

On holidays, Father would often disappear. When he did, I would take off from the office to explore the neighborhood on foot. He probably would not have objected even if he knew, but I preferred to do it in his absence, for fear of incurring his ire.

Unfortunately, the upscale residential neighborhood around Father's office held nothing of interest for me. I rarely saw pedestrians. Most of the homes were walled in. If I as much as slowed down while walking by a gate, a guard dog inside would start bouncing toward me, barking viciously. Their aggression was in startling contrast to the feral dogs I knew in the countryside of the New Territories. I imagined that the people living in those houses were just as truculent as their dogs.

Usually I wandered aimlessly as far as I dared without risking getting lost. One place that provided some diversion was a Catholic

school for girls, called Maryknoll. The school's grounds—the flowers, trees, birds, and insects—served as a refreshing refuge from the monotonous asphalt streets and walled-in homes. I treated it as a park with a smidgen of the nature that enchanted me in the mountains and glens of the New Territories.

I never felt as confident wandering the streets of the quiet residential area around Father's office as I did roaming the mountains. Cautious and timid, I was not the same boy looking for trouble in the streets of Shanghai during the civil war, or seeking excitement in the slum of Nanjing with my buddies. My friends in the slum had called me a daredevil because I was always proposing wild adventures and bold actions; and in Shanghai, Aunt Helen had preached to me the virtues of being meek and timid to counter my propensity for wandering the streets recklessly. "Blessed are the meek, for they shall inherit the earth," she quoted to me from the Gospel of Matthew. And then she added: "Nowadays, people use new technologies to kill. They don't feel the impact of their victims' deaths, and they don't have any remorse. You can never be too cautious!"

At the time, I didn't fully understand what she meant and paid little attention to her warnings. But after experiencing the cruelty of my schoolmates and the harsh treatment by Father, I became much more fearful. Now, living in Father's editorial office, located in a quiet and uneventful neighborhood, I seemed to have taken Aunt Helen's sermon on meekness to heart, always feeling a little nervous when I ventured out of the flat.

Since Father never gave me any money, I didn't have the bus fare to go to the commercial areas of Kowloon or Hong Kong. Nor could I go to a movie, buy a snack, or visit a classmate.

But one place within a safe walking distance where I *could* go was Mother's theological seminary.

I visited Mother once a week without ever telling Father. He never said a word about her after she left, and I didn't think he would want to know that I visited her. I suspect the fury that almost

overwhelmed him at the moment he learned of Mother's departure never left him. According to the tradition in which he grew up in the village in Shandong, a woman never walked out on a husband, certainly not an older woman without any money or means of support. Perhaps he cussed and ranted about Mother when he was with his close friends. I had no way of knowing, because I no longer witnessed his social interactions as I had on some occasions when he entertained friends in our humble home in the New Territories. Since he and I moved to his office, he conducted all of his social activities away from his residence-cum-office. In his interactions with me, Mother had been completely erased, as if she never existed.

At the seminary, Mother looked healthy and content. When I showed up, she would come out to see me at a reception room. I didn't know exactly what she did all day, but I assumed that she studied, since the Chinese term for "seminary" contains the logographs pronounced as *xue yuan*, which means "institute of learning." During my visits, our conversations were always halting. Most of the time I didn't know what to say, and she was, as usual, hardly talkative.

Of course, in the East Asian world, brief periods of silence at a social gathering are not a cause for concern or embarrassment. When Mother and I were not speaking to each other, I stared at my feet in the spartan reception room of the seminary, and she tended to fix her gaze on me as if she was trying to measure my physical growth and development. She usually asked me about my schoolwork, and proclaimed herself pleased with my academic progress.

My visits with Mother never lasted long, but a new relationship began to develop between us. The way she looked at me and the way she put her hand on my shoulder as I walked out of the seminary at the end of each visit gave me a feeling that I had never experienced from her at home. Care and affection were transmitted not so much verbally as through body language and facial expressions. I deeply enjoyed seeing her and treasured her affection.

8

A HIDDEN AGENDA

In 1955, when I approached sixteen years of age and was ready for the eleventh grade, Father initiated a dramatic change in our interaction.

Prior to this point, we never had a conversation. He gave orders; I obeyed. That constituted the mainstay of our relationship. As I had mentioned earlier, our relationship resembled a contract: food and shelter in exchange for good academic performance.

The summer before I started my eleventh-grade school year, Father began to make time to talk to me about important political events and major political figures in the world, several times a week and often for an extended period of time. I had no idea why he took this initiative—if he felt it was time for me to take an interest in the goings-on in the world, or if he was perhaps just bored and wanted an audience for his opinions.

At the beginning of Father's efforts, he did all the talking, and I listened, showing the lukewarm attention that was the minimal level of obedience required of a son. But after a couple of months—partly

because I had acquired the prerequisite knowledge, and partly because I began to understand that politics and politicians shaped our time if not our lives—my curiosity and interest were aroused. Before long I started to respond to Father's observations, asking him questions, probing his statements, and supplementing his talks by reading history books.

Father was overjoyed at my response. Always miserly in the past when he had to buy me clothing or school supplies, he became unnaturally generous, buying me journals, magazines, biographies, and books on twentieth-century political events and leaders. I, for my part, eagerly consumed everything he threw at me.

Through our discourse on international politics, a new dimension, absent of anger and contentiousness, blossomed in our relationship. Neither power-based nor unduly one-sided, this new facet of our relationship grew rapidly. Within a short period of time we came to share a common interest in the Third World and international conflict. Astonishingly, we had animated and exuberant exchanges in which there was give-and-take on both sides. Even more incredible, sometimes we disagreed and argued heatedly over the assessment of a particular situation—and he didn't mind when I took an opposing view. He, for example, still looked upon England as a major power, while I felt that England, now stripped of its colonies, was a waning empire. He felt that America, notwithstanding its economic and military strength, lacked the experience and guile to lead the world. I was of the opinion that America's money and guns could go a long way in international politics.

Looking back, I am sure that our political discourse, as well as our new relationship, owed its success to the profound transformation of the world during the 1950s. In the wake of World War Two, there was never a dull moment in world politics. One earth-shaking event followed another, and one unforgettable character eclipsed the next, claiming center stage in an endless parade of events that were at once sensational and mesmerizing. Two themes dominated

international politics: the cold war pitting the Western allies against the Soviet bloc, and the emergence of new nations through independence movements among European colonies and semi-colonies in Asia and Africa.

Father liked to focus on China and Third World countries emerging from colonialism, but the cold war served as the larger context for all regional conflicts. We never veered far from the players and events of the confrontation between the East and the West in our discussions.

Among the most fascinating politicians that captivated Father in those days was Gamal Abdel Nasser of Egypt. A young man in his thirties, he led a military coup that created the Republic of Egypt, stirred up Egyptian nationalism, and forced the withdrawal of the British garrison—80,000 strong—from Egypt, thus securing the full independence of his country from British dominance. He went on to inspire the first Algerian insurrection against the French in 1954, and started the Pan-Arabist movement to combat colonialism.

In 1956, as his forceful and unyielding stance together with international condemnation doomed the British-French-Israeli joint invasion of the Suez Canal, Nassar became not only the most popular leader in Africa, but also a hero of the Third World for battling against Western colonialism. To the people of Asia and Africa he embodied a newfound sense of empowerment.

With admiration, and possibly a tinge of envy, Father spoke glowingly of Nasser's defeat of the colonial powers in Egypt. I had a feeling that he had finally come to grips with the fact that power did not come from the fountain pen.

Another of Father's favorite people was Anthony Eden, the golden boy of British politics, the protégé of Winston Churchill. Father brought up Eden in many of our discussions, but not just for his prominent role on the stage of world politics: Eden had attended Christ College at Oxford as he did. He made me read Eden's famous 1938 speech against Neville Chamberlain's policy of appeasement

of Adolf Hitler, when Eden resigned from the British cabinet. Eden was then the youngest foreign secretary in English history.

The irony of this assignment, coming from Father, did not escape my attention. Eden's resignation came around the same time that Father's political mentor, Wang Jing-wei, set in motion the process of creating a collaborationist government in Japanese-occupied China, with Father as a core member. During our analysis of Eden's courageous speech, I could barely manage to suppress my urge to ask Father why he hadn't followed the example set by Eden.

Next in importance to Nasser and Eden in my political education was Indonesia's firebrand president, Sukarno. Sukarno was an Asian hero in the anticolonial movement. He had earned his reputation by toppling the Dutch, who had been colonizing and exploiting Indonesia for over 400 years, from the first days of the spice trade. After defeating the Dutch, he consolidated his reputation by unifying into one nation the myriad feudal fiefdoms scattered across the Indonesian archipelago.

In 1955, Surkano gained international fame for sponsoring the Bandung Conference in Indonesia to oppose colonialism and promote solidarity among the nations of Africa and Asia, many of which were newly independent. Father considered the Bandung Conference an epoch-making event. It brought together the leaders of the world's dispossessed and downtrodden, highlighted on the international stage the moral abyss of Western colonialism, and signaled the end of the colonial age. How he wished that he could have played a role in that watershed conference!

When he talked about the Bandung Conference, I saw for the first time the emotional side of a man obsessed by political ambition. He became so animated as he described Jawaharlal Nehru's speech that he had to be imagining himself in the audience, supporting and applauding the charismatic Indian prime minister's condemnation of colonialism. The vehemence of Father's indignation at the transgression committed by colonial powers poured out

like a torrential flood. It transcended all of his ideological convictions and abstract political theories.

"What eloquence! What clairvoyance! The Third World nations have defeated and will continue to triumph against the colonial powers. Nehru and his mentor, Mahatma Gandhi, personified this victorious struggle of the Third World nations."

I was moved, transfixed, by his effusive emotions.

In our discourse on Sukarno, Father was quick to point out that the Indonesian hero had collaborated with the Japanese during the Second World War, though he neglected to observe that Japan was the "enemy of the enemy" of Indonesia's independence movement. Sukarno's collaboration with the invading Japanese aided the cause of Indonesian independence from the Dutch, whereas Wang Jing-wei's collaboration with the Japanese betrayed the desire of a nation to resist Japan's military aggression.

Like most Third World leaders, Sukarno veered toward dictatorship after winning popular acclaim. In the end, he was toppled in a military coup, covertly supported by the CIA, in the mid-1960s.

———

China, not surprisingly, was the most frequent topic in my political education under Father.

Like the millions of Chinese residents of Hong Kong, Father and I were reminded daily, in myriad ways, that we were colonial subjects. We were not entitled to British citizenship and its attendant civil rights, but we contributed to the British treasury. Every New Year during the 1950s, the governor of Hong Kong proudly announced to the colony the exact amount of money with which the crown colony had enriched the British treasury, while shanty-towns covered the hills of Kowloon and Hong Kong and almost all educational institutions in the colony operated as private, profit-making business enterprises.

Before my time, the British posted signs in certain parks declaring "Dogs and Chinese prohibited." Those signs came down in the late 1940s as a gesture acknowledging that China was one of the four victorious Allied partners in World War II. While the British had abandoned such crude discriminatory practices, they and, by racial extension, Europeans and Americans, continued to enjoy privileged access to wealth and power in the colony. During the 1950s, doors opened for whites, simply by virtue of their being "white," that were closed to Chinese. They could always acquire prestige and wealth regardless of ability and drive.

Nothing could be more infuriating and degrading to a person than to be treated as an inferior in his own country by a people who didn't even belong there.

Paradoxically, the Chinese in Hong Kong, despite their fear of the Communists and their distaste for the Nationalists—their reasons, after all, for taking up residence in the crown colony—wouldn't dream of giving up being Chinese. Their political allegiance went to either Mainland China (Communists) or Taiwan (Nationalists). Over time, some might switch their allegiance from one side to the other, depending on transactional expediency.

Father never spoke of Taiwan, even though my brother and two of my sisters were living there. It was clear to him that Chiang Kai-shek, notwithstanding his outlandish claim of representing all of China, would never return to the mainland. On the island of Taiwan, Chiang and his Nationalist cronies lived safely under the protection of the Seventh Fleet of the U.S. Navy. Politically they had been reduced to irrelevance, according to Father's assessment.

Mainland China was a different story.

Seven years after founding the People's Republic, the Communist regime had achieved a level of political, economic, and administrative control unprecedented in China's modern history. Chairman Mao and his colleagues were at the height of their popularity. Even today, in spite of China's enviable economic expansion, the esteem

of the Communist ruling elite among the Chinese people does not come close to what Mao, Chou En-lai (Mao's prime minister), Liu Shao-qi (the nominal head of the country), Zhu De (a marshall and founder of the Liberation Army), and their Politburo colleagues enjoyed in mid-1950s. To some people, the mid-fifties represent the golden age of socialism in China.

Back then, people living on the Mainland remembered the chaos of the precommunist years and the ineptitude of Chiang Kai-shek's Nationalist government. They were also impressed that the Communist government had made universal education and universal medical care its top priorities. Those two goals stood as symbols of an audacious and grandiose design in a country that had fallen centuries behind Europe and America in technology, economy, and industrialization. In spite of the lack of infrastructure and seemingly insurmountable obstacles, the Communists progressed rapidly toward their lofty goals.

For all of these reasons, many people felt in the mid-1950s that for the first time in more than a century their country might have found a path to restore its past glory. The consensus was that the Communists had unified the nation, secured its dignity and independence, and was leading it toward modernity. Most people reluctantly tolerated the viselike control exercised by the Communist Party. They considered the loss of individual freedom a necessary sacrifice and they hoped that the sacrifice was not permanent. Those who rejected Communist rule had gone to Taiwan, Hong Kong, or overseas.

Among the three million Chinese living in Hong Kong in 1955, Communist sympathizers constituted only a tiny minority. Most of the entrepreneurs, the technocrats, and the educated elite who fled from the Communists to Hong Kong remained opposed to communism. Not Father. For reasons he never explained to me, Father had begun leaning toward the Communists by 1955.

Abandoning his attempts to form a "third column" (the first

and second political powers being the Nationalists and the Communists), he no longer organized and subsidized his political cronies. He appeared to be swept up by the success of the Communists. He didn't tell me this in so many words, but he no longer referred to Communists as "nihilists bent on destruction," as he had when he first moved to Hong Kong. It was obvious from the way he talked about the members of the Politburo of the Communist Party and their policies that they had impressed him with their efficient control and manipulation, which, in some areas, involved enlightened policies.

"Don't you think Mao was clever in gaining the support of the peasantry and stimulating their productivity by eliminating the landowners?" Father asked during one attempt to tutor me in contemporary Chinese politics.

In reality, the Land Reform Movement of the early 1950s was brutal and bloody, causing the death of hundreds of thousands of people, many of whom were neither oppressive landlords nor predatory hooligans. Nevertheless, the land reform won the hearts of a great number of the poor peasants, who constituted the vast majority of the Chinese population. Their elevated social status in the new order, combined with their fear of a central government that penetrated every nook and cranny of rural China, something that no government had ever attempted in the past, unleashed a burst of productivity that made the nation nearly self-sufficient in food production for the first time in the twentieth century.

"The Communists are wise to create a national spoken language and simplify the written language to facilitate communication and universal education," Father observed admiringly another day. "Nearly forty years after the May Fourth Movement, they have moved the nation further ahead in the right direction toward universal literacy."

Later he declared, "It is a stroke of genius to combine traditional herbal medicine and acupuncture with Western medicine in

the Communist attempt to deliver universal medical care. Traditional medicine requires less technology and equipment. And it is very effective in many areas of health care."

Father ought to know. Dr. Song had saved his life with acupuncture before he attended Peking University.

"By granting a certain degree of autonomy and preferential treatment to the minority ethnic groups, the government pacified and incorporated them into the nation in one stroke. This is a brilliant and unprecedented achievement," Father cooed on yet another occasion.

To their credit, the Communist leaders had set out to deal with the long-standing historical conflict between the majority, which is called Han Chinese, and the hundreds of minority ethnic groups almost immediately after the founding of the People's Republic. With preferential legislation; the creation of autonomous regions; the promotion of the most important minority languages, such as Uighur, Mongolian, and Tibetan; and other initiatives, the government had established an enlightened policy toward minority groups. Its implementation by Han Chinese cadres, who, by and large, had a deeply rooted prejudice against minority culture and people, was another matter altogether. Ultimately the central government failed to eradicate Han chauvinism and discriminatory treatment of the hundreds of minority ethnic groups, which festered like a cancerous growth during Mao's Cultural Revolution.

But as cloying as some of Father's accolades could be, some of his enthusiastic praise of the Communist Party's policy was not off the mark in those days. In the mid-1950s, before the Anti-Rightist Movement began, the party exuded the promise of a new beginning toward a harmonious nation composed of several hundred different ethnic groups.

Father's lectures and our discourses on political topics were without a doubt the highlight of my high school years. I appreciated his knowledge and relished the learning. He, in turn, reacted favorably

to my exuberant responses and took pleasure in our discussions. Unaware until then that I was capable of wit and sarcasm, he laughed at my acerbic comments on politicians. I can still recall with great clarity how startled I was the first time he broke into laughter in my presence when I referred to Lavrenti Beria, the sinister and feared KGB chief under Joseph Stalin, as a "balding, sawed-off Rasputin." But he was not amused when I called Winston Churchill a "lump of blubber." He thought Churchill deserved greater respect.

One memorable day in 1957, toward the end of my high school years, Father called me into his presence and sat me down.

"You've got brains," he said.

I felt a flush of pleasure deep inside.

"You've also got passion," he continued.

Then he added, without rancor, "I only wish you had your elder brother's good looks. Then you would have a good chance of becoming a great leader of China someday. But with your brains and hard work, you might still have a chance."

At age seventeen in 1957, I had accepted my pedestrian appearance. My family was all very attractive; my elder brother was exceedingly handsome, and my four elder sisters never failed to turn heads wherever they went. I was the only one born with a ho-hum face.

After joining Father and Mother in Hong Kong at the age of ten, I had even heard them asking themselves on several occasions why their youngest child was not as handsome as their other children. But Father's critique of my physique was completely matter-of-fact, a politician's assessment of my resources and weaknesses, and it no longer stung me.

So it wasn't because I was hurt that I couldn't find the words to respond to Father's comments.

Rather, it was because in all of my daydreams and fantasies, be-

ing a political leader had never appeared once. I yearned for the loyal and devoted human relationships that made my year-long sojourn in Nanjing's slum the most rewarding time of my childhood. I dreamed of traveling afar to explore the world, as on those Sundays when Aunt Helen took me to the harbor of Shanghai. I imagined acquiring a wealth of knowledge on anything and everything, following the example of my Shanghai big brother, Da-ge.

"Leading and managing people?" I thought skeptically. "What good would that do me?"

I remained silent.

But Father was in a generous and expansive mood. He didn't let my silence stop him from continuing to outline my future.

"To prepare you for operating in the political arena, I want to tell you some basic rules today," he told me earnestly. "You must always bear them in mind because they will help you to avoid pitfalls and treachery.

"Rule Number One: Keep everyone in the light while you yourself remain in shadow."

Puzzled, I looked at him in bewilderment.

"This means finding out everything there is to be known about everyone without ever divulging your own thoughts, your own plans, your own feelings, or any other important information about yourself," he explained.

I thought that I didn't normally volunteer information about myself anyway, but then neither did I bother to gather information about anyone else—Father being the only exception. "What a strange rule!" I said to myself in silence.

Father carried on.

"Rule Number Two: Find out who is connected to whom. Everyone has an inner circle. Make it your business to know every person's circle of confidants."

Curiosity, not interest, prompted me to ask, "How do you do that?"

"Very simple," he responded. "You tell a person a sliver of scintillating but inconsequential gossip and see how it spreads. Wherever it spreads in the first few days will be the inner circle of that person. It's like connecting dots.

"Another trick serving the same purpose is to ask a person a seemingly trivial question, the answer to which may reveal the source of his knowledge, which may, in turn, point to one or several members of his inner circle."

I thought both of those tricks were clever, but—while nodding my head to indicate that I understood him—I was also thinking to myself: "What do I care about other people's inner circles of friends?"

"Rule Number Three," Father continued: "If you wish to strike in the west, make noise toward the east first."

That was a military ploy promoted by the great strategist Sunzi. I had already read it before. So it was not a surprise.

"Rule Number Four: Never attack anyone unless you're positive that you have the means and intention to finish him off."

"By finishing off someone, do you mean destroying him?" I asked.

"Yes! Either politically or physically," Father answered firmly.

I refrained from asking if he had ever destroyed anyone. Perhaps he hadn't, I thought. After all, for most of his political career he'd believed that power stemmed from the fountain pen, not the gun.

"Rule Number Five: Always make time to listen to others unless they're speaking utter rubbish. Even if they do, you should listen in order to find out why they speak rubbish.

"Rule Number Six: Patience, patience, patience."

As Father enumerated his rules, it dawned on me that being a politician differed completely from *studying* politicians and political events. Studying politics was akin to watching a puppet play, but being a politician was to be a puppet. The former was interesting; the latter, alienating. I knew a politician never considered him-

self a puppet, but the issue came down to a matter of perspective, especially in the developing world.

If Father was right with his rules, I reckoned, politicians led excruciatingly tedious and sickeningly paranoid lives, plotting, scheming, doubting, suspecting, and watching their backs at all times, as if they were waging a protracted war against the colleagues they collaborated with and the people they led. For me, life outside of politics was already full of battles: battles with Father, teachers, and classmates; battles with kidnappers, undercover police, and bullies; battles with fear, ghosts, and devils. The last thing I needed was a protracted war against more people.

I began to think secretly that I would never become a politician.

But Father was not done with his lesson for the day. At the end, he casually announced his expectations of me—or, more accurately, another one of his fantastic dreams.

"Well, my son, if you were lucky enough to become the president of China someday, you should consider your elder brother for the head of the secret police."

I was stunned.

"Father," I wanted to say, "you're getting carried away by your imagination!" But that would only have invited a blowup, so I kept my mouth shut.

I was also shocked by his suggestion about making my brother, who was living in Taiwan at the time, the head of "my secret police." I had always thought that the chiefs of secret police were butchers, like Stalin's Beria, Chiang's Dai Lü, and Mao's Gang Shen. Why would Father wish my brother to become such a loathsome, evil figure? I didn't understand. But Father was merely speaking in the hypothetical mode, and I decided not to challenge him.

These grandiose expectations notwithstanding, the new phase of my relationship with Father produced numerous delightful consequences. In the past, Father went out for entertainment with his

friends. But soon after the onset of my political education, he be-
gan to take me to cinemas, restaurants, and beach resorts. Our re-
lationship went through a change during those two final years in
high school. It might not qualify as a loving father-and-son rela-
tionship, but it had definitely moved beyond hostility and antago-
nism. I remained fearful of him, but I also saw his human side. He
no longer treated me as a nonentity, to be dismissed or ordered
around. On many occasions, he even gave every indication that he
valued my original ideas.

As with the shift in my relationship with Mother, I did not ques-
tion too deeply where this new rapport was coming from. I was too
hungry for his approval and affection. I was also too young and too
gullible. All my study of politicians had not diminished my na-
ïveté.

I should have taken his advice that day to heart.

As graduation approached, I had three options after earning my
high school diploma: seeking a low-level clerical job in Hong Kong,
applying for admission to a Taiwanese university, or pursuing a
university education in China.

In practice, the three choices boiled down to one question:
Should I seek employment or pursue further education?

If I wanted to attend a university, I had to know where and how.
There was no such thing as a counseling service in my high school.
Most of my schoolmates relied on their families for help and guid-
ance in figuring out what to do after graduation. I didn't have a
family; the only advice I received came from Father. He suggested
that I should consider seeking a university education in China.

Most of my classmates planned to attend universities overseas.
America, Canada, England, and Australia were their destinations.
They had connections through family friends, Christian missions,
or extended family members who were already overseas.

Hong Kong offered no opportunity for higher education for graduates of a Chinese high school. Only the graduates of a British school were eligible to take the entrance exam to the University of Hong Kong, a small institution belonging to the British Commonwealth educational system.

The few British secondary schools in Hong Kong were originally established for the children of British colonial officers, and a Chinese had to embrace a full-fledged "comprador" mentality to send his or her children to a British school because they would grow up illiterate in Chinese, without even a cursory knowledge of their own history, cultural heritage, or literary traditions. Teachers and students of Chinese schools despised these British flunkies. Periodically, our teachers gave us the British system's Advanced Level exams in mathematics, physics, chemistry, and biology to show us how easy they were so that we could mock the kids in British schools, and run-ins on the street often resulted in fights that wouldn't break up until the wail of police sirens was heard.

If I were to take a low-level clerical job in Hong Kong, I would come under the supervision of a graduate of a British school because graduates of British schools had higher status and better qualifications, according to the colonial government. This was an indignity I refused to suffer.

As far as going to Taiwan was concerned, I knew next to nothing about it. My siblings there did not communicate with me; and, as I've mentioned before, Taiwan never came up in my political discussions with Father. He and I agreed that it was not a promising place to forge a career.

Thus the only choice open to me was to return to China. Father sealed that choice by talking up China—and by markedly not offering me financial assistance to go abroad.

I had read about North America and Europe in Father's office. I had seen pictures of Paris, Venice, New York, Rome, Grand Teton, Yosemite, and other wonderful sites. Nothing would have been

more enticing to me than to visit those places. Just dreaming about such places excited me.

I coveted my classmates' opportunities to attend universities abroad. No, more than coveted—I was sick with envy. Every time someone announced that he or she was going to this or that university in America, Canada, England, or Australia, I got tight in the chest and felt immediately depressed. How I yearned for the same opportunity! I would do any work and pay any price to study abroad, if only someone would point the way or lend me a helping hand.

But no one did. Going overseas to study was not an option available to me. Father never mentioned it once as a possibility. I had no financial resources, and I was completely unaware that a person could win admission to a university in America or Canada on the basis of academic merit.

Faced with the inevitability of returning to China, I tried to console myself in moments of dejection. "Isn't it perfectly reasonable to seek a future in your own country?" I asked myself.

I even attempted to use nationalism as a crutch. "After all," I reasoned, "as Father says, the Communists are doing some very intelligent things and working hard to bring China into the modern world. I can be a part of that."

I promised myself in my diary that I would do my best to serve my country and distinguish myself in the process.

In September 1957, at seventeen years of age, I walked across the border between China and Hong Kong for the second time in my life. The first time, my back had been to my homeland; now it was to Hong Kong. All my belongings fit in one small suitcase.

At the border, I thought about Aunt Helen and our trip seven years earlier. I was a little boy then, holding tightly on to Aunt Helen's hand in a sea of refugees fleeing China. I still shook when I thought about the frightening experience of being separated from

her and left behind in the train station in Canton. Hong Kong was a novelty then. Even Father was a stranger.

I surveyed the border as I got off the British train.

The same bridge. The same checkpoint. Only this time, it was quiet, without a long line of refugees. The only people present were Chinese soldiers and British police, standing on guard. The Hong Kong government had closed the border permanently toward the end of 1950, while the Communists permitted any Chinese nationals from Hong Kong to cross over to their side. But few Hong Kong residents were walking that way in 1957.

I stepped forward.

Crossing the bridge spanning the river that separated Hong Kong from China, I felt indescribably lonely, partly because of my doubts about the wisdom of returning, and partly because of the unknown future I was stepping into. There was one escape hatch, my Hong Kong identity card, which entitled me to return to the colony. I hoped I wouldn't have to use it.

As I moved forward, I couldn't stop thinking about Aunt Helen and the distress that had prompted her to leave. I hadn't spoken to her in seven years, but recalling the troubles that had befallen her in Shanghai in 1950 gave me an uneasy feeling in the pit of my stomach.

I tried to ward off my anxiety by thinking about all of the praiseworthy policies instituted by the Communist government that came up in my political education, provided by Father. "If the Communists can turn Father around so that he speaks so highly of them," I told myself, "and if the nation is developing with so much promise, then by returning I will partake in that promise."

Now, as a welcoming breeze cooled my perspiring forehead and hands, I held my suitcase firmly and walked briskly across the bridge toward China. In spite of my conscious efforts to be brave and optimistic, I could not erase my doubt and overcome my anxiety. I crossed into China barely managing to keep a ray of hope flickering in my heart.

PART IV

GUANGZHOU, COMMUNIST CHINA

1957–1958

9

THE REFORM SCHOOL

A HUNDRED YARDS INTO THE CHINESE SIDE of the border, I was met by a cadre dressed in a gray Mao tunic. Like his outfit, he looked gray and somber, with a dour and sullen face. He spoke a northern Mandarin dialect, and was businesslike, but not discourteous.

"I am Comrade Zhu Hongyi," he said briskly, "working for the Committee for Overseas Chinese Affairs, an arm of the national government in Beijing. It is my job to welcome returning students, and escort you to the city of Guangzhou—Canton City."

His presence signaled to me the efficiency of the Committee for Overseas Chinese Affairs. "Are you always on duty here? How did you know I would arrive?"

"Yes, someone from my office is always here. We want to make sure that every returning Chinese student is met at the border," he replied.

On the train ride from the border to Guangzhou, he took out reams of forms. To fill them out, he fired question after question at

me. They ranged from routine ones about my name, age, weight, height, place of birth, etc., to unusual ones probing every recess of my seventeen years of existence—where I lived, what I read, who I associated with, how I felt about my friends, what schools I had attended, what academic standing I had attained, what I did for fun, where I had traveled, on and on.

Out the window went Father's Rule Number One of political operation—"Keep everyone in the light while remaining in shadow yourself." The cadre not only shone a probing light on me, he stripped me naked.

After obtaining my life history, he interrogated me about each member of my family, with the same relentless and meticulous probing.

When Father's name came up, he betrayed just a hint of surprise. Quickly masking his facial expression, he proceeded to the next question. I was a little taken aback that he recognized Father's name and wasn't sure what to make of it. Was that an ominous sign?

With that in mind, when Mother came up in the questioning, I decided to hold back information.

I knew that the Communists did not approve of religion. I was also aware that they forbade a married couple from splitting up without government permission. For those reasons I thought it best not to reveal that Mother had left Father to attend a theological seminary. I also wished to avoid delving into my parents' failed marriage. It was as unsettling as it was embarrassing.

When the cadre asked if Mother had a profession, I replied simply that she had always been a housewife and a homemaker. That terminated any subsequent questioning about her.

When the cadre came around to questions about my siblings, he was startled to discover that I hardly knew anything about them. I couldn't tell him what they did, where they lived, or what schools they went to; I didn't even know their current addresses. All I could

tell him was that two of my elder sisters and my brother were in Taiwan, one of my elder sisters lived with her husband in Hong Kong, and another one was in the Philippines. After some probing and feeling confident that I wasn't withholding information about my siblings from him, he commented, "Your family is unusual."

To which I replied, "That's for sure!"

"Is it because your family is Westernized?" he enquired, looking at me quizzically.

Being aware that the Communists did not look favorably on "Westernization" at the time, I took offense at his nosy implication. But I controlled my indignation—it was imperative to make a good impression, especially just after my arrival. So I merely said, passively, "No, I don't think so. My family is just unusual."

By the time he finished the interrogation, we were almost at the railroad station in Guangzhou, one and a half hours after our journey began. He had established a hefty file for the Communist bureaucracy on an ordinary, nondescript, seventeen-year-old student. I had no doubt that the file would grow continuously from then on. If someone in my family had had a hidden birthmark or took a trip to Patagonia, the information would have found its way into that file.

In addition to being meticulously thorough in conducting the interrogation, the dour-faced cadre was an expert at switching roles.

Starting as my welcoming escort, he had transformed, by the end of the interrogation, into a taskmaster, directing me here and there, ordering me to do this and that. As the train pulled into Guangzhou station, he told me, "In the suburb of Guangzhou, I am going to hand you over to a special school established for students who returned from overseas."

"But I am not from overseas," I protested. "There isn't a sea separating Hong Kong from China. Just a small river."

"Well, we include Hong Kong and Macau in the 'overseas' category at this point in time," he said officiously, dismissing my protest.

"But, of course, they are without a doubt an integral part of our motherland. You *know* that we will take them back."

"What will I do in the special school for students returned from overseas?"

"You will undergo thought reform."

Alarm, like a dark shadow, overcame me.

"Reform," in Communist jargon was correctional as well as punitive. People were sentenced to "reform camps" after committing a crime. I had learned this in Shanghai before going to Hong Kong. Counterrevolutionaries and criminals underwent "thought reform."

Trying to hide my anxiety and disappointment, I asked, "Will I be allowed to go to a university?"

"I don't know. You will find out in time," he answered casually.

I fell silent, but my heart was heavy.

I hadn't come back to seek thought reform, and didn't think I needed any. I disliked imperialists and colonialists, approved of communism intellectually and intended to serve my country. Those were the reasons for my return. Why was I being sent to a reform school?

Demoralized and concerned, I boarded a bus with the cadre heading toward the special school in the suburb of Guangzhou. As the bus wound its way through the city, it stopped at an intersection to allow a large, placard-waving crowd to cross over.

Raising their fists periodically in unison, the crowd was chanting:

> *Struggle, struggle*
> *Against the Rightists;*
> *Strangle, strangle*
> *The Anti socialists!*

In front of the crowd stumbled three men wearing tall dunce caps and paper robes, on which many characters were written in

black ink. Their heads were bowed in disgrace, their bodies bent forward. Their hands were tied together behind them with leashes held by three men who appeared to be the leaders of the chanting crowd parading past the bus.

It was a spectacle that took my mind off my own discomfort.

Unable to make out the characters on the paper robes of the men on leashes, I asked my guide, Comrade Zhu, "What's happening?"

He told me with a smile, "This is a crowd of patriots parading three Rightists in a political struggle against the renegades. These parades are happening all over the country since Chairman Mao launched the Anti-Rightist Campaign."

"What is the Anti-Rightist Campaign?" I asked innocently, without revealing that I had read a number of articles in Hong Kong about it. I wanted to hear the official rendition of this national campaign.

"It is a campaign to uncover and punish antisocialists and counterrevolutionaries. These traitors tried to undermine socialism and the proletarian dictatorship by taking advantage of Chairman Mao's magnanimous policy of letting a hundred flowers bloom."

"Oh, I see. I have read the Chairman's article, 'On the Correct Handling of the Contradictions Among the People.' He urged citizens to criticize the party as well as the government, using the old adage: Let a hundred flowers bloom and let a hundred schools of thought contend."

I showed off some of my knowledge acquired under Father's tutelage.

"Very good!" the cadre said as he looked at me, pleasantly surprised. "It is important to study the Chairman's writing."

I didn't let on that I had also read some articles that suggested that Mao lured his critics into the open with his call for letting "a hundred flowers bloom" so that he could all the more easily squash them. No one knows for sure whether or not Mao conspired to lay

a trap, or had indeed started out with the hope and ideal of soliciting constructive criticism, only to find that he had unleashed more negative sentiments than he could tolerate. The fact is that many people, especially intellectuals, who responded to his "hundred flowers" campaign in 1956 with patriotic exuberance and well-meant criticism found themselves labeled "Rightists" a year later. They were then purged with ruthless vindictiveness and punished by mob rule.

The Anti-Rightist Campaign might not be as bloody as Joseph Stalin's great purge, but it was equally destructive and devastating to the victims. Unbeknownst to me at the time, it marked the end of what many people considered "the golden age of socialism" in China. It also signaled the beginning of Chairman Mao's folly.

As the leashed prisoners and their tormentors passed by, I asked Zhu, "What is going to happen to these three Rightists?"

"They will be paraded around the city like animals to be butchered," he said, with a kind of steely satisfaction that made me shudder. "But we won't kill them. We Communists are civilized. We will humiliate them, make them confess their crimes, expose their counterrevolutionary treachery, and finally we will reform them."

The word "reform" sent chills down my spine.

I was being sent to a "reform school." Was I going to be paraded around, humiliated, and forced to confess a crime that I didn't commit?

Allaying my fear with the thought that I was not a Rightist, I tried to forget completely the spectacle of the parade and what it might represent.

When the bus stopped in a suburb named Shipai, the cadre and I got off. The reform school was right in front of me. I had a full, unobstructed view.

In the center of a large campus, there were dozens of identical, two-story, gray brick buildings surrounding a gigantic, sprawling, single level concrete structure. On one side of these buildings was a full-sized athletic field. On the other side, an imposing, multileveled Stalinist-Gothic monstrosity fabricated of concrete. Behind it were four rows of bungalows, made of the same gray bricks. The campus looked like an army barracks, grim and austere.

Comrade Zhu led me toward the Stalinist-Gothic structure. It was the administration building, filled with cadres and bureaucrats.

Inside, we passed by the Office of the Communist Youth League, the Office of Propaganda, the Office of International Relations, the Office of Relations with Guangdong Province, the Office of Relations with Guangzhou City, the Office of Communication, the Office of Marxism-Leninism, the Office of Instruction in Science, the Office of Instruction in Chinese Language and Literature . . . There were a mind-boggling number of offices. The largest was the Office of Political Cadres.

Walking past the open doors of the offices, I could see each of them shrouded in gray, with bare concrete floors. Their walls were plastered with white mortar darkened by soot. The spartan furnishings consisted of drab brown desks and chairs. The only color in each office appeared in the portrait of Chairman Mao, prominently displayed on a wall facing each door as if the Chairman were greeting you upon your entry. With cheeks that were too rosy, lips too red, hair too black, and a forehead, accentuated by a receding hairline, too shiny, the portrait looked like a bit of kitsch inspired by Maxfield Parrish, displaying an overnourished figure in a country that had been plagued by hunger and scarcity of food for more than a century.

On the second floor of the administration building, Comrade Zhu and I walked by the Office of the Secretary of the Communist

Party. Signaling for me to wait at the door, he walked in, hoping to say hello to the commissar. But no one was in.

This was the one office that looked different, furnished with a good-sized Peking carpet on the concrete floor and several sofas around the carpet. There were garish curtains hanging on the windows.

Finally, on the third floor, Comrade Zhu deposited me at the Registration Office and bade me farewell. I was glad to be rid of him. In one afternoon, he had barged into my life, tried to strip me naked, and came close to taking command of my existence.

At the registration desk, I filled out a batch of forms consisting of a subset of the questions with which I was interrogated on the train. A clerk then told me that I was assigned to bed number 3 in room number 8 on the ground floor of Building number 14. Handing me five pages of printed material, he recited an outline of its contents in a monotone remarkable for its utter boredom.

Then, looking me in the eyes, he informed me solemnly, "This contains all instructions on life and rules in this institution. From now on, you are a ward of the state. One of your fellow students will guide you to your assigned space." He pointed at a short, skinny waif standing in the corner not far from me.

My guide introduced himself as Cai Xui-liang, a student returned from Vietnam one year ago. He was friendly and eager to show me around.

I learned that the dozens of two-story buildings functioned as dorms and classrooms. The large concrete structure in the center of the campus was our dining-cum-assembly hall. The bungalows behind the administration building housed the entire staff of the school from the secretary of the party to the janitors.

"How is life here?" I asked my guide, Cai.

"Not too bad," he said. "The food is lousy, but we eat three meals a day. Can't complain. My family couldn't manage that in Hanoi. After Ho Chi Minh took over from the French, the Vietnam-

ese have been squeezing out the Chinese." Cai spoke in short, manic sentences. "My father lost his wholesale rice business. He now operates a pedicab. Can hardly feed our family. Everyday, we worry about anti-Chinese pogroms. My mother is afraid to go out. We hope that I will do well here. Then my entire family will come back to China, even though we have been in Vietnam for three generations by now."

When Cai found out that I came from Hong Kong, he said that there were quite a few returnees from Hong Kong and Macau, but that most of the two thousand plus students at our school came from South and Southeast Asia: Vietnam, Indonesia, Thailand, Malaysia, Cambodia, Laos, the Philippines. They had all come back for pretty much the same reason: a strong anti-Chinese sentiment mushrooming in their countries, which had recently freed themselves from colonialism. Cai told me that Chinese were targeted for attack by the newly empowered natives because under colonial rule the Chinese had enjoyed a social and economic status higher than that of the indigenous population.

We had a long discussion about racial and ethnic prejudice and discrimination as we walked slowly about the campus.

This was the first time I became aware that the British were not the only people who discriminated against Chinese. Cai helped me to understand that ethnic prejudice existed everywhere, and that it wasn't just directed at Chinese. He also pointed out that the Chinese perpetrated racial prejudice and discrimination as much as any other people. We Chinese considered Westerners "devils"; we concocted every possible derogatory name, such as *nu* (slaves), *fan* (savages), and *miao* (barbarians), for minority groups in our own country; we thought of other Asians as inferior and less "civilized"; we even discriminated against fellow Chinese from different regions. It was an eye-opening realization for me.

I liked Cai and told him that I hoped to be his friend. We parted company at Building 14 with a warm handshake.

Like every other room in each dormitory building, the room I shared with fifteen other students in Building 14 was twenty-eight feet long and nine feet wide, a rectangular space with a window at one end and a door at the other end opening into a corridor. Each room held eight double-decker bunk beds, four linked together along each wall from the window end to the door end. A long narrow table stood between the two rows of bunk beds, barely leaving any space for a person to squeeze by sideways. The table was for studying. The bottom bunk beds served as chairs during the day.

Within a few minutes I met all fifteen roommates—all male—and discovered that everyone came from Hong Kong. It turned out that Building 14 housed students from Hong Kong exclusively. Some were there for a second year. Most had come at various points during the summer after they graduated from high school. I was one of the last to arrive. All of them came from blue-collar working-class families and had attended second-rate or third-rate Chinese high schools that charged far less tuition than my school, Pei-Zhen. After graduation, they had little or no chance of improving their life beyond what their parents could achieve as factory workers, sales clerks, longshoremen, bus drivers, train conductors, professional waiters, or domestic servants of the rich. China offered them many more prospects and a much brighter future than the British colony.

My roommates were surprised that I graduated from Pei-Zhen Middle School. One of them remarked, "I thought every graduate from Pei-Zhen went to the United States."

"Now you know you didn't think correctly!" My sardonic response lashed out quite spontaneously, and I regretted it as soon as it left my mouth. Flushing, I tried to soften my rudeness by adding, "Well, only the rich ones go to the United States. I am not one of them."

My roommates didn't have to tell me that they came from poor backgrounds because well-to-do families in Hong Kong wouldn't send their children to China even if they sided with China politically.

Hong Kong denizens had learned to hedge their political alliances a long time before they settled there. One never cast one's fortune entirely with either the Communists or the Nationalists. Well-to-do people made their fortunes in Hong Kong, kept their money in America or England, and sent their children to the United States, Canada, or Australia. It was as if all of the upper-class people of Hong Kong had taken a page from the great poet and playwright Bertolt Brecht, who, before settling in Communist East Germany in 1950, took out an Austrian passport, even though he was a German, and stashed away his money and the copyrights of his literary works in Switzerland.

I wanted my roommates to know that I was one of them, not a scion of a once privileged family. They were a nice, friendly, and unassuming group. Like me, they supported Communism and wanted to serve their country. All of us hoped to enter a university next fall.

—————————

Life in the reform school was strictly regimented from Monday through Saturday.

At six o'clock sharp in the morning, everyone woke up as a shortened version of Rossini's *William Tell* Overture was broadcast over loudspeakers that had been installed in every corridor of every building. The broadcast began with the soft, melodious prelude, which allowed you to end your dreams gently. Within a minute or two, however, the almost deafening fortissimo finale depicting a cavalry charge with trumpets blaring and timpani thundering would definitely jar you out of bed.

Whoever it was who chose to wake up the campus in this manner

probably paid a hefty price for "contaminating the proletarian mind with decadent bourgeois music" during the so-called Cultural Revolution ten years later.

Breakfast was served at 6:15. It consisted of tasteless rice gruel and salty pickles.

At 7:00 a.m., political education began. It lasted through the entire morning, except for a thirty-minute break in the middle, during which everyone lined up on the athletic field to do calisthenics, led by a physical education teacher.

Political education took place in classrooms. Each classroom had forty-eight students. My class consisted of all sixteen of us from room 8 and another sixteen from room 9 of the same dorm. The other one-third of the class were the occupants of a room in a girl's dorm. Everyone, male and female alike, came from Hong Kong. An assignment to a classroom was permanent and unchangeable for the year.

A cadre supervised and controlled each political education class. He or she directed our thought reform, orchestrated our activities, evaluated our progress, and determined our fate. We learned later that her letter of evaluation played a decisive role in our chances of getting admitted to a university.

After lunch came nap time, one and a half hours long, universally imposed, whether or not you needed it. The same abbreviated *William Tell* Overture terminated the afternoon nap.

At 2:00 p.m. everyone returned to the classrooms to study mathematics, physics, chemistry, biology, and Chinese literature until 5:30 p.m. under different teachers, who rotated from one classroom to another.

Dinner was at 6:30 p.m. The rest of the evening was spent in supervised study time in the classroom until 9:30 p.m. The supervisor was the cadre in charge of political education.

By 10:00 p.m. all lights were off.

Sunday was free, marked by the suspension of the broadcast of

William Tell and two meals instead of three. We spent the day doing laundry by hand, sweeping and cleaning our room and the corridor in our dorm, writing letters home, taking a walk in the neighborhood with friends, playing chess and Chinese checkers, or engaging in soccer and basketball games.

Our letters, both incoming and outgoing, were routinely checked by faceless security agents. More than once, a parent wrote back to ask why his or her child had sent an incomprehensible letter written by some unknown person. That was because an incompetent or drowsy security agent had replaced a letter in the wrong envelope after opening and reading a stack of them.

Still, I held on to my hopes. Father admired the Communists. Surely the harsh regimentation, the enforced minimalism, were all part of learning the simplicity required of greatness and part of the individual's sacrifice for the good of the nation. Mao was still a hero to many people in those early days, and as I sank into the rhythms of life at the reform school, I did my best to push away the dark shadow that had hung over me since crossing the border.

———

Political education in the morning began with the study of socialist and Marxist literature, which included the writings of Mao, Stalin, Lenin, Marx, Engels, and various contemporary Chinese Communist leaders.

After that came the study of past and current world events cast in their historical contexts.

The final session of the political education class was devoted to the discussion of important issues such as how to be a good socialist, the value and importance of manual labor, the implication of proletarian dictatorship, and the nature of the Anti-Rightist Campaign or any other mass movement launched by the party in the past and the present.

The leader of my political education class was a woman. A

former low-level political commissar of the Liberation Army, she was a veteran of the Korean War. She always wore a navy-blue outfit, the female version of the semimilitary tunic and pants worn by Mao, Chou En-lai, and all Communist leaders. By then, this outfit of Mao's had become the national uniform, worn everyday by everyone, all 500 million people, across the entire country. The color of the uniform was either blue or gray.

The female version of the Mao tunic had an open neck and short lapels. Lacking breast pockets and their buttoned flaps, it looked less military than the male version. Although Mao made the outfit into a national uniform, Dr. Sun Yat-sen, the leader of the democratic revolution that overturned the Qing dynasty in 1911, was the first Chinese to wear it formally.

With broad cheeks, shining eyes, thin lips, short hair, a slightly raised chin, and a haughty expression, my political education leader would have been an attractive woman if she hadn't carried herself with arrowlike rigidity at all times. One could spot her hundreds of feet away in a crowd because she always folded her hands stiffly behind her back, whether walking or stranding still, as if she were haranguing soldiers in preparation for a battle. She was in her early thirties, unmarried—except to the party. She proved to be as loyal and obedient to the Communist Party as a pious nun utterly devoted to her church.

Her name was Comrade Liu.

On each weekday, she showed up promptly in class at seven in the morning, fresh and ready to rumble. Dispensing political indoctrination with skill and experience, she usually started the class by guiding us through an article authored by one of the Communist "saints." She was good at highlighting the important points, providing a hagiographic outline of the author, and asking us questions to check if we had studied the article beforehand. Each article was treated as gospel or revelation. We were made to believe in it.

Important passages had to be memorized so that we could recite them on command.

After the daily "gospel" we moved on to past and present world events. There, she set the agenda, chose the topics, and taught us the relevant party interpretation, which could not be challenged or altered. The 1956 Hungarian Uprising, for example, was a counterrevolutionary putsch orchestrated by the CIA; the Korean War was a socialist struggle against the ever-expanding Western imperialists, led by the United States; Marshal Tito of Yugoslavia was a despicable revisionist who deserved death by a thousand cuts; and so on.

Having come from Hong Kong, most of the students in my class had been exposed to different interpretations of world events and a wider range of factual information. But if anyone dared to present an opinion different from the party line, Comrade Liu would dismiss it as bourgeois, revisionist, or deviant.

One day, she chose to discuss McCarthyism in America, claiming that it was a capitalist conspiracy to suppress the rising consciousness of the American proletariat. The conspiracy, according to her, was hatched by such arch-capitalists as Rockefeller, Ford, Mellon, and Vanderbilt.

"The American people were against McCarthyism. In particular, the Teamsters, autoworkers, and miners fought valiantly against Joe McCarthy, the ruthless agent of the capitalists," she claimed triumphantly toward the end of her lecture.

At that point, unable to restrain myself any longer, I spoke up to correct her.

"I understand that a significant portion of the American people was behind Joe McCarthy for several years," I said. "They supported him and regarded him as a patriot. I don't believe he was working for the Rockefellers or Fords."

My statement brought on an immediate condemnation. The

corners of her mouth turned down, her eyes ablaze, Comrade Liu barked at me, "You have been under the influence of imperialist propaganda in Hong Kong! You need to shed those poisonous thoughts, which also smack of colonialism and capitalism!"

That shut me up instantly. I couldn't risk being labeled a running dog of colonialists and capitalists. I also couldn't argue with her claim that I had been under the influence of imperialist propaganda. To her, the simple fact of living in a colony constituted indisputable evidence of having been under the influence of heresy.

It crossed my mind that if I had been under any influence at all, it was Father. He talked at length with me about McCarthy in the larger context of political opportunism. By his yardstick, an opportunist was one who failed to take advantage of an opportunity to advance himself *wisely*, and McCarthy proved himself an opportunist only because he did not abide by the principle of moderation.

I knew I mustn't bring up Father in my political class. Uncertain of his standing among the Communists at that time, I thought I'd better keep my political discussions with him a secret.

In all our political education classes, we were instructed to accept the official version and interpretation of world events. Even facts and data that aroused suspicion could not be checked or verified. Indeed, the very existence of facts was dubious. The school didn't have a library, not even a single encyclopedia.

When it came to factual information on history and politics, Comrade Liu served as our authoritative source. We were supposed to regard her as omniscient. When pressed on some issue of which she had scant knowledge—the Communist Party of Italy, for example—she would simply wave it away with the magical words, "It is the party's view that this issue does not require our attention at this moment."

And that would be the end of it. She spoke for the party. No one doubted that.

In the beginning, I, like my fellow classmates, was interested in

hearing her interpretation of political events. Within a couple of months, however, her perspective and analyses became quite predictable. Into her statements she wove a set of formulaic expressions consisting of terms such as "imperialism," "capitalism," "revisionism," "socialism," "Marxism," "Leninism," "hooliganism," "defeatism," "oligarchy," "ruling class," "petite bourgeoisie," "revolutionary spirit," "antagonistic contradiction," "proletarian dictatorship," . . . and so on. After too many iterations, these terms ceased to convey any meaning. They became hollow slogans marked by banality. It was as if she spoke exclusively by rote, repeating endlessly what she had memorized. There was no spontaneity, no new information. Not even an unexpected turn of phrase.

The most abused expression in her diatribes was "the people." Called upon at convenience, as if it were a magic wand, "the people" could support or condemn, glorify or vilify, promote or degrade—anything, anyone, any nation, regardless of the facts.

The most authoritative term in her lexicon was "the party." It combined the wisdom and power of Zeus, Vishnu, Jehovah, Mohammed, and Buddha. Whenever she uttered the word "party," she exuded either an excitement or enthusiasm that carried with it a sweet smile—which made her almost adorable—or a forbidding seriousness that usually heralded an admonishment in the name of that same sacred entity.

She was undoubtedly in love with "the party," if love had a place in her heart.

The word for "party" in Mandarin is just one syllable, pronounced as *dang*. If Comrade Liu began a sentence with *dang*, we knew that either a commandment or an ultimatum was forthcoming. That would be the end, the finale. The Almighty had spoken through her.

At the beginning of the year, all of us in class would jerk to attention upon hearing *dang* from her. After hundreds of iterations

over a few months, it began to sound almost ludicrous, like the *William Tell* Overture broadcast over the loudspeakers twice daily. By the winter months, we had become so inured to that piece of music that we could sleep through the entire broadcast—charging cavalry and all—but for our fear of unpleasant consequences. *Dang* suffered a similar fate: It became a mere space-filler in speech, the equivalent of an "um" or "ah" in spoken English.

For relief, my roommates and I played around with the omnipotent monosyllabic word and made it a mantra for us to ward off evil. For example, if someone farted in our cramped bedroom in the night after the window and door were shut, one of us would yell out loudly, "*Dang,*" and everyone would crack up.

———

I had hoped that my roommates and I would become bosom friends. But camaraderie never developed among us. Other than sharing our distaste for the authoritarian way Comrade Liu handled us, we had very little in common. To me, they were obsessed with survival and pragmatic to a fault. Life revolved around food and material gain. I understood the pressure and urgency of survival. But I also sought relief in imagination, dreaming of traveling the world and experiencing everything and anything that differed from what had been available to me in the past. My roommates, like my siblings before them, thought my imagination and dreams indicated an unstable personality.

The only one who took exception to their view was Mei Sheng-ren. Four years older than I was, Mei called me a "creative nonconformist." He liked discussing life, politics, Marxism, and the human condition with me. Nicknamed "the Theoretician" because of his eloquence and knowledge of philosophy, Mei was bright, erudite, and fearless in his pursuit of reasoned discourse. He had more books than anyone else in our dorm, and probably in the school. Since we had no space for books, he lined them up along the

guardrail of his upper bunk bed. To see him curled up in his bed surrounded by his books always made me think of him as a true bibliophile who not only studied his books but also slept with them.

Most of Mei's books were philosophical tracts beyond my comprehension. My attempts at reading some of them never went very far. Their terminology and convoluted arguments tried my patience. All of us in the dorm room respected Mei for his erudition as well as his moral integrity. He was the one person whom everyone trusted. We felt we could always rely on him for fairness and objectivity.

Beyond my friendship with Mei, which was primarily intellectual, I had wanted to cultivate one with Cai, the guide who had showed me the grounds of the reform school upon my arrival. Unfortunately, the administrative grouping of students at the reform school made it difficult for Cai and me to spend time together. During the year we were there, we met occasionally on Sundays. I always found conversation with him stimulating.

The one bright spot in my new life at the reform school was my continued relationship with Father. I wrote to him weekly, reporting on my activities and thoughts. He wrote back faithfully, exhorting me to work hard and strive for success, bolstering his exhortations with homilies, didactic quotations from great men of the past, and illuminating historical anecdotes. I grew to respect him, even adore him, as a young son normally did regard his father. This new, budding relationship between us had been a source of my optimism and strength in China.

Within a couple of months at the reform school, I and everyone else in my political education class understood that Comrade Liu held the leash on our lives. She determined not only what we read but also what we did. She could change our daily schedule at will, and dole out powerful punishments via criticism and denunciation. Once Comrade Liu had decided that someone harbored a

capitalistic mind, a reactionary attitude, or a counterrevolutionary tendency, that person would become a pariah. He or she could look forward to time in a labor camp. It was as if our society had adopted a revised version of Hinduism and created a new social stratum of "untouchables" composed of capitalists, reactionaries, and counterrevolutionaries.

While Comrade Liu wielded power, she knew next to nothing about science and technology beyond the fact that the earth rotates around the sun and the moon rotates around the earth. But it wasn't her ignorance that stood out so offensively. It was her disdain for science that shocked me. Perhaps I might have been more understanding of her had I considered that she was merely following the party leaders, especially Chairman Mao. It was not until the late 1980s that the world came to understand that Chairman Mao conjured up mass campaigns that repeatedly brought famine and catastrophe to China, causing the loss of tens of millions of lives. The Chairman paid lip service to science and common sense, while in practice he cast them to the wind and ordered the nation to engage in absurd and destructive activities that were not only unscientific but also contrary to common sense.

One such activity I participated in, in the spring of 1958, was the national mobilization to exterminate the "Four Pests." It was the first of a series of disasters precipitated by the Great Helmsman after the Anti-Rightist Campaign.

"National mobilization" meant that all 500 million people in China stopped work in order to take up a single specific task—in this case, the extermination of sparrows, flies, mosquitoes, and rats.

First, the sparrows.

Sparrows, according to the party, consumed precious grain and therefore should be exterminated.

The party ordered people to cover every spot of arable land and human habitation on the entire eastern seaboard, if not the whole

country. They were instructed to bang pots and gongs as loudly as possible to scare the birds into flight. After some time, sparrows, finches, wrens, and robins, along with myriad species of songbirds, dropped to the ground from panic and exhaustion. They were then stomped to death.

This national mobilization continued at a mind-boggling scale for an unthinkable four days, killing millions and millions of birds each day.

The poor birds! I saw them drop onto the ground, twitching, trembling, and heaving from overexertion, eyes half-closed and fluttering from terror. It was an unbearable, ghastly sight. Instead of stomping on them, which I could not do, I wanted to hold them in my hands and cuddle them.

No one knows how the Great Helmsman and his colleagues arrived at the decision to launch the Campaign to Exterminate the Four Pests. An ordinary biologist, if consulted by the Politburo and the Central Committee, could have told them that the campaign to eliminate sparrows amounted to nothing but a folly, for the simple reason that sparrows are opportunistic feeders. They consume some grain during the harvest season, but for most of the year they feed on the bugs and caterpillars that could destroy an agricultural crop.

More important, the mobilization didn't just kill sparrows. It destroyed all birds. Among them were many species that specialized in preying on a great variety of harmful pests. The disappearance of those birds set off unchecked reproduction and infestation of insects, which, among other deleterious effects, devastated agricultural crops for years.

———

After the birds came the flies.

Five hundred million citizens were now armed with flyswatters in another four-day national mobilization. The order from the party was straightforward:

"Stop work, swat flies!"

It didn't take a biologist to see the futility or the absurdity of swatting flies in a country where open sewage provided fertile breeding grounds for flies everywhere, both indoors and out.

Indoor open sewage was a Communist innovation I had never experienced before. By comparison, it made an outhouse in the slum of Nanjing seem like a modern hygienic toilet.

On every floor of each building, there was a toilet consisting of a thirty-foot-long and one-foot-wide ditch cast in concrete. Three-foot-tall walls separated the ditch into ten stalls without doors. You stepped into a stall to relieve yourself by squatting over the ditch.

Feces and urine piled up in the concrete ditch; some hung along the sides. The entire ditch was infested with tens of thousands of maggots. A janitor flushed the ditches with water once every two days. The waste flowed into an underground holding tank from which untreated sewage was retrieved for use as night soil.

Going to the toilet was like going to war.

To begin with, you could be asphyxiated by the ammonia fumes and other noxious odors if you lingered too long. Everyone knew that when you went to the toilet, you had to abide by two important rules:

Rule Number One: "Make it quick!"

Fortunately nobody suffered from constipation. Diarrhea remained a national scourge, as it had been when I lived in the slum of Nanjing. I was so fast that I could hold my breath during an entire visit to a toilet.

Once you learned how to cope with the pungent, revolting fumes, you advanced to the next stage. Here you followed Rule Number Two: "Never stop flailing!"

When you squatted over the concrete trench, flies buzzed and flew at you like kamikaze bombers because you had interrupted their reproductive frenzy. Their hairy legs, dipped in feces, were ghastly to behold. Wherever they landed, they left traces of human

excretion. Attacked by innumerable kamikaze flies, you held your pants with one hand to prevent them from dropping into the waste and flailed away with the other hand as if you were frantically churning water while drowning. Unfortunately, you couldn't win against the flies. They simply overwhelmed you with their numbers. Even flailing incessantly couldn't avoid an outcome of being covered with tiny traces of feces; by faithfully following Rule Number Two you merely avoided total disaster.

Every time I came out of a toilet room, I felt as if I had been wallowing in human waste—like Juan-Juan's kidnapper, who had fallen into the shit pit in the slum through my treachery. But, unlike the kidnapper, I suffered this punishment at least once a day. Each time, I wished I could jump into a lake to clean myself. In the absence of a lake, I could only splash tap water on myself if I happened to go to a toilet at an hour when the water supply was not shut down.

All of the students in the reform school knew, from high school biology, the life cycle of the common fly. Its evolutionary strength lies in its prodigious reproductive capability. During its short life span, each female fly lay tens of thousands of eggs, which hatch into maggots. We understood that swatting flies—even 500 million people swatting flies—would never put a dent in the fly population in a country with raw sewage everywhere facilitating their breeding activities.

One day into the mobilization, my friends, who were mostly my roommates, and I decided to appeal to Comrade Liu for a change of strategy in executing the party's order. We proposed to replace flyswatting with sprinkling lime powder in open sewages every day. Our argument was as simple as it was sensible.

Lime powder was cheap and available. It would kill maggots and prevent flies from laying eggs. If we reduced their reproductive grounds, their numbers would diminish correspondingly because their life span covered at most a couple of weeks.

Comrade Liu was amused.

"Very creative idea!" she commented with a smile. "But swatting flies is a decision made by the party in the central government."

She began to raise her voice.

"Our leaders must have considered all possible methods of eradicating flies before they settled on the best and most effective one. You don't mean to imply that you are wiser than Chairman Mao and Premier Chou, do you?"

Well, I *did,* but I dared not open my mouth.

She had an incomparable knack for bringing up an unimpeachable authority at just the right moment to shut you up. Who would dare to claim that he was wiser than the Great Helmsman and his first deputy?

Unfortunately, shutting us up with an outright rejection of our idea did not go far enough for Comrade Liu. Determined to punish us for our impudence in suggesting an improvement on an order from the party, she sprang a ghastly trap on us.

"Now, to make sure that you will participate in the mobilization with the correct socialist spirit, I will discuss with the party leadership tonight the possibility of launching a competition tomorrow whereby we will award a red flag to the student in each dorm who swats the largest number of flies at the end of the mobilization."

"But how can we count the number of flies we swat? Who is going to verify a person's claim?" I protested.

"You will keep every fly you swat, count them, and turn over to me both the dead flies and your account at the end of the mobilization," she said with satisfaction. "I will verify your number."

Inscrutable and efficient in handling dissent, she had an answer to every question. Our well-intended suggestion had just bought us more trouble.

The next morning, just as Comrade Liu said, the party secretary of the school announced the fly-swatting competition over the

loudspeaker system before breakfast. Every student was ordered to make paper cones or find matchboxes for storing the carcasses. Each time we killed a fly, we were to scoop up the smashed remains and place it in our handmade paper cone.

By the end of the third day, an unbearable stench of rotting fly carcasses permeated our dorm. It was awful.

I sounded the alarm.

"An epidemic of communicable diseases could break out from the rotten flies," I warned my roommates in all seriousness. "It's no longer a laughing matter."

Everyone concurred with me.

That evening before going to bed, my roommates and I fanned out in our dorm building to alert everyone to the risk of storing dead flies in our dormitory rooms. Then we went to other dorm buildings with our flashlights to pass on to others the same warning.

The next morning over breakfast, word spread among us that we should present all paper containers of dead flies to the office of the secretary of the party so that we could demonstrate to him what we had already accomplished. Nobody knew who started the idea, but it sounded reasonable.

By 7:00 a.m. several hundred students, perhaps a third of the student body, had gone to the administration building and laid their paper containers of dead flies at the door of the secretary's office. When I arrived, there was a pile the size of an African termite mound with a frightful, noxious odor that could knock out the fainthearted.

At lunch hour, the party secretary and all of the teachers of political classes—i.e., all the party cadres—assembled in front of us in the dinning hall. The secretary, a short man with square shoulders, a perpetual frown, and a wrinkled forehead, raised a microphone to his lips.

"Listen up!" he said, looking agitated. "I want to know who

initiated the idea of placing dead flies at my door." The microphone squawked into the silence.

No one answered.

There were several minutes of silence.

The cadres, under the watchful eyes of the secretary, started walking among all of the students, scrutinizing everyone's faces to see if someone's facial expression or body language betrayed guilt or knowledge of the culprit.

But, although everyone was tense, no one broke down during the scrutiny, because nobody, as far as I knew, felt guilty. No one knew who had originated the idea. We believed it was reasonable to show the secretary the results of our labor, while at the same time averting a health crisis in the dormitories.

Unable to find the culprit, the secretary and his cadres became furious.

After a brief and hushed meeting on their feet in the dining hall, they came to a decision. The secretary announced solemnly that an investigation, as well as other corrective measures, would be carried out. Then, he and his battalion of cadres marched out.

After lunch, as everyone lay down to nap, Comrade Liu burst into my room.

"On your feet!" she ordered the roomful of us. There were a few murmurs of surprise, but everyone got off their bunks and onto their feet, waiting for her directive. "Straight to the office of the party secretary," Comrade Liu said tersely. She led the way out of the dorm.

As the sixteen of us walked into the secretary's office behind Comrade Liu, he was stone-faced, pacing back and forth behind his large desk, one of the symbols of his elevated status and authority.

A wizened, short fellow with an air of condescension, he was rumored to be a veteran of the Long March, which automatically conferred on him an aura of invincibility and prestige. Less than ten thousand veterans of the Long March survived in a country of

500 million. These veterans were venerated as the original members of the Communist "brotherhood" and the true comrades of Chairman Mao. As the party secretary, he held all the power at the reform school. The superintendent, a figurehead, served as his deputy. The institutionalized hierarchy, with the secretary at the top, was the hallmark of every institution and every bureaucratic unit, including the army. This organizational practice reinforced the party's supremacy and monopoly of power.

After we lined up in front of his desk, the secretary glowered, "Which one of you initiated the idea of dumping dead flies at my door—or was it your collective idea?"

"No, it wasn't!" we answered in unrehearsed unison.

"We heard during breakfast that we were supposed to do it in order to show you how well we have carried out the party's directive," I added.

"Did you put your dead flies here?" he asked me menacingly.

"Yes, I did."

"Did you, you, and you?" he asked, stabbing his fingers at my roommates.

Everyone gave the same affirmative answer.

The secretary shifted into a different line of questioning.

"Did you suggest to Comrade Liu that we should not swat flies?"

"Yes, we did. We thought we had a good strategy to exterminate flies," one of my roommates, Song Lin, responded.

"When Comrade Liu rejected your suggestion, you incited this heinous behavior of placing the dead flies at my door because you were angry, weren't you?" he hissed.

"No, we told you that placing flies at your door wasn't our idea! We followed others because we thought it would be nice for you to see our achievement." Several of us responded simultaneously with slightly different versions of the same defense.

Standing with arms akimbo, he thought for a while, and then

said, "Well, at this moment I cannot prove that you lot are the culprits. But you are not off the hook! We know that you started the rumor of an epidemic disease last night. You are troublemakers. Comrade Liu and I will intensify our effort to reform you after the mobilization."

With that ominous warning, he dismissed us.

Now we were scared, in addition to being furious.

In suggesting the alternative strategy of using lime powder, we had never questioned the party's directive to kill flies. Okay, true, there was an element of mischief in heaping the dead flies at the secretary's door. But Comrade Liu had made it very clear that she meant for us to hand over the dead flies. At worst, we deviated from her order a bit by handing over the flies to a superior. Now the secretary threatened to lower the boom on us.

Leaving the secretary's office with my roommates, I felt the same crushing frustration that overwhelmed me each time Father beat me. It was a frustration that combined anger with despair. I never intended to get in trouble, yet trouble seemed to follow me everywhere. I wished that someone could point out how I might escape my predilection for disaster.

As we took off for another afternoon of fly-swatting, my roommates headed toward the usual dining hall and toilets on campus. I left the campus and wandered toward the commercial center of the suburb, Shipai, where our reform school was located. Along the way, I wished there were mountains like in the New Territories of Hong Kong to ease my anguish of frustration and despair.

There was, of course, no mountain in the suburb of Canton City, which is an alluvial plain created by the Pearl River. But the verdant rice paddy offered its own charms.

With innumerable green tufts in perfect geometric formation, the tall, grasslike rice plants grew out of a sheet of water that extended as far as one could see. When they undulated in the breeze,

the tufts leaned toward each other as if they had coalesced to form a sparkling sea of a tropical paradise.

I sat down by the road to gaze at the rice paddy, and dreamed of sailing away on an imaginary green sea to some hidden paradise like Calypso's island, of which I had learned from a book on Greek mythology in Father's office. I was tired of contending with people and wished to stay away from this hostile world. I thought Ulysses was eccentric, if not silly, to turn down Calypso's entreaty to remain on her magical island. Of course, at the time, I had not yet tasted the joy of a happy marriage or experienced the love of an innocent child. Indeed, the very idea of a family or a home was alien to me in my youth. Ulysses' yearning for Penelope, Telemachus, and his home in Ithaca, while being entertained by Calypso on her paradisiacal island, seemed to me irrefutably strange and incomprehensible.

Hours went by, until hunger jolted me back to reality. It was dinner time, but I was in no hurry to go back to the school. Dinner would be the same fare as always: coarse, low-quality rice, and a small bowl of inedible, tough green vegetables that I had dubbed "Chairman Mao's trees."

Chairman Mao's trees came from green vegetables grown to excessive size. The party had instructed farmers to overgrow green vegetables so that the statistics of harvest were favorable. It was a way for local party leaders to gain brownie points for improving productivity. The cadres enhanced their careers this way, while people got splinters from eating overgrown vegetables that punctured their tongue and cheek.

I had been subjected to this unpalatable diet for nearly eight months without a break. For once, hunger would be a relief.

Then I remembered that I had a job to do; namely, swat flies. Forward to the commercial center!

The so-called commercial center had two food markets, three

general stores, and one restaurant. Like everything in the nation, they were state-owned. People bought their staples and oil with their ration tickets in food markets, clothing and shoes in general stores with another type of ration ticket. Food was scarce and consumer goods mostly unavailable. The store shelves stayed empty most of the time.

The state-owned restaurant in the commercial center rarely had clients. With an income of thirty to forty yuan per month, equivalent to a few U.S. dollars, most people couldn't afford to go to a restaurant. There were also other reasons to avoid restaurants.

Waiters, like everybody, were public employees, with state-established wages. They therefore had no interest in serving customers. Sometimes they would spill food deliberately on customers to show their annoyance. For the same reason, cooks did not want to cook. If they happened to be in a foul mood, they would put cockroaches in your stir-fried pork.

Managers preferred not to deal with customers. Welcoming and seating customers meant work. Instead, they sat in a corner reading a newspaper or chatting with the waiters to pass the time.

Being government employees, the people in the staff did not care to work. Everyone received more or less the same immutable meager salary, regardless of skill or performance. There was absolutely no incentive. Why work?

The only people who ate in restaurants were local party chiefs. They entertained visiting cadres at government expense. The waiters, managers, and cooks wouldn't dare to offend *them*. If they did, they might end up in a labor camp.

In short, restaurants generally served as the private dining halls of party VIPs.

When I walked into the restaurant in Shipai, the sweet aroma of cooked meat drew my attention immediately. There in the middle of the restaurant were four party stalwarts sitting at a table, having a whale of a time, eating dishes of duck, pork, and chicken.

I had not seen a dish of meat or eaten any protein-rich food in eight months. Day in and day out, my diet consisted of tasteless, mealy rice and Chairman Mao's trees. The smell of cooked meat wafting across the restaurant did not merely make my mouth water—it almost brought tears to my eyes.

The men sitting at the table paid no attention to me.

Spontaneously, I walked up to them and without any warning smashed their dish of glistening roast duck with my sticky, dirty flyswatter. In my head, I thought, *Have a little fly goo with your roast duck, buster!*

One of them stood up with clenched teeth. He cocked his arm to swing at me. I took a step back and screamed, "Chairman Mao said, 'Swat flies'! There were flies in your duck dish!"

Then I added, "Chairman Mao also said *not* to resolve internal contradictions among people with violence!"

For a brief moment, the four party stalwarts were stumped and speechless.

Taking advantage of their momentary confusion, I quickly backed off and made my exit.

Out the door I ran as if the ghosts from my old nightmares were chasing me. After rounding a corner and realizing that no one was following me, I slowed down and caught my breath.

Reflecting on what just transpired, I wasn't at all pleased with my mischief. My actions might have been a spontaneous reaction to the glaring privileges of the ruling class, but they signaled to me that my anger and frustration had gotten out of control.

As a little boy, I had resented the authority and privileges of adults. But I did not have much justification for my negative, rebellious sentiments other than the way Father controlled me. Now, as my resentment focused on party cadres, I found that I had a litany of grievances against them.

Preaching to the people, they raised the banner of socialist equality and glorified their efforts to create a classless society. They

praised the virtues of the proletariat, and claimed that their ideology was scientific and progressive. They condemned nonsocialist nations, accused capitalists of enriching themselves through exploitation, excoriated Western politicians as servile stooges of capitalists, and scorned entrepreneurship as the unethical pursuit of money-grubbers.

Yet here, in my own socialist country, they had established themselves as a new ruling class with power on an unprecedented scale, with privileges far in excess of what I had seen among capitalists in Hong Kong! Worst of all, they ruled by arbitrary decree, disdained science and logic, stifled creativity, and made a mockery of freedom. Using their own terminology, I could reasonably claim that they had dragged China from semicolonialism back to feudalism, with the Great Helmsman being the new emperor, members of the Central Committee the new aristocrats, and the party the new oligarchy.

As I walked back to the campus, I began to suspect that returning to China might have been a serious mistake.

But I didn't dare to dwell on it. If I admitted this to myself, the consequences would be devastating. By returning to China, I had closed almost all doors behind me. There was no better description of my predicament at the time than the old cliché of having backed myself into a corner.

I wondered why 500 million fellow citizens sheepishly accepted the shenanigans of their rulers and government. My fellow students and I could not be the only people who recognized the folly of the Campaign to Exterminate Four Pests. Yet no questions were raised, no challenges mounted, and no protests appeared.

Was it fear on the part of the populace, or was it herd mentality deeply rooted in human evolution? Could it be the Confucian emphasis on loyalty and obedience—or could it be our long history of absolute monarchy? Did the repressive instruments of authority make it impossible for the victims to speak out, or were we just in-

herently submissive? Perhaps a combination of all the above had created a docile and accepting populace.

Unsettling thoughts!

Even more puzzling and disturbing to me than the willing servitude of my fellow citizens was Chairman Mao's popular support. Conventional wisdom claims that power corrupts. But from the victim's perspective, much more disturbing than power's corrupting influence is its capacity for self-propelled expansion.

10

A RUDE AWAKENING

AT THE END OF THE CAMPAIGN TO EXTERMI-
nate the Four Pests—there were two more equally disastrous sub-
campaigns, against mosquitoes and rats—Comrade Liu, with the
collaboration of the secretary of the party, announced a new regi-
men specifically for my political education class.

From now on, every Monday afternoon, instead of studying sci-
ence, mathematics, and Chinese, students in my class were required
to engage in sessions of mutual criticism and self-criticism. We had
participated in this bizarre practice twice in the past. Now it would
be a weekly exercise.

Because these sessions could last from one to three hours, we
protested that they would take away precious study time from us
and handicap our performance in the upcoming university entrance
exam, which was held nationally in June.

This protest was dismissed.

The joint practice of self- and mutual criticism meant that each
student had to play the roles of both confessor and inquisitor.

The confessor stood up in class to declare his or her undesirable behaviors and incorrect thoughts. Then, the rest of the class acted as inquisitors by verbally skewering the confessor. In order to demonstrate that you had the promise to become a good socialist, you, as a confessor, would detach yourself from your ego and join the mob to condemn yourself. That might earn you a word of praise afterward from the lord of the play, Comrade Liu.

During this Kafkaesque drama, there was no understanding priest or forgiving God. Just Comrade Liu. She was the producer, the director, and the master of ceremonies. Far from forgiving or understanding like a benevolent priest, she orchestrated and egged on the class to behave like a lynch mob. If the tradition of stoning a wrongdoer still existed—and if we had the stones—she would have made us hurl them at each confessor.

Nobody liked "self-criticism and mutual criticism." To us, it was Comrade Liu's attempt to divide and conquer, another way for her to solidify her authority over us. It sowed dissension and incubated animosity among friends and classmates.

At the first Monday session, no one volunteered to confess. We all sat there, wishing for a hole to hide in. Our lack of "revolutionary spirit"—dubbed "a cowardly bourgeois mentality" by Comrade Liu—unleashed a tirade of condemnation from her on each and every one of us. Her tirade amounted to a summary of all the shortcomings and undesirable qualities she had managed to observe during the past nine months. It was a cathartic display of venom on her part.

I was singled out for arrogance, insubordination, capitalistic deviance, and wise-cracking irreverence, among other things.

I had to quietly admit to myself that her criticism was not without grounds.

Mei was guilty of citing Plato and Aristotle, being obtuse in his philosophical ramblings, misrepresenting Hegel's dialecticism, and,

worst of all, subsuming Marxism, Leninism, and Chairman Mao's thoughts under the heading of "philosophy."

"If not as philosophy, how else are we to categorize the Chairman's thoughts?" my roommate, Mei, retorted.

"Truth! Chairman Mao's thoughts are truth!" Comrade Liu shot back with a stern look.

Mei smiled and didn't respond. His waning smile and body language suggested that he saw the futility of arguing with a true believer. Besides, he had already embarrassed Comrade Liu several times in philosophical discussions with his knowledge and logical mind. He was of the opinion that Comrade Liu might have been a good commissar in the army, but she didn't belong in an educational institution. He could ill afford another confrontation with the boss.

Always taking everything seriously, Mei was not amused by Comrade Liu's groundless criticism. His smile in response to Comrade Liu's assault on the scope and content of philosophy was a tactical retreat, not a concession of defeat.

Neither Mei nor I was surprised when at the end of that first Monday session, where she lambasted everyone, Comrade Liu designated the two of us to lead off the following week's session of self- and mutual criticism. Mei would go first. I was to follow him.

The following Monday, Mei began the afternoon session in his usual serious and measured manner of speech, like a philosopher engaged in deep thought.

"I am ashamed of myself," he intoned, pausing for the words to sink into the audience. "No, I am burdened with more than shame. Even guilt doesn't adequately describe my wrongdoing."

He paused again as he scanned the class in all seriousness.

"I should flagellate myself, put a hair shirt on my chest, and beg for forgiveness from Comrade Liu and every one of you, because I had a dream last night."

Everyone perked up at his exaggerated, melodramatic, self-deprecating preamble. What was Mei up to?

Then he dropped the bomb.

"I dreamed of having sex with Comrade Liu."

At first we all thought we had misheard Mei's words.

No one *ever* talked about sex. Not in our school, not anywhere. Sex never made an appearance in life. It was not in the air. It was not in movies. There was no sex education. There was no courtship between boys and girls. When we studied the human reproductive system in biology, we had to memorize the names of all the anatomical components, from the cervix to the epididymis. But it was just reproductive biology, totally detached and abstracted from life and behavior. Memorizing terms like "clitoris" and "glans penis" was no different from memorizing names like the "triceps muscle" or the "olecranon process" of the ulnar bone. In our daily lives, one would *never* see physical contact, not even hand-holding, between a male and a female. Female bodies were always clad in nondescript Mao uniforms, concealing any curve that could stimulate sexual thoughts; they did not look any different from a male body, except in size. Even though we were young men and women in our late teens, we never imagined sex. Sex simply did not exist. We weren't even aware that we were suppressing sexual thoughts.

In retrospect, perhaps the meager, protein-deficient diet helped us to obliterate the natural physical impulses of youth. Our diet barely kept us alive. Whatever budding libidos we might have had prior to coming here had been starved out of us.

Mei was oblivious to the tension in the room. In that hushed classroom, he carried on with his confession.

"I dreamed of Comrade Liu's oozing orifice flanked by her pink, delicate labia."

There was no mistaking what we heard now.

Each word echoed in our ears as clear as a marble dropping on a jade plate: *orifice, labia, oozing.*

Just hearing them made me dizzy.

Comrade Liu exploded, "Stop your lewd speech!"

Her eyes blazed with anger, and her face betrayed distress.

"Please do not interrupt my self-criticism. I take every order from the party seriously," Mei countered calmly. He went on, "My member was as hard as steel. I—"

"Shut up, you despicable dog! You are an animal!" Comrade Liu screamed desperately, thrusting her right hand at Mei in a gesture of rebuttal. Tears started streaming down her cheeks. She stood up, her chair crashing behind her, and stormed out of the classroom.

"Well, that's the end of self- and mutual criticism for this week," Mei said matter-of-factly.

Some in the classroom thought Mei had overstepped the boundaries of decency, but most of us looked at him in awe as we dispersed from our classroom.

His courage knew no bounds.

Until that day, nobody could imagine Comrade Liu, the inscrutable and unflappable iron lady, in tears. But it had happened, and it was Mei, our theoretician and philosopher, who made it happen. Comrade Liu, the great authority and the embodiment of *dang*, had been lampooned.

We were sure that Comrade Liu dashed out of the classroom because she had lost face by allowing herself to break down in tears. We never tried to fathom why she cried. Her anger, we understood. But her tears? Unfortunately, none of us knew Freudian psychology.

Three days later, Mei received a written notification from the superintendent informing him that he was no longer welcome in the reform school. He was given a choice of returning to Hong Kong or joining an extremely primitive collective farm on Hainan Island in the Golf of Tonkin.

The party, the missive went on to explain, considered the collective farm the best place for serious thought reform, for cleansing oneself of the toxic remains of colonialism and capitalism.

Without any hesitation Mei opted for the farm, on the grounds that he was a committed Marxist, and a Marxist should live in a Marxist country.

"I have paid my dues in a British colony," he told me. "It's time to live in my own country."

With that declaration, Mei left in good spirits the following Monday. In his farewell, he told me that he was glad that from now on he would be living among the real proletariat, not the lying, scheming, and brainless likes of Comrade Liu.

Even though Mei had left the school, Comrade Liu was never the same after that incident. She no longer put people down in a knee-jerk reaction to dissent. She stopped addressing us in her usual unreserved, authoritarian manner. She was no longer as focused as before in her control of us. Sometimes she even appeared morose and absentminded.

Her transformation disconcerted us, since now we could no longer predict her moods and behavior. It was strange how we had fallen victim to familiarity, even oppressive familiarity. We preferred predictable oppression to the unknown. Comrade Liu's unpredictability raised our anxiety levels. Sometimes she went ballistic over the slightest provocation. Other times she failed to respond to a blatant challenge to her authority. Sometimes she acted as if she were lost, so much so that she didn't even acknowledge a student's question. Paradoxically, we became more guarded and circumspect in her presence than we were when she acted predictably as an oppressor. Some of us actually began to feel sorry for her.

Without Comrade Liu's ironfisted shepherding, the Monday afternoon self- and mutual-criticism session degenerated into a farce of formulaic confessions and lackadaisical condemnations. Comrade Liu watched our charade without much interference or interest.

Fortunately, there was less than a month remaining for us to suffer from her malaise. The national university entrance exam was coming up. We could go home after the exam for the summer and come back to China to attend university the following fall.

The national university entrance exam lasted for two days in June. The subjects of the exam included Chinese literature, political thought, physics, chemistry, biology, and mathematics. I wasn't nervous during the exams, and I thought I aced the science and mathematics parts. The Chinese and political thought exams were easy, but I couldn't be as sure of my performance in those two subjects because they involved writing essays as well as answering questions on factual information.

After the two-day ordeal, I exuded confidence, believing that I would be admitted to the top two institutions of my choice.

I had made the Bejing Institute of Geology my first choice in my application, because I thought, as a geologist, I would be able to explore all sorts of exotic places. My second choice was the Northwest Institute of Geology in the Uighur Autonomous Region, also known as Chinese Turkistan, three thousand miles west of Beijing. Central Asia's magnificent steppes and mountains had always stirred my imagination. If I couldn't get into the top-ranked Beijing Institute of Geology, I would gladly be in the sparsely populated Uighur Autonomous Region, free to roam among its majestic grassland, mountains, and glaciers.

Three weeks later, the results of the entrance exams were announced.

To this day, I cannot quite remember how it happened. I know the exam results were announced. I can no longer recall how. Were they posted as they had been in my father's day, on large paper banners, pasted to the school walls? Were they mailed to us individually? Were we called into our classrooms and handed slips of paper

with our names, scores, universities? Did one of the cadres walk around the dorms and distribute a list?

Perhaps the impact of the occasion was too traumatic, too painful, too devastating, and as a consequence I blocked it out of my memory. Even my diary remained blank for several days.

What I do recall is my consternation and utter bewilderment when I learned that I had failed the exams.

I had not gotten into either the Beijing Institute or the Northwestern Institute of Geology. I had not gotten into any university at all.

Four days later, I went to seek an explanation from Comrade Liu.

When I showed up in her office unannounced, she seemed to have been expecting my visit. She looked cool and collected, like the confident, authoritarian Comrade Liu of pre-Mei days.

"You've come to ask me why you are not granted admission to a university," she said with a smile. But the smile had a sting to it. "Well," she announced with ill-concealed glee, "you are politically unfit to become a student in a university."

I must have made some sound of shock or protest. She put up her hand to stop me. Looking me in the eyes, she said, "We know of your father. Tell him that he is not welcome in China. On this point, I speak with the authority of the Committee on Overseas Chinese Affairs of our central government."

Then she said something that rocked me to the core. "Your father made a mistake by sending you back. He wanted to test the waters to see if he could rehabilitate himself politically in China."

Each word was like a blow to my face, a stab in my chest. Comrade Liu saw it, and spoke clearly so that I would miss nothing. She thought that I was there under Father's direction, acting on his behalf. She thought that telling me he was unwelcome would hurt me.

"Well, get this clear." She cleared her throat and raised her voice. "*We don't want him!*

"He is a traitor, and if he returns we will put him in jail and punish him for his role in Wang Jing-wei's collaborationist government. Make sure that you pass on my message to him." Her eyes glinted with satisfaction.

I felt nauseous and ill, clammy even in the early summer heat. I don't remember what I said to her. I don't remember if I said anything at all. I turned and left the room, stumbling back to my dorm. The world seemed hazy and unreal.

The rejection wreaked havoc on my psyche. For two days, I couldn't eat and barely talked to anyone. Depression would be an inadequate description of my mental state; utter despondency was closer to accurate.

In addition to the pain of failure, Comrade Liu had capped my devastation by blowing me to pieces with her message for Father. She had made sure that the final curtain fell in front of me under her watchful eye.

She had unintentionally succeeded in revealing Father's hidden agenda—and destroying my trust in him. It was a trust that had been developing during the past three years after Father had initiated my political education. I had begun to treasure our rapport, which was inching toward a normal and affectionate father-son relationship.

Now that entire part of me had been shattered like a dropped vase. Gone. Vanished!

Comrade Liu's message had all the more effectively demolished my hopes for a relationship with Father because she did not intend to do so. She inadvertently made me understand why Father had taken the time and made the effort to mentor me.

Father was thinking about himself all that time when he tutored me in politics. He wanted me to serve as his trial balloon.

He had lured me into thinking that returning to China could lead to a bright future, but in reality it was his ambition to restart his political career by seeking acceptance from the Communists.

In that moment I understood that no matter how much Father yearned for acceptance by the Communists, he couldn't afford to return to China himself without some positive signal from them. He knew, as Comrade Liu said, that they could put him on trial again for collaboration with the Japanese during World War II and send him to jail.

So he had sent me instead.

How could I not have seen it? Even Comrade Liu had figured it out.

I should have caught on to his scheme, since his whole life was consumed by political ambition. In his political discussions with me, he made clear that he no longer detested Communists. In fact, he repeatedly praised Mao and other Communist leaders. He had coaxed and manipulated me into playing the role of his pawn, his mine-shaft canary, to learn how the Communists would respond to an overture from him.

Nobody knew that he and I had a strained relationship unlike any other Chinese father and son. The cadre who guided me from the border to the reform school had hit it right on the nail when he commented, "You have an unusual family." But he did not know the extent to which my family was unusual.

In Chinese culture, father and son are an inseparable unit. During the imperial days, capital punishment was often meted out to both father and son if one had committed a serious crime. During Mao's Cultural Revolution, in the days to come, millions suffered unspeakable punishment because a father or son had been designated a counterrevolutionary. This, in fact, was precisely what happened to my half sisters, the children Father sired in his native village, during the Cultural Revolution: they were tortured and "struggled against" on account of a father they had never even met or seen.

It was natural that the Committee of Overseas Chinese Affairs saw my return to China as a probe, an overture by Father, not a

young man's attempt to seek a future and forge a career in his own country. Comrade Liu understood this. Father certainly knew that the Communists would likely view my return in that light. I was just too naïve to see through his ploy.

Comrade Liu's words marked the end of a dream of forging a career in my own country. I had been rejected not because of my own misdeeds, but because I was the son of a collaborator and archreactionary. I had no choice left but to acknowledge the end of my future in China and consent to return to Hong Kong.

———————

In high school, I had been vaguely aware of the risk of returning to China, but not of the kind that ultimately befell me.

With the cold war against the Communist bloc raging at a fever pitch and the Korean War fresh in people's memory, the Western Allies demonized China, as well as any person associated with it during the 1950s. The Chinese were regularly depicted as devious and dangerous in the Western media. Sax Rohmer's earlier racist portrayal of the Chinese in the form of the villainous Dr. Fu Manchu enjoyed a considerable popular revival in American television during the 1950s. At the same time, the Australian prime minister, Robert Gordon Menzies, had openly warned the world of a "Yellow Peril."

A sympathizer with Communist China in Hong Kong was considered dangerous and a potential spy, not to be granted an entry visa to any country in the West.

I was worse than a sympathizer, having voluntarily returned to China.

I was also more contemptible than a Chinese Communist because I had tried and failed to be one.

Mother had warned me before I went back. But Father was more persuasive, and he was the one who had held the purse strings. By withholding financial support from me, he had made my return a foregone conclusion.

Now that China had slammed the door shut in my face, I became not only stateless, but was also denied of any future. There would be no chance for me to have a college education anywhere, and without a college education, I had no marketable skill and no prospect for a career—any career.

I could swallow my pride and apply for a clerical job in Hong Kong, assuming that a sympathetic employer would hire me. I could imagine the derision and laughter if I managed to become a clerk in a company. As an employee, I would always have to endure the ridicule:

"Here is Dumb Li, who couldn't make it as a Communist!"

In that small enclave of Hong Kong, where unbridled entrepreneurship would eventually supplant colonial rule, whatever I chose to do, people would assess me for the rest of my life—at best, as a nobody; and at worst, as an abject failure.

PART V

HONG KONG

1958–1961

11

VULGAR MATERIALISM

IF I HAD RETURNED TO CHINA WITH A HEAVY heart, wary of what lay ahead of me, I left it a broken man, clueless about how life could go on.

Crossing the border into Hong Kong on July 16, 1958, I was an eighteen-year-old without a purpose, a mission, or a plan in life. I had no money, no prospects, and no family. I didn't even have a place to return to in Hong Kong.

Father's office was out of question. He had used me in cold blood. I didn't want to see him—just thinking of him made me seethe with anger.

I headed to Mother's seminary.

When Mother saw me in the reception room, her face betrayed her shock.

I had not written to her or Father that I had failed to win admission to college and was returning to Hong Kong, but that was only a small part of her astonishment. For a moment she gazed at me without uttering a word. Then she said:

"You look like a ghost! What has happened?"

"I have been rejected," I said blankly, meaning to stop there, but suddenly the words poured out.

"Father used me as a probing stick. The Communists explained it to me. He is not wanted there, and neither is his son!"

Like my words, my tears started to gush out, and they kept on spilling even though I tried to wipe my face dry with my hands. I was choking as I broke down sobbing. So I gave up on trying to hold back my emotions, and allowed myself to cry my heart out.

When I stopped, Mother said, "I am going to get some food for you. You look like you will soon faint if you don't take some nourishment."

She looked at me another moment, her brow slightly furrowed, then left me sitting.

Fifteen minutes later, she returned with a big bowl of noodle soup with sliced pork, mushrooms, and vegetables. After almost a year of living on coarse, mealy rice and Chairman Mao's chopped-up tree branches, I had forgotten what real food tasted like. The soup, with its delicious aroma, overwhelmed my senses.

Tears started running down my cheeks again. They fell into my noodle soup as I gulped it down.

Watching me, Mother shifted uncomfortably in her chair. She was a slender woman but looked, to my flesh-starved eyes, well-fed and healthy. I couldn't stop looking at her.

When I finished eating, she asked, "Why are you so thin and so pale?"

"Am I?" I said, a little surprised. "I have not seen myself in a mirror since I went back to China."

"Well, we will have to restore your health. In the meantime, what do you intend to do?"

"I don't know that, either. But first I need a place to stay. I am not going to Father's office."

If my tone of voice took Mother by surprise, she didn't show it.

She thought for a few moments. She had no financial resources and scant social connections, but after pondering for some time, she said, "Perhaps we can try the Tongs. They took over the apartment we used to have in the New Territories. We helped them when they fell on hard times. Maybe they are willing to shelter you temporarily. I'll go with you to ask them."

I can't begin to imagine what went through Mother's mind as we stepped into the spacious garden of our former home a few hours later. This was the home from which she had walked out on Father more than four years ago. Her face betrayed no emotion. All business, she didn't say a word as she led me through the garden toward our old apartment, now occupied by the Tongs.

The motley collection of trees and flowering plants in the garden remained the same: jasmine, magnolia, guava, plumeria, bamboo, and various tropical vegetations. Seeing them stirred up an almost unbearable flood of memory that had until then receded into the distant past. I felt overwhelmed as I recalled my first taste of nature, my love of animals, my fear of ghosts, conflict with Father, the lesson of expulsion from school, the taste of racial discrimination at the hands of the British, Mother's unique "divorce" from Father. I tried not to dwell on them, but they flashed through my mind anyway, as if they, being associated with the place, had their own will.

When Mr. and Mrs. Tong saw me, the first words out of their mouths were almost exactly the same as what Mother had said a few hours ago.

"*Aiyah!* Why are you so thin and so pale?"

Their question stirred up an irresistible desire in me to see what I looked like in a mirror. When I did, I was taken aback.

My hair had lost its luster. It had reverted to what it once was, tufts of dried dark-brown weeds standing in protest on my head. My eyes were droopy, my lips looked swollen and colorless, my cheeks were sunken, and my skin was sallow. I looked horrific, like an anorexic waif.

I wasn't aware that I had lost so much weight. I had always been skinny. In China, I felt skinnier. But everyone looked skinny in the reform school, and people didn't pay any attention to their bodies, thinking this "frivolous." Why should anyone care what his body looked like as long as it didn't hurt? Besides, it was always covered.

When I had a chance to get on a scale at a rice shop two days later, I realized that it was no wonder that Mother and the Tongs had reacted to the sight of me with such alarm and exclamation. My weight stood at ninety-six pounds. I was six feet tall.

The Tongs welcomed me with open arms. They were a happy family, an elderly couple who doted on a young daughter. Their grown-up son had already left home. It was a new experience for me to live in a family where everyone talked to everyone else. Such a dramatic contrast with my taciturn parents! Before living with the Tongs, I thought silence was the norm of family life.

The first month, I didn't do much besides sleep, suck down noodle soup—and any other dishes Mrs. Tong prepared—with great enthusiasm, and sit listlessly. I slept and woke when the others did and responded politely when questioned, but I did not open myself up, either to myself or to my companions. While my body was repairing itself, my mind was sunk in lethargy and depression. I felt like a failure, purposeless, dejected, worthless.

A few things happened to change that.

First, Mrs. Tong helped me to get on my feet financially. A kind and calm matron, Mrs. Tong was a physics teacher in high school. But unlike the physics and mathematics teachers at my high school, she didn't run any review classes at home to augment her income, even though many students in her class asked her for them. She thought the practice was unethical. My presence allowed her to respond to those students who needed extra attention in mathematics

and physics. She recommended me to their families as a private tutor when school started in August.

Once a week, I went to the home of each student to help him or her learn mathematics and physics for two to three hours. The work gave me an opportunity to demonstrate my command of a body of knowledge that I had acquired in high school and that had become almost second nature to me because of the year of daily preparation for university entrance examinations in the reform school.

I discovered that I had a knack for developing rapport with my students. I was chronologically young, only one or two years older than they were, making us contemporaries with hardly any age gap, but emotionally and psychologically I was many years their elder. My experience in life far exceeded their sheltered and wealthy upbringings, which gave me the necessary distance to understand them and be patient with their complaints and troubles. For their part, the students respected me for my knowledge and wisdom, and liked me for my energy, wit, and resourcefulness. They connected with me almost instantly.

Most of these students were intelligent. Some suffered from the excessive pressure of unreasonable expectations from their parents, and thus performed sub-par academically. Some lacked the motivation to work hard because their parents paid no attention to them beyond provisioning them lavishly. Doing poorly in school was their passive, yet effective, way of striking back at their parents. Some were accustomed to so much wealth in life that they didn't feel the need to pursue anything with determination, and still others were so intimidated in school that they had convinced themselves of their lack of aptitude for mathematics and science, even though they were actually quite capable. These browbeaten youngsters, hammered down by a rigid and unforgiving educational system, needed encouragement and positive reinforcement to overcome their fear and inferiority complexes.

All of them, for one reason or another, mucked around in school, fell behind, and quickly found themselves no longer capable of keeping up with their courses in mathematics and science. A few were on the brink of flunking out of school entirely.

As my pupils' new buddy, one who would neither judge, punish, nor berate them, I won their trust and confidence easily. Getting them to reveal their grievances to me meant that I had progressed two-thirds of the way toward transforming them into creditable students. They needed some technical help here and there, true, but much more important, they needed someone to hold their hand, understand their feelings, and counsel them with empathy.

The rewards of tutoring went in both directions. My success in helping the students to help themselves led to the warm glow of many new friendships and congenial feelings. And for my part, the gratitude and adoration I received from my pupils and their families made me feel that life was worth living again. Slowly I began to overcome my self-perception as an abject failure—a constant cause of depression since leaving China.

I liked my pupils, enjoyed tutoring them, and took pride in their academic improvement. Each time a pupil battled his way up from the brink of academic disqualification to B-level standing, I celebrated by taking him to a good restaurant. I was not only proud of his achievement but felt also that I had accomplished something worthwhile.

Within six months, my reputation as a tutor had grown immensely by word of mouth and my services were in great demand. Every family wanted their children to do well in school, and if they could retain my services to achieve that goal, they didn't mind paying me whatever fees I charged. Some parents considered me a miracle worker who transformed their allegedly incompetent child into an intelligent student within one semester. They failed to understand that I did not make their child any smarter—I merely helped the child to awaken to his own capability.

I tutored scores of students and expanded my range of academic subjects from mathematics and physics to all the sciences, and English as well.

Tutoring yielded me a handsome income. I had never earned money before, nor had I ever been given any money. Mother didn't give me any when we lived in the slum. Aunt Helen didn't in Shanghai. Father, of course, made me feel like a beggar, if not a criminal, whenever he had to spend any money on my clothing or school supplies. I would never have dreamed of asking money from him. Da-ge in Shanghai used to buy me a lollipop now and then, and of course I never forgot the time he treated me to an ice cream sundae. Back then I thought he had a magic pocket in his pants that grew money.

The parents of my pupils paid me cash after each tutoring session—twenty-five Hong Kong dollars. It was a lot of money for me at a time when one could buy a good meal, freshly cooked by a street vendor, for three Hong Kong dollars. With the first batch of money in hand, I was exhilarated, in addition to feeling a growing sense of independence and empowerment.

For weeks I relished the feel of bills in my pocket. It gave me hope for taking the next step in life beyond survival, even though I didn't have the faintest idea what it would be. Being self-sufficient with an income made me feel born-again, not in the Christian sense, but as a person starting afresh—and start afresh I did!

Soon I was able to rent a room in the back of an apartment in the city of Kowloon and began to live the life of an independent young bachelor, eating most of my meals in restaurants and becoming an avid consumer. I enjoyed generously treating my friends to restaurants. Most of them were my pupils.

When I discovered shopping and conspicuous consumption in 1959, Hong Kong had only just begun to move onto the fast track of economic development. Both the island and Kowloon Peninsula still looked like a Third World city, full of street peddlers and stodgy buildings. The tallest structure in Kowloon was the old Peninsula

Hotel, and the most imposing building on the Hong Kong side was the old Bank of China, not the glittering steel-and-glass high-rise designed by I. M. Pei in the 1990s. The Victoria Strait, which separates Hong Kong from Kowloon, was much wider in those days; in later years the government kept on filling it in—and thus narrowing the harbor—in order to make land available for development as Hong Kong embarked on a path of dramatic economic expansion in the 1960s.

Shopping was a new experience for me. In the past when I needed clothing, shoes, or school supplies, Father always took me to the most inexpensive street vendors and picked out the cheapest items for me. Now, with money to go to department stores, boutiques, and tailors, I indulged.

I had shirts, pants, and suits tailor-made to fit my slender build. I acquired elegant ties and bought gold-plated cuff links with matching tie clips. I squandered money on dandy socks and imported shoes.

But shopping soon lost its appeal for me. Within a couple of months, the novelty wore off, and instead of being an exciting adventure, it became a tedious chore, to the point where if I had to shop, I first made up my mind on exactly what I needed and then made a beeline to acquire it in the shortest amount of time possible.

When I was not tutoring, I lounged in elegant hotels, sipping English tea with cream and sugar and eating dainty little sandwiches made with cucumbers, chopped eggs, or boiled ham. Decked out in sartorial elegance, I read English as well as Chinese newspapers and magazines while reclining in a comfortable chair in front of my tea and sandwiches served by uniformed waiters.

In the evenings, I went to movies and visited nightclubs, sometimes alone, sometimes with my pupils. Traditional nightclubs featured local bands performing jazz and other popular music originally played by such artists as Glen Miller, Artie Shaw, Benny

Goodman, Tommy Dorsey, Count Basie, and Duke Ellington. In the late 1950s, rock and roll was new to Hong Kong. Avant-garde nightclubs had bands that played more up-to-date music, such as Bill Haley's "Rock Around the Clock" and Elvis Presley's "See You Later Alligator," two of the local favorites.

I thought rock and roll was hilarious. With its fast tempo, pounding rhythms, and often strained, high-pitched vocals, it seemed to be designed to incite people to riot, or at least shed all constraints and inhibitions. I couldn't help but imagine what would happen if, instead of Rossini's *William Tell* Overture, my reform school in Guangzhou broadcasted rock-and-roll music! People would probably shun it as incoherent noise, but if they resonated with it, all hell could break loose. I laughed loudly by myself imagining the impossible scenario of Comrade Liu loosening up to Elvis's cooing and gyrations!

In retrospect, the transformation in my life from abject deprivation in the reform school to conspicuous consumption in Hong Kong was so swift and dramatic that I still find it astonishing that it didn't cause as much as a ripple in my psychological state. I took to luxury living without a hitch, as if I were brought up in it.

Perhaps I felt entitled, after years of deprivation. Perhaps moving from poverty to affluence is inherently smooth for anyone, and only sliding in the other direction is painful and jarring. Or perhaps I was too numb at the time to feel the emotions such a transformation would normally engender.

I have no good explanation, though I now suspect that my habitual, till-then lifelong contempt for conspicuous consumption might have been a defensive mechanism all along, promoted and encouraged through Communist indoctrination during my year at the reform school. At the least, it seems that "vulgar materialism," contrary to what Comrade Liu taught us, is not without its merits, and deserves reconsideration!

I lived not far from Mother's seminary, which was also in Kow-loon, and brought her fresh flowers every week. On weekends, I invited her to dim sum in a teahouse or for dinner in a restaurant. We still didn't have too much to talk about. When we did speak to each other, she liked to focus on my future, which I didn't wish to think about at the time, partly because I could envision nothing on the horizon, and partly because I wanted a break from living and planning for any future at all.

The "future" was what I had lived for in Father's office and in the reform school. And it all came to naught!

As for the present, Mother observed rather noncommittally that I was "wallowing in materialism."

"I rather enjoy it," I confessed half-abashedly.

Mother laughed, finding my forthright confession amusing.

"I suppose you've earned the right to some indulgence," she yielded. But she never ceased to give me advice, admonishing me not to stop seeking further education and developing myself intel-lectually. It was delivered gently, but over time her advice found its mark.

We did not talk about my father or my time in China. Once, Mother brought up his name in passing. My whole belly clenched with anger. I still felt sick at the thought of his plot to use me as a probe in China.

At Mother's behest, I enrolled in a newly established post-secondary institution in the New Territories to take courses in mathematics, physics, philosophy, and English literature. The insti-tution, named Chung Chi (or Worship Christ), assumed the tradi-tional designation "Xue Yuan," which means "an institute of learning." This was the same designation Mother's theological seminary used, because the University of Hong Kong, a British uni-

versity, held a monopoly on the term "university." The colonial government prohibited the granting of bachelor's degrees outside the University of Hong Kong.

The driving force behind Chung Chi was Andrew Roy, a remarkable man who had spent decades as a Presbyterian missionary in China after earning a Ph.D. in philosophy at Princeton. A tall, handsome, elderly man, Dr. Roy always glowed with warmth and enthusiasm. His kindness was saintly, and his optimism, contagious. If all the missionaries and proselytizers shared only half of his spirit and munificence, I felt, the whole world could have become Christian!

Dr. Roy taught courses on Plato and Socrates. I audited one, and participated in many incredibly stimulating discussions on justice, human nature, forms of government, the essence of knowledge, and the relationship between the individual and society. I would give anything for another round of conversation with him in light of our current understanding of the biological foundation of human nature.

I also took other philosophy courses. Mei ("the Theoretician"), my erstwhile roommate at the reform school, had been the one who initially aroused my curiosity on the subject. At the reform school, Mei spoke of Descartes, Hobbes, Jean-Jacques Rousseau, Kant, Hegel, Adam Smith, and others. I wanted to find out who they were and what was the essence of their philosophy.

Another teacher at Chung Chi awakened my interest in literature. Dr. Hansman was an English missionary who taught a yearlong survey course on English literature, ranging from the Renaissance period to the Romantic Age. A no-nonsense taskmaster, she demanded weekly ten-page papers from each student on selected works of the literary greats: Edmund Spenser and Shakespeare, Milton and John Donne, Dryden, Jonathan Swift, Samuel Johnson, and so many others. Under her guidance, I made my first

foray into English composition and discovered a lifelong affinity for both the challenges and the rewards of writing in English.

Prior to attending Chung Chi, studying and going to school had always served as a means to an end, with a specific utilitarian goal. At the very beginning of my education in Hong Kong, seven years ago, the goal had been to appease Father—an escape from physical punishment and a strategy for gaining food and shelter. Later, the goal switched to conventional success in China during my high school years. I studied in order to win admission to a major university in China, which, in turn, could lead to a career, possibly as a technocrat. Father's wish for me to climb the ladder of prestige and power had always loomed in the back of my mind, even though I didn't want to be a politician. As much as I wanted to dismiss it, I could not completely overcome my lifelong indoctrination: a father's wish was an inalienable command!

At Chung Chi I had no practical goals. I didn't take courses there in order to earn a better income or seek an eight-to-five job after graduation. In 1959, the postsecondary Christian institution offered a smorgasbord of courses without the colonial government's authorization to confer a degree or society's recognition to enhance the employment prospect of its graduate. It didn't pretend to be anyone's stepping-stone for conventional success: it existed purely for the sake of providing an education for young people who could go no further after secondary school. For the first time, I pursued learning according to my own interests and curiosity, without any utilitarian concern.

It was a refreshing experience.

Of course, what I learned at Chung Chi barely scratched the surface of the works of the great Western philosophers and literary giants. But the first step toward satisfying a long-held curiosity, like the first sip of water after an arduous trek in the desert, always brings the most gratifying pleasure. Chung Chi gave me the opportunity to take that first step.

Many months after I had become comfortably ensconced in my new life in Hong Kong, I ran into a schoolmate, Cheng Yi-ming, from my dorm in the reform school in Guangzhou. A tall and handsome fellow whose father worked in a textile factory in Hong Kong, Cheng was in my political education class under Comrade Liu. We were not close. A reserved and cautious fellow, he considered me rash and insolent, whereas I placed him among the dull and cowardly in the reform school.

At the time of our unexpected meeting, we were walking in opposite directions on Nathan Road, the main thoroughfare of Kowloon, when we saw each other. He happened to be between interviews for a clerical job in a clothing store; I, on my way to brunch at a teahouse. The pleasure of an unexpected reunion cast aside our differences. We shook hands warmly.

"Hi, Yi-ming. Fancy meeting you here!" I said.

"Gee, Li Na"—he looked at me up and down—"you must have won the lottery!"

Knowing that he came from a poor family, I responded, "No, I am far from being rich. I have to dress well in order to tutor kids from wealthy families." Then I quickly changed the topic. "When did you return to Hong Kong?"

"About a month ago. I couldn't take it anymore. Chairman Mao's Great Leap Forward Movement is wreaking havoc on people's lives. Many have died from starvation."

I looked at him. Even after one month in Hong Kong, his pallid face and sunken eyes still bore the effects of the ordeal he had gone through.

"What happened in our reform school?" I enquired.

"They started rationing the rice," Cheng said. "When you left, we could still eat as much rice as we wanted during lunch and dinner. As you know, it wasn't good rice, but it filled our stomachs.

About four months into the Great Leap Forward, each student re-
ceived only six ounces per meal, less than half of what most of us
needed. Then, what you used to call derisively 'Chairman Mao's
trees' was no longer available. Instead we got a tiny dish of pickled
radishes to accompany our rationed rice. Two months after that,
they cut out lunch. My stomach growled incessantly. So I came
back to Hong Kong."

Cheng's account shocked me. The Great Leap Forward had
been front-page news, but I had seen nothing about China's starva-
tion in the media of Hong Kong. Chairman Mao called upon the
entire population to help increase the nation's steel production and
accelerate China's march toward socialism. Farmers stopped farm-
ing, students stopped studying, workers stopped working. People
melted down everything made of iron, from pots and knives to
window frames and doorknobs, in backyard "iron furnaces." The
media in Hong Kong predicted catastrophic consequences for the
nation's economy. Cheng's personal experience yielded a hint of
the extent of that calamity. Later on it came out that the Great
Leap Forward caused widespread famine in the nation and the
death of millions of people in rural areas.

Who could imagine that the folly of one mad emperor could
cause such extensive suffering for hundreds of millions of people?

I invited Cheng to a teahouse as my guest so that we could con-
tinue our conversation. He told me that Comrade Liu and the sec-
retary of the party remained in control, as ever, that many new
students had come from overseas, that all the students had to work
at the "iron furnaces" in the nearby villages, and that life had be-
came even more regimented than when I was there. In spite of suf-
fering from a starvation diet, no one dared to speak against the
Great Leap Forward. The great mass of people, in silence, endured
the agony and depravation inflicted upon them like a herd of ani-
mals standing motionless in a violent rainstorm on an African sa-
vanna.

Sadly, the Great Leap Forward was not the only shocking news from Cheng.

"Mei, our resident philosopher and friend, died two months before I left," Cheng informed me toward the end of our lunch. "The unofficial news, which originated from the Office of the Political Cadres, is that Mei committed suicide by hanging himself at his collective farm on Hainan Island."

I could see Mei taking his life under certain circumstances. He was a proud man, and had always articulated the principle that life was worth living only with dignity. He became a Marxist because he believed that Marxism would free the oppressed from their servitude. Poverty did not degrade people, he thought, servitude did.

I fell into a long silence at the news of Mei's death. He had always been a symbol of courage to me.

As I grieved the loss of a friend I adored and respected, Cheng suddenly caught sight of the clock on the wall of the teahouse.

"I have to go," he announced in a panicky voice. "I'm late for my interview. Thank you for dim sum!"

I dreamily shook hands with him as he said good-bye, not even having the presence of mind to ask him for his address. After a while, I paid the bill and walked into the tropical sun, feeling dazed and listless.

Since returning to Hong Kong, I had consciously sequestered my China experience in a hidden corner of my memory. I didn't want to think about it or deal with it—especially not what it revealed about my relationship with Father. Now this unexpected encounter with Cheng unleashed a flood of memories into the forefront of my consciousness. Sadness, anger, remorse, and frustration churned inside me. I fought to keep myself from yielding to melancholia. My failed sojourn in China was inextricably linked to Father, whom I had been trying to blot out of my life. I didn't want to confront what Comrade Liu had told me about him, and I didn't want to see him.

But for reasons I couldn't quite articulate, the death of Mei and the resurgence of memories of my China experience made me feel that it was time to pay Father a visit. Perhaps I no longer felt angry toward him. Perhaps reestablishing contact with him would put a closure to my venture in China.

The next Saturday afternoon, I showed up at Father's office without warning.

He was sitting in his bedroom, sipping a glass of Dubonnet, munching fried peanuts, and reading a book. As I walked into his room, he remained in his seat, paying barely any attention to my sudden appearance after almost two years of separation. He looked sullen and grim.

I stood in front of him, not knowing what to do or say.

He finally put his book down and cast a glance at me. "Why are you here?"

"To pay you a visit," I said calmly.

"You've been in Hong Kong for almost one year," he barked with sarcasm. "*Now* you are paying me a visit?" He raised his head to stare at me.

I knew that he would have heard of my return to Hong Kong through his friends via the gossip channels. The exiled politicians in Hong Kong formed a social circle. They might not all be friendly with one another, but they sustained their connections through gossip. Mr. Tong, who had graciously accommodated me in his home for three months, belonged to that circle, and I knew my father would have heard of my return from him directly or indirectly.

But his sarcasm and his enmity irritated me.

"I had good reasons to stay away from you," I said coolly. "Would you like me to explain?"

"Go ahead," he replied nonchalantly, taking a sip of his Dubonnet.

I told him what Comrade Liu said and gave him a brief account of my state of mind after China refused to admit me to a university.

Then I added, "It was unfair of you to use me as a probe. You could have at least clued me in to your scheme. You knew that my return to China was a risky undertaking, but you kept me in the dark and manipulated me into going back. I paid a hefty price for that disastrous venture."

Father pulled himself up from his chair, his long frame unfolding until we were nearly at eye level. Looking me straight in the eye, he shot back:

"I am your father. A father needs not consult his son on what he does or what he plans." He was almost hollering with rage. "If I prosper, you will benefit. If I fail, you will suffer. It's the rule of life!"

It was a hell of a claim of power. I didn't want to let him continue treating me as part of his personal belongings, something that he could use for whatever purpose suited him. I had to respond and take a stand, then and there, against his claim of ownership.

"No, it's not *the* rule of life, Father. It's *your* rule of life—and I don't accept it!"

He glared at me, but I hadn't finished.

"You should also know that I don't recall ever benefiting from your success or prosperity. In the future, don't expect me to serve as your instrument or bear the burden of your failure!"

I saw the very moment when he snapped. Just as when I had returned home with the expulsion letter from my first school in Hong Kong, he swung his right arm to backhand me. But I was no longer a ten-year-old weakling. In fact, I was bigger, taller, stronger, and swifter than him. This time I was not taken by surprise.

I ducked. His hand flew by.

He let out an inarticulate roar and, bending his knees in a karate pose, started punching my chest. Left, right; left, right; left, right; his fists lashed out, just like karate practice.

Astonished, I stood there and took the hits in absolute passivity, my mind dysfunctional, my feelings suspended. When he stopped,

a few moments later, anger welled up in my chest through the ice in my heart. His punches didn't hurt that much; he was still strong, but he was an old man. What wounded and angered me was the fact of his violent outburst.

As his arms fell to his sides, he stepped away from me, avoiding my gaze.

"Why did you stop?" I asked defiantly.

"My arms are tired," he retorted without even looking in my direction.

His icy rejoinder pushed me beyond the limits of my tolerance. All the lessons on Confucian ethics, filial loyalty, ancestral respect, and obedience to parents in the world could no longer hold me back. I exploded in a fury.

Grabbing his arms, I held him still and hissed between my teeth into his startled face.

"This is the last time, absolutely the last time! You will never hit me again! Do you understand? Never again! If you try, *I will break your bloody arm*!"

Fuming, I let him go and stormed out of the room.

At the door of the flat, the maid, who cooked all that delicious food I ate during my high school years, met me. She asked innocently, "Was someone drumming in Mr. Li's room?"

"No, no, no," I said. My voice cracked a little. "My father and I were playing a game."

Outside on the street, an irresistible urge to scream consumed me. I felt an unbearable shame. Shame on account of Father! Shame on account of myself, and on account of what happened during our brief encounter!

Only blocks from his office, I broke down, collapsing on the sidewalk and crying like a child. I rocked on my knees, sobbing noisily in great tearing breaths. Luckily pedestrians were rare in that upscale neighborhood; otherwise they might very well have

formed a circle around me and waited to see if I had gone mad, a typical response to any spectacle of emotional display in public.

By the time I regained my composure, I was exhausted, overwhelmed by loneliness and a haunting feeling of emptiness. I picked myself up off the ground and began to walk slowly home, my eyes burning, clutching my stomach as though wounded.

Depression crashed back down on me with a vengeance.

Life seemed insufferable. Poverty and hunger inflicted pain, but affluence and a sated belly had not freed me from suffering, either. What was the purpose of living? What was the purpose of *my* life?

In a Chinese upbringing, the explicit and implicit ideal in life, as articulated in school, taught at home, and transmitted through traditions, is to strive for conventional success. The pillars of conventional success are prestige, power, and wealth, in this same order of importance.

Even though I was financially self-sufficient at the time, I couldn't claim to have embarked on any lifelong, worthy pursuit. I hadn't accumulated any wealth and didn't use my money "benevolently," to benefit my clan or family. I hadn't achieved anything that could be considered prestigious—particularly not through my education, the typical path. And I certainly had no power, the one pillar that was least attractive to me. In fact, I deliberately avoided thinking about the traditional goals, or any other goal in life. Since returning from China, the struggle for survival had spared me from such weighty issues as planning for the future.

Now, in my depression, the future—or more precisely, the absence of a future—haunted me again. What would I do? What would become of me? What was my mission in life?

I didn't have a clue.

I had always doubted the validity of the prescribed goals of life. Father, who lived by them, did not inspire me with confidence in their enduring quality. He acquired prestige, wealth, and power

before midlife, and then lost everything in the blink of an eye. What's more, I felt that his obsession with conventional success had warped him, even dehumanized him.

Yet I had no substitute for the traditional prescription. Questions and doubts besieged me, while answers and confidence escaped my reach.

In Dr. Roy's class on Plato, I came to understand the superficiality of my thoughts as well as my lack of insight into life. I had been trying to fortify myself by reading books of philosophy and literature. Now, in a moment of desperate need for some understanding of the human condition, I was clueless. All that reading hadn't helped. My shallowness and inadequacy tormented me.

I felt like a shipwreck, lost in the great ocean, becalmed and rudderless.

That evening, after dining listlessly in a Russian restaurant, I bought two-dozen loaves of bread and distributed them among homeless children in a nearby shantytown.

Wide-eyed, the children looked at me with an expression suggesting that I had gone insane. A madman had come to give them bread!

I understood their reaction. A well-to-do person never showed up in the shantytown for fear of disease, violence, and the sight and stench of unbearable human suffering. If someone did, it would be for an official reason and he would make every effort to shoo away these dirty and unkempt street urchins.

But they didn't know that I secretly identified with them. The year I spent in the slum of Nanjing was still, without a doubt, the happiest time in my life. My friends and I were all street urchins. We were defined by our unwavering loyalty and absolute devotion to one another. Ever since, I had longed for that idealized and perhaps romanticized human relationship, which, if it exists at all, probably occurs only among innocent children bonded together to overcome great physical hardship.

That evening, as I gave away loaves of bread to the shantytown kids, they didn't know that in spite of my well-dressed and well-fed appearance, I thought of myself as being no different from them. I wished for a miracle to deliver me back to my friends in the slum. I would be glad to give up all of my material gains if I could only return to that former life and join them again. Giving food to the street urchins in the shantytown eased my agitation, as if I were recapturing a little bit of that feeling of solidarity with my buddies.

But afterward, the melancholy feeling of being adrift continued to haunt me all night, and the next day, and the day after . . .

Days went by and I became desperate.

I tried talking to myself, something I had not done since my childhood days of imagined ghosts. It didn't work. Melancholia clung to me like a leech, draining me of lifeblood.

Within a week, my state of mind had regressed to a serious depression, reminiscent of the aftermath of the psychological devastation brought on by Comrade Liu toward the end of my days at the reform school.

But in many ways it was worse this time!

I could no longer distract myself with the desire to seek good food and physical comfort. That had lost its motivating power, because I was already well fed, well dressed, and able to afford my own living space. It was pleasant to eat well and dress elegantly. But it couldn't solve the problems of my spirit.

I tried reading suspense novels to take my mind off the weighty issues of life, but lack of concentration spoiled my attempts. I couldn't sink my teeth into either the plot or the language.

My tutoring suffered. My pupils thought I had become absent-minded.

As my depression spiraled downward, I stopped attending classes at Chung Chi and skipped visiting Mother. One day blurred into the next. Everything seemed gray and meaningless.

One morning I realized that I was no longer a wreck adrift, but

a sinking ship, and going down fast. What could I do to pull myself up, to lift my spirit?

There was no possibility of seeking psychiatric help. I had never heard of a psychiatric practice in China or Hong Kong. The overwhelming majority of Chinese people considered psychiatry witchcraft, at least in those days. Seeking help from a psychiatrist involves revealing your innermost feelings to a stranger who has no other connection with you. It is a practice that stands in opposition to every imaginable social convention and protocol of human relations in the East Asian world. Instead, a person might seek to unburden himself to one with whom he shares an intimate, interdependent relationship. This mutual dependency is the pillar of human relationships in East Asia. Either people are mutually dependent on one another or they have no relationship at all.

A strange bird, I had nobody to depend on. This time, there was no Aunt Helen to offer guidance, no Da-ge to provide advice.

After a few weeks, salvation came unexpectedly.

Late one evening after tutoring, I went to the sports field of Chung Chi to run around and around on the track, in the darkness of the night, hoping to clear my mind. After a few laps, I was sucking in air so hard and my heart was beating so fast, pounding in my chest, that I thought I was about to die.

But the thought of death didn't stop me. Death by exhaustion seemed infinitely preferable to endless depression. I kept running, straining to breathe, my calves stiffening and my abdomen cramping. Finally my legs became too shaky to run, so I slowed to a walk and spent at least another hour on the track.

That night, I collapsed in my bed and fell asleep in my sweat-drenched clothes almost immediately. I slept for almost sixteen hours. It was as if the sweat had drained all of the black thoughts from my mind.

Upon waking, my legs were sore, but my mind felt clear. For the first time in weeks, I felt capable of functioning again.

I decided that running would be my remedy, and returned to it, sore legs and all, the next evening, and the evening after next, and so on.

After one month of relentless daily running, both my spirit and my body felt stronger. I joined the track club at Chung Chi. The coach decided to try me at sprinting.

I ran my first 100-meter sprint in just under twelve seconds.

The coach said, "Wow!"

I beamed.

After that I bought myself a pair of spikes. They were so light and provided so much more traction than sneakers that, wearing them, I felt like the Greek god Hermes, with wings on his feet. Within weeks, I dropped my time for the 100-meters to the lower end of eleven seconds.

I won my first 100- and 200-meter races at Chung Chi's annual track meet with ease. Then I represented Chung Chi in track meets with all other postsecondary institutions in Hong Kong and won championship after championship in both events. I brought all the trophies and medals I won to Mother. Often she and I went out to dinner to celebrate my most recent victory.

Winning was addictive as well as contagious. It gave me a high without a letdown, and it helped me to forget my failure. After tasting victory in track, I enlisted in all the intercollegiate and international contests I could find, winning debating contests, essay contests, and oratory contests. Over twelve months, I became a small celebrity in the postcollegiate Hong Kong world, a minor success story.

In Chung Chi's track club, I met a 400-meter runner, David Lin, and became good friends with him. His steadiness and cheerful disposition balanced my impulsiveness and propensity toward moodiness. Bespectacled and handsome, he came from a happy family with a lot of support from both parents. We complemented each other

temperamentally and enjoyed each other's company in outings to restaurants and short excursions to the outlying islands around Hong Kong. I treasured his advice, and he appreciated mine.

One day, David told me about an upcoming competition for several full scholarships, covering all expenses, to attend colleges in the United States. To highlight the International Refugee Year of 1961, the U.S. State Department offered six fellowships to Hong Kong residents as a one-time contribution to the welfare of refugees from Communist China. Just about everyone of Chinese origin in Hong Kong qualified as a refugee from Communist China. The only other eligibility requirement was a high school diploma.

David wanted both of us to toss our hats into the ring.

I was reluctant to join David and explained to him that I had to have been blacklisted by the U.S. Consulate for having returned to China in 1957 for one year. He countered that as his friend, I was obliged to keep him company in the competition, even if I was blacklisted. He wanted my moral support and companionship during the grueling competition. In addition, he pointed out that I lacked any conclusive evidence to support my claim of being blacklisted.

After some back-and-forth on this issue, I gave in to his insistence.

More than a thousand people took part in the contest, which involved written tests at the preliminary stage, then three stages of interviews until the final six winners were chosen. Convinced of my blacklisted status, I entered it without harboring any hope, and therefore, felt completely at ease. I was merely doing my friend a favor. As it turned out, that relaxed attitude enhanced my performance in the exams and in the interviews.

Much to our astonishment, both of us were chosen.

David was selected to attend Reed College in Oregon, and I was told to go to Bowdoin College in Maine. Until that point in time, I had never heard of either Bowdoin College or the state of Maine.

But I was neither disappointed nor discouraged by my ignorance

or the obscurity of the destination chosen for me. A fellowship to study abroad was a gift from heaven, something I had dreamed about since high school. With a fellowship, I would be able to pursue a degree, seek a future, and forge a career. Most important, I would have an exit from the confining enclave of a colonial society to seek a new life.

But I had one last hurdle. The fellowship package did not provide airfare from Hong Kong to the United States, and despite my relative financial security, I did not have the resources to pay for the flight myself.

I went to Mother, the one person who I thought might be able to help me, and asked if she could somehow use her connections to find me a loan. My heart was in my throat.

Mother looked at me with her customary placid expression, then said, "My son, I will do my best for you." Her eyes showed a spark of determination in them, and there was a touch of steel in her voice. I remembered the day when she had pledged to try to be a better mother to me, so long ago.

Miraculously, Mother arranged for her church to grant me a loan, which I promised to pay back in two years. I didn't know if her church was aware that they were loaning money to a heathen.

I was free at last! I whispered it aloud to myself at night. *"I am free!"*

My excitement brought on many nights of insomnia. Each sleepless night, I went back to my favorite Russian restaurant to buy as many loaves of bread as I could carry and distributed them to the hungry children in the shantytown.

I remembered that at the depths of my depression, almost one year ago, bringing bread to the starving children had eased my heartache. Now, pain no longer plagued me. On the contrary, I was filled with hope and happiness. I just wanted to share my good fortune, secretly in my own heart, with the street urchins, even though they could not know my intention or my joy. It was the only way I

could cherish the happiest days of my life when I was with my bosom friends in the Nanjing slum. Now, for the first time, I felt that perhaps there was promise in my future to match the happiness of those days long past.

———

September 6, 1961, was the date of my departure.

On my way to the Kai-De Airport, I went to Mother's theological seminary to bid her farewell. At the end of my brief visit, she hugged me for the very first time in my life. Then she said solemnly, "Son, I know you can fend for yourself. My only wish is that you should never marry an American."

"Mother, I don't ever intend to marry!" I responded with determination. I had never thought about marriage, yet my spontaneous response was genuine and resolute.

My pronouncement that I would forsake marriage startled Mother as well. She looked at me with mournful eyes, just like the time she announced to me that she was leaving Father. But she didn't say anything more, gently acknowledging that control of my own life was mine alone. I took my leave of her with a grateful heart.

At the airport, I marveled at the sight of airliners landing and taking off. Then I looked admiringly at the plane I was scheduled to fly in, a white four-engine propeller plane with the letters "TWA" painted in red on its tail. It was the vessel that would carry me to a new life, a fresh beginning in a country I had read and heard so much about.

I was indescribably excited. But my excitement was also accompanied by apprehension. I had already started wondering: Will America be kind to me? Will I be able to adapt, or will I end up coming back to live in a Chinese society?

As I was getting ready to board, I looked at the waving crowd around the gate, all of them gathered there to send off their loved ones and friends. Apart from David Lin's family, I did not recog-

nize anyone. But this made me neither sad nor nostalgic. I was pre-occupied with starting afresh and launching a new life. Then, suddenly, I caught sight of Father at a distance.

There he was, tall and gaunt, at the back of the crowd, his big head and his grave expression jutting above the shorter people in front of him. I had not told him that I was leaving and didn't expect him to be there. He must have found out about my departure through the usual gossip channels. For a brief moment, his presence dazed me.

As I made my way through the crowd toward him, what I knew of his life flashed through my mind.

A self-made man, he had reached the end of the road, the end of his ambitious and single-minded pursuit of prestige and power. There had been a burst of great promise in his early thirties, but the promise never bore fruit. The latter years of his life brimmed with frustration and disappointment.

His wife had left him. His children kept him at arm's length. Prestige and power eluded him. His political career had died and was never to be resurrected. After twenty-some years of living in a British colony, he remained a total stranger among a sea of Canton-ese and Westerners.

He was a forlorn and tragic figure, and I had shunned him for nearly the past three years. Preoccupied with my own survival, I had never looked at his life from his perspective. Now, at the moment of my departure, his view of the world unexpectedly broke upon me like a sudden storm.

I found myself overcome with remorse.

I had expected him to be different from what he was: a product of the miserable and pitiless life in rural Shandong. In my heart, I had wanted him to be something other than who he *could* be—a one-dimensional man who didn't have the faintest idea how to re-late to his family, a man who had for most of his life behaved ac-cording to the traditions and laws that had served his ancestors for

generation after generation. He truly believed that his single-minded pursuit of conventional success was to the benefit of every-one related to him: his immediate family, his clan, his fellow villagers. He thought that keeping his family at arm's length and using his children as pawns for the greater good of the family line were the path to bringing a better future for everyone related to him, just as he had been taught. When failure became painfully clear and irreversible, he had retreated into a cocoon and acted ir-rationally, even abominably.

In response, I had retaliated against him with anger and con-demnation.

With all of these thoughts crisscrossing my mind, I didn't think about what to say as I walked toward him. By the time I reached him, words escaped me. I stopped before him. He was tall and yet stooped, proud and yet broken. His face was lined with sorrow, and he did not speak.

Standing before him, I saw his haggard image recede as tears filled my eyes.

Then I caught sight of his arms reaching out and felt his em-brace. Instinctively I closed my arms around him and drew him close. Only then did I feel his tears falling on my neck.

We remained wordless as we parted. My throat was tight as I turned around to enter the boarding gate, tears streaming down my cheeks. I did not, could not expect any further miracle than the embrace he had just given me. But then there was Father's fading voice, shaking with emotion, calling out to me as I moved away.

"Take care of yourself, my son!"

In the plane, brushing the salt from my cheeks, I resolved to stay in touch with him and rebuild our relationship once I arrived in the States. There would be more to my life—years more of learning, of succeeding or failing, of heartaches and joy—but even then I knew that nothing would compare to that irreplaceable moment as I stepped forward onto the plane and a new life, his voice fading behind me.

EPILOGUE

BEING IN THE UNITED STATES IN 1961 WAS not like anything I had imagined. I was assigned to a fraternity for athletes at Bowdoin College. The fraternity housed the entire football team, the entire baseball team, and the entire basketball team. Responding to a request from the college administration, the brothers of that fraternity graciously allowed me to sleep and eat in their house—but only as a "guest," because "We don't admit colored people as brothers," as they explained to me on the day of my arrival. Nonetheless, they were excited that a "yellow speedster" would join their stable of athletes. (Later on I found out that I owed my room-and-board privilege at the fraternity to my reputation as a record holder in the 100 meters in Hong Kong.) But sprinting was behind me. I wanted to take maximal advantage of the opportunity to get a college education. Members of the fraternity took great offense at my decision not to join the track team.

One day about a week after my arrival, as I returned to the fraternity house from the library, a hulking linebacker from the football

team asked me, in all seriousness, "Hey, Chinaman, does your father run a laundry shop or a chop-suey joint?"

I was mystified.

Besides not understanding the word "chop-suey," I couldn't make any sense of notions like "laundry shop" and "joint," which were completely out of context to me. And what did they have to do with Father? It was like asking a pedestrian in a pinstriped three-piece suit on Wall Street, "Does your father herd Bactrian camels or cashmere goats?"

More than confused, I didn't know how to respond.

Was the question a joke? A riddle? A test? A provocation? An insult? I didn't have the slightest clue.

"Bubba" Smith, who looked like an enormous cube of muscle with a dot for a head, had a smirk on his face as he waited for an answer. Following the old Chinese tradition of keeping a low profile and shutting your mouth when you are lost, I chose not to respond and tiptoed around him.

"Fuck you, chink!" I heard him yelling behind me.

I was mystified again, because I understood neither the F-word nor "chink." I hadn't learned them in my English classes in Hong Kong, nor had I ever heard a British overlord, whether in contempt or condescension, use either of those two words. But the tone of Bubba's voice told me that he wasn't friendly, at least not as friendly as when he asked me if my father ran a laundry shop or a chop-suey joint.

Looking back, I understand that American culture in 1961 still belonged firmly to the 1950s, and that a fraternity of athletes was, and may still be, an animal house. The Civil Rights Movement had not yet come into its own in 1961. The youth rebellion had just begun in Berkeley with the Free Speech Movement. The anti–Vietnam War movement, which would galvanize the nation and bring a sea change in American values and society, hadn't yet begun. So, it was, by and large, the not-so-tolerant America of the

1950s, in terms of cultural and ethnic diversity, that I experienced upon my arrival at Bowdoin College.

I wrote to my father weekly, reporting on my bewilderment and surprise in what I saw as America from a very narrow perspective in a small college town in Maine. I told him that even though I hated Hong Kong as a British colony, I would return as soon as I earned the highest academic degree. In the meantime, I would patiently suffer this strange nation of wealth, material abundance, and natural beauty for the sake of an education.

But that was not what fate had in store for me.

By the time I went to graduate school, at Stanford, and then Berkeley, I serendipitously, without any conscious design, underwent a lengthy but dramatic as well as traumatic transformation that resulted in my acclimation to, and embracing of, America. (But that's another long story, one that I hope to tell another time.)

Father responded faithfully to my weekly letters with admonitions, moral lessons, edifying stories, and description of great men and memorable events in history. His letters were written in Classical Chinese with elegant calligraphy. Each letter was numbered, starting with number 58, in continuation of the series that had begun when I went to China, four years before.

In his didactic letters, a new theme, one that had never come up between us in the past, emerged. He was concerned about Americans' obsession with sex. Describing at great length the debilitating and deleterious effect of sexual indulgence, he warned me against falling for the "American obsession." According to him, the first symptom of sexual indulgence was the deterioration of eyesight. Warnings against sex became a regular fare of his teachings. He harped on Hugh Hefner, Marilyn Monroe, Jane Russell, and Hollywood as being symptomatic of the unhealthy American obsession. At one point he sent me a recommendation, in Classical Chinese, of what he said was considered by legendary herbal doctors a healthy

frequency of sexual intercourse during the twenties, thirties, forties, fifties, sixties, seventies, and eighties of a man's life. The entire prescription was cleverly and skillfully couched in euphemisms to avoid any mention of such coarse words as "sex" or "intercourse." Each euphemism consisted of four characters, and therefore, four syllables. All seven euphemisms rhymed. Upon receiving the prescription, I laughed so hard that the fraternity brothers thought I had momentarily lost my senses. Sadly, I did not keep the prescription. The only euphemism I can remember from the list was the recommendation of frequency for a man in his eighties:

Gong-xi fa-zai, which is a greeting equivalent to "Happy New Year!"

In 1970, nine years after my arrival in the United States and toward the end of my first year of teaching in the University of California system, I invited my father to make a month-long visit to the United States, at my expense. When I met him at the airport in San Francisco, the first words out of his mouth, accompanied by a telling smile, were:

"So, my son, you are wearing glasses!"

I laughed and admitted that I had become nearsighted, without either denying or confirming that my myopia was caused by sexual indulgence. For me, his words were now revealing a part of him that a Chinese son could never see. I learned much more about him when I accompanied him for a thorough physical checkup at the UC Medical School in San Francisco.

By then, my father had not had a physical exam in nearly thirty years. He was in his seventies, still with pitch-black hair, an athletic gait, perfect vision, and a sinewy, lanky build. At the beginning of the exam, a young physician asked him a rather lengthy series of questions in an attempt to construct his medical history. During the entire session, I sat behind him.

"Mr. Li, have you ever passed blood in your stool?"

"Yes."

"Did you see a doctor?"

"No."

"What did you do?"

"I curled up in my bed and stopped eating for a couple of days until the bleeding stopped."

"Why didn't you see a doctor?"

"Why should I? Doctors in Hong Kong were only interested in robbing me!"

My father's answer stunned the interviewing physician, who had to pause for a minute as he collected his wits.

More or less the same sequence of questions and answers followed with respect to his urinary system. He passed blood in his urine, and would wait for it to clear up without medical intervention. But when the questions moved on to the respiratory system and the physician asked my father if he had ever coughed up blood, he answered,

"No. That's for people who suffer from tuberculosis. Not I. I am too strong for TB!"

When I lived in China and Hong Kong, tuberculosis was a leading cause of death, associated with poverty and hard physical labor. One of my elder sisters did contract TB, as I noted earlier in this book. Luckily she survived and now lives in England.

When the physician asked him what the worst illness he had suffered in the past thirty years was, he answered without hesitation:

"Malaria. It was hell!"

"What did you do?"

"I took quinine until the fever and shivers went away."

"You mean you medicated yourself?"

"Of course, who else would medicate me? I bought quinine from the pharmacies. Everyone in Hong Kong knows what malaria is!"

When the doctor switched to questions in the neurological area, the answers my father gave were always a simple negative, until the doctor asked:

"Mr. Li, have you ever been knocked unconscious?"

My father glared at the physician, and then, pointing at his own nose with his index finger, said fiercely, "No! Only I knocked other people unconscious!"

Stifling his own laughter, the doctor ended the interview. As I walked out of the interview room with him, while a nurse was talking to my father, he commented softly, "Your father is a phenomenon. He'll live to be a hundred and fifty!"

Well, the doctor was mistaken in his diagnostic prediction. In 1989, at the age of ninety-one or ninety-two (no one knows for sure which year my father was born), Father made his pilgrimage to the Amur River on the border between Siberia and northern China, where he tragically, and unnecessarily, met his death.

As I related earlier in this book, my father had gone to that desolate place on the bank of Amur River to visit the two daughters he had fathered as a teenager in his Shandong village. They were living with their mother on a collective farm operated by the Liberation Army, across from Russia. At the farm, where living conditions and facilities were primitive, he came down with a bitter cold in the middle of a frigid winter and died shortly thereafter.

After his death, reading between the lines of the official death report sent to me by the Chinese authorities, I pieced together what had most likely happened.

Owing to the fever, electrolyte imbalances, and the lack of proper medical care, my father began to slip in and out of delirium. The staff of the local medical aid station interpreted his delirium as "schizophrenic insanity" and confined him to a primitive insane asylum, where he, like most other inmates, was restrained in a straightjacket. At one point, he snapped out of his delirium and demanded to be released. When the staff of the asylum refused to comply with his demand, he started cursing and spitting at them. The staff then injected him with a powerful dose of tranquilizers, which killed him almost instantly.

My father was born in a humble and backward village during the Manchu dynasty, and died in an equally humble and backward village during the Communist era. Years before his death, while attending graduate school in America, I became a man of two minds: an East Asian mind, steeped in Confucian philosophy, and a Western mind, originating in the Greco-Roman civilization. Father recognized my double identity when he visited me in the United States. He never said anything about his perception, but after that visit, he stopped addressing me by my Chinese name. Instead, even though we conversed exclusively in Chinese, he called me "Charles"—in English, of course—each time I visited him in Hong Kong.

"Ah, Charles, *ni lai-le*!" (You've come!) was his standard greeting when he first saw me on each of my visits.

Li Na saw his father as a tireless warrior, a victim of his time, and sent him money every month for twenty years, in accordance with filial loyalty. Charles saw him as a vain and combative figure of tragedy, consumed and wasted by unfulfilled ambition. Neither Li Na nor Charles was right, and neither of them was wrong.

ACKNOWLEDGMENTS

IN PREPARING THE FINAL DRAFT, I BENEFITED immeasurably from the wise and nurturing comments of Alison Stoltzfus. She is a jewel among professional editors.

John Nathan, a noted author and raconteur, read an early draft of my manuscript. His favorable response strengthened my resolve to push ahead in writing the narrative.

Finally, this book would never have been written without the initiative and encouragement of Judith Regan. Years ago she started telling me that I had a bellyful of fascinating stories that should be written down. In spite of my reluctance and hesitation, she never gave up on me. Finally, in 2006, I heeded her advice during a year of sabbatical in Paris and discovered the joy, challenge, and reward of writing. She has led me to a new pursuit that I will treasure forever.